40
WATERCOLORISTS
AND HOW THEY WORK

40 WATERCOLORISTS AND HOW THEY WORK

FROM THE PAGES OF

American Artist

BY SUSAN E. MEYER

WATSON-GUPTILL PUBLICATIONS, NEW YORK

PITMAN PUBLISHING, LONDON

84- 358
Aug. 13, 1984

First published 1976 in the United States and Canada by Watson-Guptill Publications
a division of Billboard Publications, Inc.
One Astor Plaza, New York, N.Y. 10036

Library of Congress Cataloging in Publication Data
40 watercolorists and how they work.
 The essays originally appeared on the watercolor page
 of American Artist.
 Includes index
 1. Water-color painting, American. 2. Water-color painting — Technique. I. Meyer, Susan E. II. American Artist.
ND1808.A1F67 1976 751.4′22 76-24797

Published in Great Britain by Sir Isaac Pitman & Sons Ltd.
39 Parker Street, London WC2B 5PB
ISBN 0-273-00971-0

Manufactured in Japan

First Printing, 1976

Introduction

I am convinced that artists working in watercolor are a special breed altogether: they have a passion for their medium, a zeal that is unmatched by any other group of painters. Watercolor has a kind of mystery, deriving perhaps from its purity, its deceptive simplicity which, by its very nature, seems to defy control. It is a fickle and willful medium, after all, and the artist must always tread the elusive line between total authority and watchful surrender, being at one moment the commander of the medium and at another moment its humble servant. There is a magical relationship between the artist and watercolor. And there is an unmistakable fellowship among watercolorists, an understanding, a camaraderie that is evidenced by the proliferation of watercolor societies throughout the United States in recent times.

For years *American Artist* has recognized the unique position of watercolor in American art. Each month the magazine features a watercolorist in a section of the magazine called *The Watercolor Page*. Originally *The Watercolor Page* occupied only a *single* page in the magazine, then was expanded into two pages, and when I became Editor in 1971, *The Watercolor Page* further expanded into four pages.

The artist invited to *The Watercolor Page* is asked to write an informal text describing his or her feelings about watercolor and how he or she prefers to handle the medium. We know from the many letters we receive from our readers that *The Watercolor Page* continues to be the most popular section of the magazine. *Forty Watercolorists and How They Work* is a selection and adaptation of our favorites—both mine and those of our readers—that have appeared in the magazine since 1971.

As you will see, no single school of thought has been used as a criterion for selection. On the contrary, we have gone to great extents to find many varied approaches. Consequently, we have studied the work of artists from every region of the country—well known artists and lesser known ones, some with important affiliations, others with none. We have chosen artists who prefer tight, carefully controlled watercolors, and those who prefer the "splash" approach. We have selected artists who depend on photographs, and those who reject the photograph altogether. We have artists who are devoted to the purity of transparent watercolor and those who admire its opaque qualities; those who use masking agents, those who do not.

In fact, we would like to think that these artists have little in common with each other *except* their passion: watercolor. And this is a devotion that ties them together more strongly than it divides them, for this is a very special breed.

Susan E. Meyer

Contents

40
WATERCOLORISTS
AND HOW THEY WORK

Mike Burns

ONE THING STANDS OUT from my early training in watercolor, something that one of my professors once said: "Before you paint anything, know it first-hand and experience it." Remembering this has led to my involvement with old houses and buildings. Family vacations find us — my wife, children, and myself—touring old farming areas or searching through deserted ghost towns looking for old decaying farm houses.

I suppose what fascinates me most about them is the starkness and simplicity of their settings and the life style of the people who lived in them. With all of the conveniences we have, it is difficult to imagine living 40 miles from the nearest town or rail head, trying to turn sage brush into crops. Some farmers made it, some didn't.

Eastern Washington and Oregon seem to have many of these architectural relics. They're found amidst wheat fields and sagebrush, and the settings are, in one word, dramatic. I also find the small rural schools fascinating, especially the one-room schoolhouses. It's these abandoned shells that provide a wealth of painting material for me.

My subject matter dictates my working habits. Due to the remoteness of my locations, I spend a great deal of time driving to an area and then more time to find the farms, schools, etc. Since so much

time is consumed in driving. I do not paint on location, rather, I prefer the use of a camera. With it I can gather more material in a given amount of time and can have a permanent record of the subject, including its detail. The actual paintings are done in my studio. With these photographs I can easily refer to a subject at any time. In addition, since each painting requires an average of ten hours painting time, it's a matter of practicality.

My "sketchbook" is a Kodak Retina Reflex 35mm camera that includes 50mm and 135mm telephoto lenses. I work with both black/white prints and color slides: KX 135 film with a speed of ASA 64 and Tri-X with ASA 400 suit my purpose best. Both give good light range, which is especially helpful for inside and detail shots. I generally take one roll of both black/white and color film per house, which gives me the material I can use for any number of paintings. It is important, however, to compose each slide frame as it might look in a final painting.

I think the distinctive aspect of my paintings is their simplicity, both in composition and subject. I treat each painting as a portrait, with the building being the subject. Only what is absolutely necessary in telling its story is included. In fact, I sometimes find it necessary to eliminate all sky and landscape,

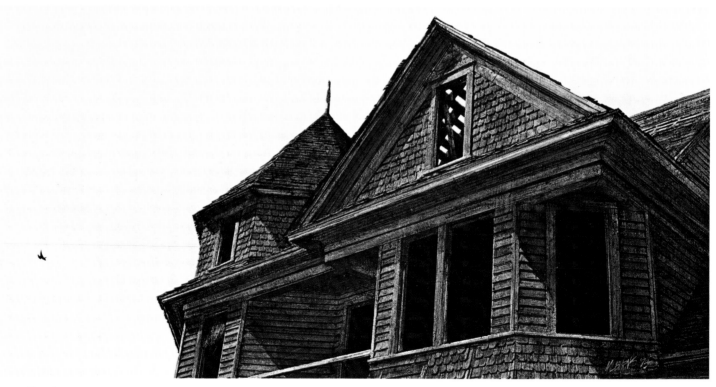

Requiescat, 1973, 24 × 48. Collection Investors' Insurance Co. When Burns finds an old house, he sometimes feels a bird should be the only living thing allowed there. Here the bird is also used as a design element.

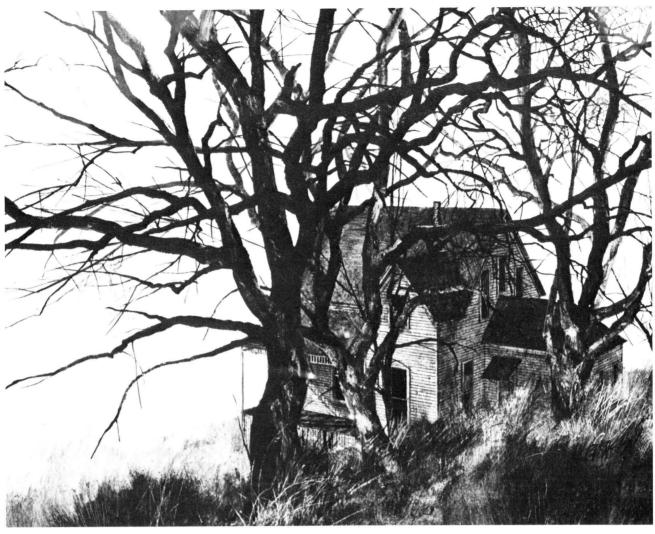

House on Wollochet Bay, 1971, 24 × 30. Collection Virginia Voorhees. Like a maze of spider webs, the trees in the foreground were used to give a mysterious mood. The house is the remaining portion of a large land grant by President Benjamin Harrison and, at the time Burns found it, was inhabited by a hermit.

BIOGRAPHY

Mike Burns lives with his wife and family in Bothell, Washington, a suburb of Seattle. He studied art at the University of Washing-

ton and Seattle Pacific College, where he received a B.A. degree in art. Following graduation he was employed as an illustrator by The Boeing Company for two and one half years, by Cole and Weber Advertising Inc. for one year, and by the Washington Army National Guard for four years.

Burns is a member of the Puget Sound Group of Northwest Painters and the Northwest Watercolor Society. His watercolors have been represented in over 60 regional and national exhibitions, including an invitational group exhibit at Expo 70, Osaka, Japan. He has won several awards in regional and national exhibits, including two purchase awards in Watercolor U.S.A., Springfield, Missouri.

Burns's work is represented in museum, business, and private collections throughout the country. He is represented by Haines Gallery, Seattle.

Psalms 61:3, 1971, 23 × 37. Collection Mr. and Mrs. Raymond Gastil. The landscape and background were eliminated to create a sense of quiet dignity. Repeated glazing, then blotting out part of the glaze, and then reglazing give the wood greater texture and depth.

Boarded Up, 1973, 21 × 30. Collection Mr. and Mrs. Claude Burns. The boarded windows seem to say, "Quiet, do not disturb." Old houses and barns hold particular interest for Burns. Feeling that each has a past life of its own, he enjoys treating them as portraits rather than as inanimate structures.

leaving the subject floating on a white background. Another noticeable feature is a total lack of clouds. I find a simple sky or background draws more attention to the story of the building. The composition is also simple. If the subject is in the middle of a flat, barren landscape, that's how I paint it. If it's lonely, I want that feeling paramount. This is why I very seldom include people. Instead, in some paintings, where I want to soften a mood or composition that might otherwise become too stark and uncomfortable, I use birds. In other paintings I use them for compositional purposes of balance or of directional lines. I feel the addition of secondary details has to be handled with extreme care. Just enough should be included to finish the composition and to make the scene come alive.

My palette is primarily made up of grays and browns. The browns consist of warm sepia, raw umber, burnt umber, raw sienna, and burnt sienna. The gray range includes Davy's gray, Payne's gray, charcoal gray, and neutral gray. Rounding out the palette, I use Naples yellow, alizarin crimson, and sap green. I use matte medium along with the watercolor paints, just enough to make them permanent and to prevent the lifting of the first washes.

Instead of watercolor paper I use ¼-inch Upson board. This is a very tightly compressed cardboard with a smooth side, which I work on, and a pebble grain side. It's a building material that may be purchased in lumber stores in 4 x 8 foot sheets. I have the boards cut into 24 x 48 and 32 x 48 inch panels. I cover the Upson board panels with white "one-coat" latex house paint. It serves the same purpose as gesso, but it's thicker and dries much faster. The panels are thick enough to prevent warping and sturdy enough to serve as their own backing board when I frame the finished paintings. At the same time, they don't add excess weight to the framed paintings.

To start a painting such as *Requiescat*, I first make a detailed drawing of the house on tracing paper. Shakes (shingles), siding, and window details are included at this stage. An accurate drawing is important to assure that the final rendering is proportionally and structurally correct. The tracing paper is then positioned on an Upson board panel, and the drawing is transferred onto it. I prefer this method because it allows for corrections without damage to the painting surface.

I use a trial mat to check the position of the house within the composition before beginning the actual painting, and I continue to use it in the same manner throughout the painting process.

The first wash, usually a mixture of Davy's gray and raw umber, is applied in a thin coat; some areas of this wash are later retained for highlights. The rest of the painting is usually built up with a series of brown washes made up of various mixtures of raw and burnt umber and raw and burnt sienna. Periodically, I blot out areas with a paper towel to add texture. The more the glazing and blotting is repeated, the greater the depth in the weathered wood. The washes are spread on with a ½ inch flat and Nos. 6 or 8 round brushes. The shadows are then added, along with the other dark areas such as windows, doors, and some roofing.

The detail work comes next. I enjoy this step because it becomes a challenge to see how accurately I can paint the detail. I feel the detail adds interest for the viewer and holds it, and I want him to see something new each time he looks at the painting. The small shadows under each siding board, shingle, window, and door jamb are painted first. These are applied with small round and flat brushes. I then stripe in the cracks and lines between the boards. A No. 1 or 2 small round brush does a quite satisfactory job.

At this point I proceed with the sky and landscape. For the sky I use various shades of white or gray latex house paint. I prefer the effect of the plain, solid-color sky to a more elaborate one. As mentioned before, I treat my paintings like portraits; therefore, I want the viewer's attention to be directed to the house, not carried away by an equally interesting sky. The latex works very well for this because it covers solidly and does not vary in tone.

A white latex base for the grass and background hills is then added. The hills are painted with a wash. When the wash dries, I use a stiff brush and a paper towel to scrub in the base color of the grass. I have a couple of old oil brushes with short, stiff, spread bristles. They look terrible but make beautiful grass. The base coat is followed by dry-brush work and the scratching out of individual grasses. The final detail involves weeds, bushes, distant trees, and birds. These are all applied with a very fine pointed round brush, a No. 0 or No. 1. The painting is now finished and ready for framing.

I purchase my frames unfinished, all of the same stock molding. The molding, a reversed style, is stained a light walnut color with a transparent stain. The mats are also uniform: I double mat each painting. The base mat is white with a top mat of off-white linen board. Generally, the top mats are five inches wide on each side with a six-inch wide bottom and top. The bottom mat, however, is about ⅛ inch wider on each side than the top mat. When in position, this ⅛ inch creates a border around the painting, and the double mat creates the illusion of depth. I usually draw a pencil line around the inside of the top mat—about an inch from the inner edge. This creates the illusion of a third mat and additional depth.

My paintings are not completed at one sitting. Due to the amount of drying time involved in each wash or overlay, they take one to two days, depending on the complexity. Occasionally, one will even take three days to complete. Patience is the key to my type of painting and, in the end, determines its success.

Claude Croney

I PREFER WATERCOLOR BECAUSE of its unpredictability. The medium seems to fit my personality: I am impatient, and watercolor has a certain spontaneity and immediacy that appeals to me. Preferring not to ponder over a painting for many days, I can usually do a watercolor on the spot or in the studio within a couple of hours. Although many people tell me that watercolor is much more difficult than other media, I don't agree. I paint in oil and acrylics as well, but I feel most comfortable with watercolor because of its familiarity.

This is not to say that watercolor doesn't have its frustrations. I burn many more paintings than I keep! I've never yet painted a watercolor that turned out 100% the way I wanted it. But I derive a tremendous amount of pleasure and satisfaction from a painting that comes close to what I wanted. Considering myself a fairly simple person, I try to keep my paintings simple as well. I try to present my subject in a bold and direct manner, placing emphasis on design and value pattern.

Whether I paint out of doors or in the studio, I always make several small, rough, preliminary pencil sketches. These are kept very simple and rather abstract. The two most important things here are the design or composition and the value pattern. I usually use the three-value approach: I break up the space with lights, darks, and middle tones. The light means anything from white paper to a very pale wash. Once I establish my idea with these small sketches, I draw, with pencil, the outline and the division of spaces on my paper, which I have stapled to the drawing board.

Most of my paintings are done on 300 lb. rough French paper. This paper takes a great amount of abuse, and I find the rough surface helpful when indicating textures. Most of my paintings are full sheets, so this large, heavy paper gives me a minimum of buckling. I also experiment with smooth illustration board, a surface that gives me a completely different effect and reacts very differently to the brush.

My palette of tube colors consists of cadmium yellow light, yellow ochre, cadmium orange, cadmium red, burnt sienna, alizarin crimson, Hooker's green deep, cerulean blue, ultramarine blue, burnt umber, and Payne's gray. From time to time I also change a color. For any one painting I never use all of the colors on my palette; only four or five, perhaps.

Brushes are very important, and I use only those of high quality. I use red sables: No. 5, No. 9, and No. 12. I also have a 1½ inch flat sable and a 2 inch varnish brush, which is an inexpensive brush and works out quite well for large, quick washes. The rough bristles in this varnish brush assist me in obtaining heavy textures in large areas. I also keep a small bristle brush in my kit, which I use for lifting out some light after the painting is dry. I may use this small bristle brush for softening an edge when necessary.

Whether I'm on location or in the studio, I always make preliminary drawings. On location I'll use a pencil and pad and leave my easel and paints in the car, rather than carry them around with me while I'm doing my preliminary work. These preliminary drawings also act as a warm-up.

The painting reproduced here in color, *Cliff House*, was painted on a 21 x 29, 300 lb., rough sheet. The idea for the painting originated from a purely abstract pencil sketch. While sketching, I was concerned only with the division of space within the picture area. The design is basically a strong horizontal with an almost as strong vertical. I could have crossed the paper equally, and it would have been valid, but not quite as visually interesting. After this light drawing, I decided against a purely abstract painting; I wanted to use shapes in a way the viewer could relate to. Only simple shapes were needed to suggest a house, tree, and some foliage.

Rather than working from light to dark in this painting, I immediately went right after the dark, positive shapes across the top of the paper, working very quickly and not worrying if the colors ran together or not. Once the area was painted in, I used the painting knife to scrape some light variations out of the darks. I did this very quickly, and before the dark dried completely I applied some more dark paint under the foliage and on the house, bringing

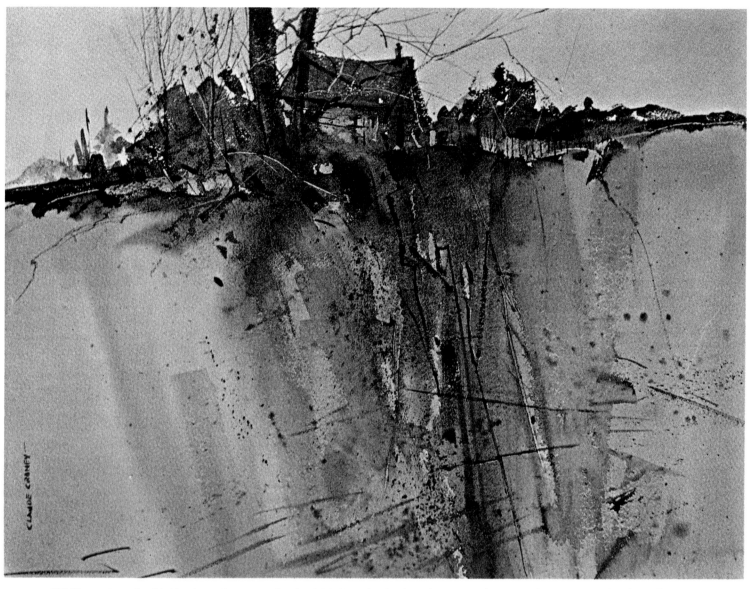

Cliff House, 21 × 29. Working from abstract studies in which the artist developed a pattern of strong horizontal and vertical lines. Claude Croney decided upon a landscape with simple shapes for his painting.

BIOGRAPHY

Born in New York City in 1926, Claude Croney attended Scott Carbee Art School in Boston at night, studied with Art Instruction, a correspondence school in Minneapolis, and attended Providence (R.I.) College. Besides several one-man shows, Croney has exhibited at National Academy, Allied Artists, and American Watercolor Society. He is the recipient of over 60 awards. Many of Croney's paintings are represented in public and private collections in the United States and Europe. Having taught for many years, Croney was asked to do a watercolor demonstration which was published in the form of color slides and cassettes by Silvermine Publishers, Norwalk, Conn. Claude Croney is a member of Boston Watercolor Society, Guild of Boston Artists, Providence Watercolor Club, Kent Art Association, and Connecticut Watercolor Society. He is a past president of Foxboro Art Club and an honorary member of California Watercolor Society. Now living in Massachusetts, Croney is the author of *My Way With Watercolor* (Watson-Guptill Publications).

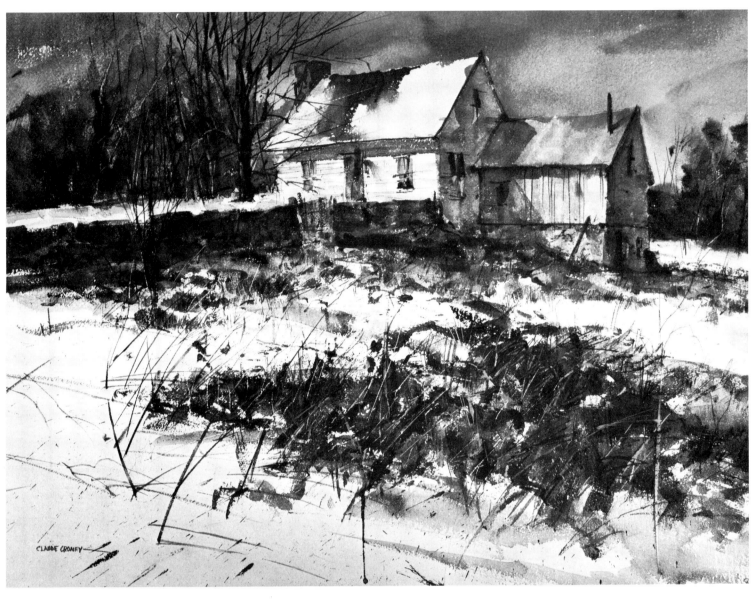

Above: *January Thaw,* 21 × 29. The original reference for this painting was a photograph of a summer scene Croney adapted to a winter landscape.

Right: *Back Room,* 21 × 29. The artist made preliminary sketches in his garage, then completed the painting in the studio.

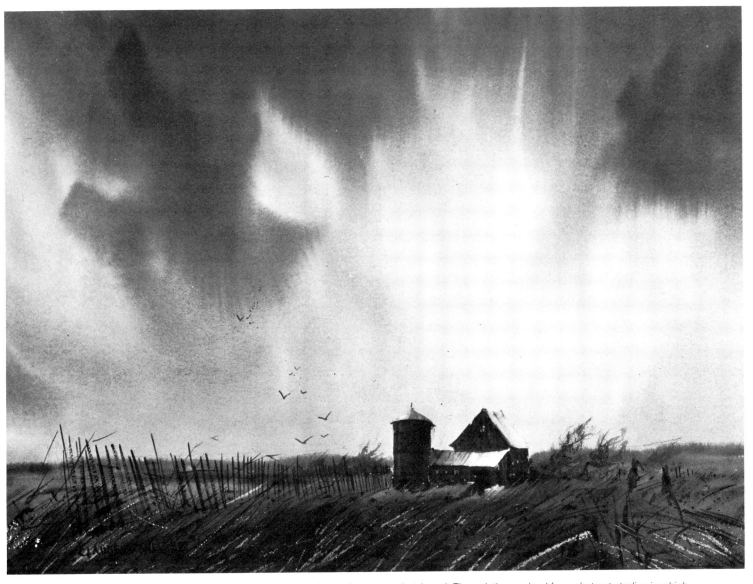

Heaven and Earth, 21 × 29. Studies of the barn were made outdoors on a sketch pad. The painting evolved from abstract studies in which the artist determined the patterns of values and shapes.

down the brush in bold, swift vertical strokes to establish my initial design.

Next I painted in the light wash of the vertical shape. Not being too concerned with what element it was—whether it was a cliff or a rock— but more concerned with the total design. I kept the washes fairly light so they would be part of the light in my design. Had I made this too dark, it would have destroyed the dark toned vertical shape.

The light wash created a large area that was quite flat and empty. To add some visual interest to this area, I used the painting knife and pressed the edge into the paper, moving the knife back and forth to force the paint into the recess created by the blade. In addition to the dark lines I created this way, I also spattered some tone into the area by loading the brush with paint and holding it about six inches away from the paper, gently tapping it against my hand. This provided a very casual and somewhat accidental quality, more effective than if I had tried to put down each spot with the tip of the brush.

By now the paper was pretty well covered, and I took a small, pointed, No. 5 brush (which I call my "nervous" brush) and added some dark accents to suggest what might be branches and small tree trunks.

I do not try to finish any one area completely, but I usually keep working over the entire sheet at the same time. As I put down each small brush stroke, I look at the total picture, rather than the one area that I'm painting. In *Cliff House* I left the white paper for the sky because I wasn't really sure what I wanted to do. Whenever I have an area about which I'm unsure, I tend to leave it for last. Quite often the value relationships established on the paper help dictate just what I want to do with this area. In this case I decided the white paper helps to create a crisp feeling in the foliage, tree, and the house. The strong contrast helps to strengthen my design and value pattern.

This painting took about an hour and a half and was painted in my studio.

R.B. Dance

BIOGRAPHY

Born in Tokyo, Japan, in 1934, Robert B. Dance moved to the U.S. just prior to World. War II. He is a graduate of the Philadelphia Museum College of Art, where he studied with, among others, Henry C. Pitz and W. Emerton Heitland and twice won their award for illustration. He is presently living in Winston-Salem, North Carolina, with his wife and two sons.

His watercolors, woodcuts, and egg temperas have been included in many invitational and juried shows: Southeastern Center for Contemporary Art's "Realist Invitational" in 1971, '72, '73, and '74; as winner of the 1973 and '74 North Carolina Watercolor Society juried shows; as a three-time winner of the Associated Artists of Winston-Salem annual juried shows; and as winner of the 1974 Northwestern Bank Open Juried Carolina Art Competition. His work is included in numerous private and corporate collections, and his woodcuts have been seen in books and nationally known magazines. In 1960 his work was selected for the permanent print collection of the North Carolina Museum of Fine Art.

ONE OF MY former teachers once looked at a precisely realistic painting and said disdainfully, "Now, that's done by the kind of guy who washes and waxes his car every day and keeps a fantastic shine on his shoes!" This good fellow was a realist himself, but of the loose variety. I, for one, did not agree with his observation and had long before learned that there is nothing more contradictory than an artist. Years have passed since that time, and I have grown closer to precise realism, yet I probably have not washed and waxed a car or shoes in 18 years. In fact, some of the sloppiest people I know are precise realists.

A large (20 x 30) watercolor often takes me three weeks to a month of full eight-hour days to complete. This is perhaps a bit more studied than the usual watercolor, but drawing, involvement with textures, and planning for the paper to be the only white area require forethought and time. However, I don't think of myself as a slow artist, since I paint quite rapidly.

After several bad outdoor experiences with people, I avoid working on location and paint strictly in my basement studio. Since it often takes me a month to complete a painting, I don't have to contend with weather, rapid light changes, people, or angry bulls. At times I will work from one or a combination of pencil studies, memory, black-white photographs, or a still-life setup in the studio. Usually I don't get too involved with numerous studies for the painting. Often I will launch into a watercolor with no study but with a precise idea of what is desired. I find the memory of my first impression the most helpful element in achieving what I want.

The black and white photographs, should I use them, are an aid to getting the construction of an object, whether mechanical or architectural, correct. Compositionally, photographs are of little use, because I simplify, distort, and generally don't refer to them in placement of masses, and color photographs are useless to me as color reference because their color is unnatural. A memory for color or color notes serves me much better and leaves me free to improvise.

My paper is usually 300 lb. French hot or cold press. Occasionally I use a 400 lb. English paper I was lucky enough to find recently at a stationery store at 1968 prices.

Earth colors usually dominate my paintings; oc-

Handy's Wheel, 1974, 20 × 9½. Collection the artist. Dance created the mottled textures of the tree trunk by pressing his arm into damp pigment and then working in additional texture by scraping and fine brushwork. The side of his palm—the effect depends on whether it is open or closed—was also used.

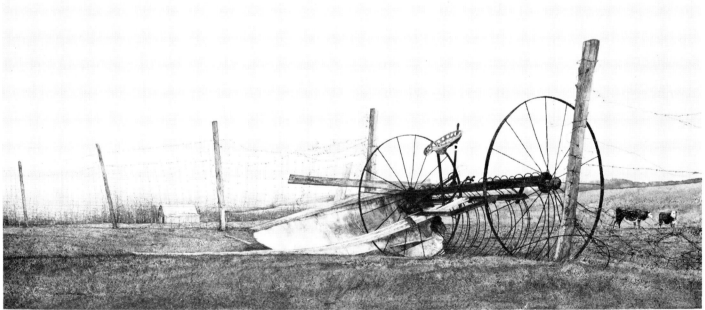

Top: *Calm Wash*, 1975, 20 × 28. Collection Mr. and Mrs. Larry R. Shouse. Dance felt the problem in this painting was to maintain complete control of the very large wash area in the foreground. Since this wash was the critical element, it was done first.

Above: *Mr. Handy's Gate*, 1974, 12½ × 28½. Collection Mr. and Mrs. James F. Hind. Atmosphere is important in Dance's choice of subject matter. Here an open sky and the play of carefully placed vertical fence posts against the circular wheels of the rake create a feeling of open space and solitude.

Halfway to Wilkesboro, 1974, 20½ × 28½. Collection Mrs. Charles L. Roediger. This painting is monochromatic browns with a touch of ultramarine. The brushwork in parts of this painting is so fine that Dance couldn't see what he was painting until the work was finished.

casional accents of brighter color keep things moving. The palette I use includes ultramarine blue, Davy's gray, yellow ochre, raw umber, burnt umber, raw sienna, burnt sienna, Permanent Pigment's Sepia-Umber, and olive green. On rare occasions I will use alizarin, cerulean blue, cadmium red, and cadmium yellow.

My brushes include the usual round red sables in Nos. 00, 1, 2, and 5 for detail work. Once I am painting I don't consciously select the next brush I'm going to use and could probably get as fine a point on a No. 2 sable as on a No. 00. Also, I use flat aquarelle brushes in ½ inch, ¾ inch, and 1 inch for broad areas and spattering. Equally as important to me as brushes are arms, hands, and scrapers.

Handy's Wheel is fairly simple compositionally, but I turned the small shed in the background 90 degrees in order to simplify and frame the light grinding wheel in a dark area. I painted the sky first with a very light wash. Sometimes I will use Miskit at this point in the painting if involved elements lace into the sky. Masking agents are used with great care, however, since when they are lifted they can harm the paper enough to ruin future washes.

After the sky came the tree. On a broad area such as this tree, I will often lay down a thick wash and wait for it to dry to a semi-moist state. Then I press my entire forearm into the wash and lift it up, hoping the combination of translucent and dense areas that have not been picked up will create an interesting texture on the paper. Before this texture is completely dry, I will work into it quickly with torn pieces of old sponge and with scrapers. The most useful scraper I've found is a good mechanical pen. With this instrument you can scrape broad areas or incise thin linear lines.

The grinding wheel, shed, foreground, and background were semi-completed next. *Handy's Wheel* is a small watercolor, and by this time about two weeks had passed, and all the elements were 90% complete. The remainder of the time was spent balancing up these elements and completing the last details. Should I feel the need to scratch out white areas, I do so at this time, using a No. 11 X-acto blade. I am very careful with this scratching, as nothing else can ruin a painting as quickly if overdone.

Now is the time to look at the painting and decide if it is bad enough to tear up. If I cannot decide, I tear it up.

Edmond J. FitzGerald

BIOGRAPHY

Edmond J. FitzGerald, A.N.A., A.W.S., was born in Seattle, in 1912, and studied there with Mark Tobey and Eustace Ziegler, and at the California School of Fine Arts. *Who's Who in America* lists 38 awards, one-man shows and collection inclusions to his credit.

He served 26 years in the U.S. Naval Reserve, attaining the rank of Commander. He commanded an LST in World War II and has had numerous combat art assignments, the most recent in Vietnam.

He was president of Allied Artists of America 1960-63 and is currently an honorary president of the American Watercolor Society. He is also a member of the Salmagundi Club, The Artist's Fellowship, and the National Society of Mural Painters. His most recent mural was installed in December 1970 in the National Maritime Union Building, New York.

He is author of *Painting and Drawing in Charcoal and Oil*, published by Reinhold in 1959, and *Marine Painting in Watercolor* published in 1972 by Watson-Guptill.

EXCELLENT PAPER is the Stradivarius of the watercolorist. Good paper is abundant, but that extra quality is something else again. It keeps us all on the lookout and is part of the fun.

The search for unusual paper has probably always kept watercolor painters on the alert. Early in the nineteenth century a young English painter named David Cox (1783-1859) came upon a paper that really took his eye: it was wrapped around a leg of mutton from the butcher shop! The paper had a water mark, as all paper at that time was handmade. He wrote to the mill on the bank of the Clyde River in Scotland where the paper was made and ordered a ream (500 sheets). In due course it arrived, and he used it a number of years—for painting, not for mutton! This stock was rather "tweedy" looking, an unbleached paper made from cast-off sails from the ship repair yards along the Clyde. Some of Cox's friends raised eyebrows over the use of such unrefined paper, surely only intended for "vulgar" use. He was asked what he would do if one of the little specks which appeared here and there in the paper were to be found in his sky. "Why," he said, "I'd simply put wings on it."

Although the paper is difficult to find these days, it's well worth the effort to look for it. It is called David Cox paper, appropriately enough!

David Cox paper isn't white, but is a warm gray or tan color. I find it especially suitable for subjects that are a little low keyed but have a few sparkling lights that appear lighter than the paper. These I paint in with opaque touches achieved by mixing Chinese white with color. It's a rather soft, absorbent paper and won't take much punishment like scrubbing or strenuous erasing. Because of the absorbency one must work somewhat more rapidly than on harder paper to achieve a large, smooth, or evenly graduated wash. If you delay unduly in laying a wash, streaks are apt to form. The absorbency makes it easier to incorporate color changes in the washes than on harder papers; the colors tend to stay where you put them instead of mixing with the surrounding colors.

My 15 x 22 paper was stretched on a plywood board. I always stretch my paper unless it's heavy weight—300 lbs.—or very small. Stretching is done

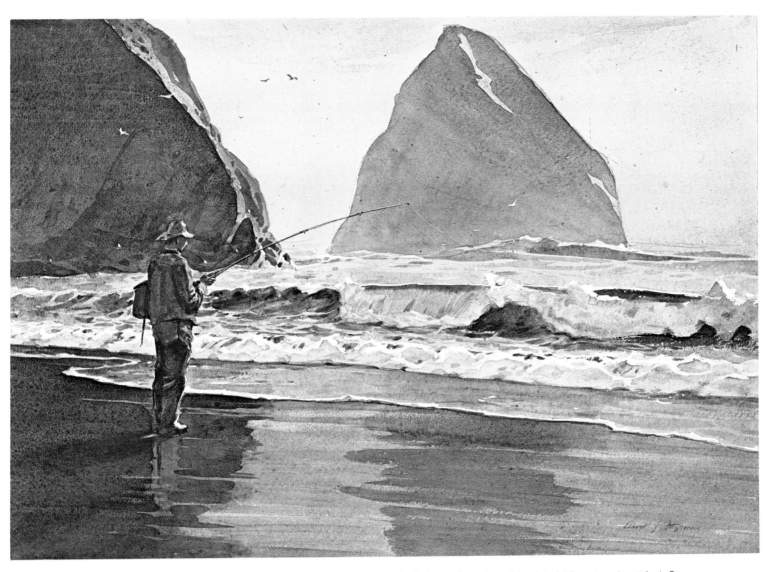

Golden Afternoon, watercolor, 14½ × 21½. Using three round sables and a limited palette, the artist painted this watercolor at Arch Cape on the Oregon Coast. The paper he used, David Cox, has a warm tan surface that forms a ground suitable for a low keyed painting as this quiet scene of a surf fisherman.

"... the surf is accommodating about posing
since, by constantly repeating itself,
its form and color values can be studied."

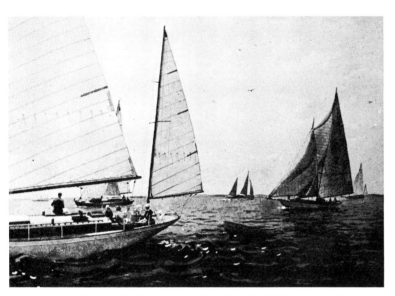

Start of the Race, watercolor, 15 × 22. Sails, masts and booms form vertical and horizontal compositional lines.

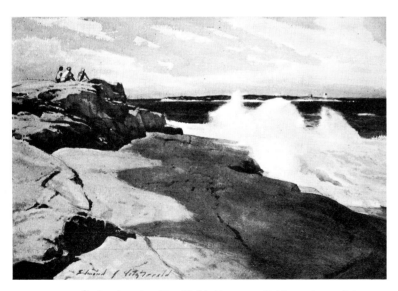

Surf, watercolor, 20 × 29. Working over a lightly made pencil drawing, the artist retained the power of the crashing surf.

to minimize the tendency of paper to cockle or wrinkle up when water is freely applied; it can be done on any stiff board or canvas stretcher by means of tacks or glue. The paper is first wet thoroughly to expand it and is then held firmly in place at the edges until it's dry. I usually use gummed tape—the glue tape used for parcels—not masking tape, which wouldn't hold. When the watercolor is finished it can be cut from the board with a sharp knife.

For *Golden Afternoon* I used three brushes — a No. 12, an 8, and a No. 1—all round sables, which I prefer to flats. I used the following professional grade tube colors: cadmium red light, Indian red, cadmium yellow pale, yellow ochre, burnt sienna, viridian, cobalt blue, and French ultramarine blue. The limited palette is my usual practice, though I sometimes use a few colors in addition to those listed.

Golden Afternoon was painted at Arch Cape on the Oregon coast in atmospheric conditions that have tremendous appeal for me. Picture the sun, filtered through an all-enveloping luminous mist, dimmed to burnished copper, about four in the afternoon in the month of August.

In such an atmosphere, aerial perspective is increased so that even nearby shapes are generalized and simplified. Also in such an atmosphere the tone of David Cox paper works well, augmenting the unifying mist.

The drawing for this watercolor was accomplished quickly because of the simplified shapes. Drawing and painting were done under considerable pressure as drifting wisps of fog occasionally obscured the sun, obliterating the dancing lights that I was anxious to capture.

I worked standing at my easel and rinsed my brush from time to time in the surf when it came my way. This kept the rinse water in my canteen quite clean. The washes dried slowly, particularly the dark areas, due to the dampness in the air. Most areas of the painting were accomplished with a single wash, a necessary procedure because of the slow drying.

I started with the large, dark wash covering the shadowy headland but avoiding the two seagulls above the figure. Ultramarine blue, Indian red and a little yellow ochre were mixed for this wash. Next a wash of yellow ochre and cobalt blue was brushed over the entire sky with a little Indian red added near the horizon. I painted the area around the large rock island with a wash intensified with more cobalt blue and yellow ochre, avoiding the areas of breaking surf and the figure. The same wash was intensified still more and carried over the entire beach in the foreground, avoiding only the fisherman's boots. When the sky wash was dry, the island was washed-in with cobalt blue, Indian red, and yellow ochre, except the light at the edge of the rock, and a lone gull.

The curl of the breaker was accomplished by

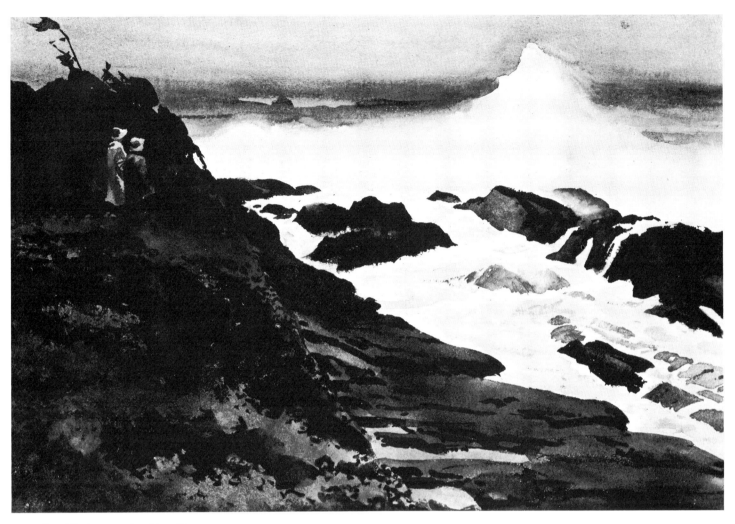

East Wind, watercolor, 20 × 29.

means of a strong accent of cobalt blue, yellow ochre, and viridian, applied horizontally along the top of the wave and just below a narrow band of highlight. While this accent was still wet, it was quickly fused with a wash of cobalt blue, warmed and grayed slightly with yellow ochre and Indian red, and carried over all of the shadow part of the white water. The shadow part of the figure, that is, practically all of him, was washed-in with yellow ochre, ultramarine blue, and burnt sienna, accomplishing color changes from cool to quite warm in various parts of the figure.

A delicate wash of cobalt blue and viridian was superimposed over the upper sky, and accents of cobalt blue and viridian were used to texture the water. Dark reflections on the sand were superimposed, using ultramarine blue and Indian red. Next, light, warm areas on the rocks and figure were carefully filled in with strong touches of red, yellow, or green as observed. Accents of ultramarine blue and burnt sienna were used to detail the figure and headland and to add a dark bird or two in the sky. Finally, highlights of Chinese white slightly warmed with cadmium yellow pale were added to catch the gleams of watery sunlight on the fisherman, gulls, and whitecaps.

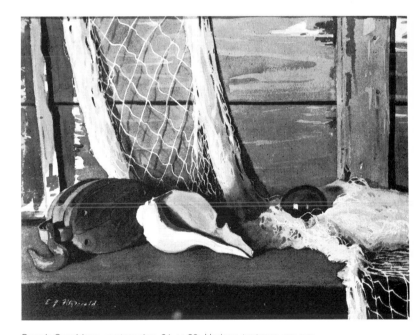

Beach Combings, watercolor, 21 × 29. Various textures are produced by using both a dry brush and wet-in-wet techniques.

25

Jack Flynn

BIOGRAPHY

Jack Flynn was born in Pittsfield, Massachusetts, in 1927. Flynn studied with Don Stone of Rockport, Massachusetts; and with William J. Schultz of Lenox, Massachusetts, and is a graduate of Butera School of Fine Art in Boston. Presently Flynn conducts watercolor classes with an associate, artist Jeanne Johns, at her Loft Gallery in Lenox, Massachusetts. Flynn's work received the First Award for best watercolor in the Springfield Academic Art Association 1970 National Exhibition and the Beveridge Memorial Award in the Association 1971 Exhibition. He is a member of the Salmagundi Club, Copley Art Association, Springfield Artists Association, Berkshire Art Association, Albany Art Institute, Hudson Valley Art Association, Westfield College Art Association, and the Decordova Museum. He is represented in numerous private collections and has demonstrated his watercolor technique to numerous art associations.

"HAPPY ACCIDENT," a term used in watercolor painting, could also apply to an incident in my life that eventually led me to painting. In 1963 I was hospitalized because of a back injury sustained while working as a stock clerk at a food store. I was not able to work afterwards for a period of five months. Needless to say, I became very bored with nothing to do. Even at the end of the five-month period, the doctor would not allow me to resume any heavy work. Through my mother's urging I began to draw, and soon afterwards I enrolled in the William Schultz Art School in Lenox, Massachusetts. A year later, Bill Schultz and I took a trip to Rockport, where I met Don Stone, a watercolorist. I enrolled in his watercolor classes and soon found this medium to be my real love.

I still prefer watercolor because it allows me to make a very positive, fluid, and sensitive statement that can be made in no other medium. Every impulse of the inspired moment can be recorded, and to me it is a very loose and sporty medium. Watercolor offers me unlimited expression, whereas I feel more restricted in other media. Watercolor is an extension of my feelings reacting to the many moods of nature. However, generally speaking, moody, low-key subject matter challenges me to express it on paper. Sometimes a watercolor goes very well, other times nothing seems to go right. Then I remind myself that there is always tomorrow to try again.

First I do many thumbnails, indicating the elements of the subject in abstract shapes. Sometimes (but not always) I make simple color studies, rearranging color masses to achieve a stronger composition, and at times I also use my camera viewer to spot an interesting or different kind of composition. I would like to make special mention that I favor simplicity and make a real effort to keep these thumbnails, whether in tone or color, *very simple* and uncomplicated.

I then pencil in my composition in outline only.

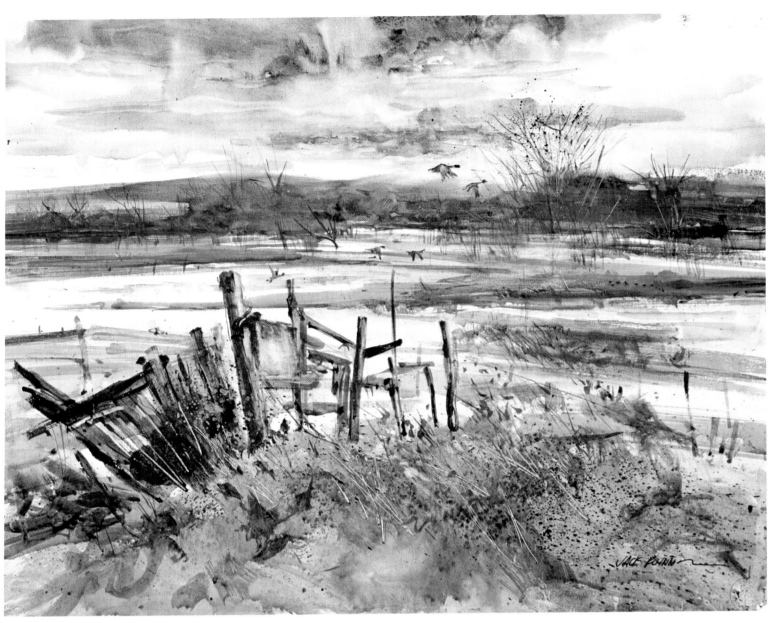

The Swamp, 1972, 15 × 22. The artist allowed rain-splashed areas of the sky to remain part of the finished watercolor.

From there I proceed to lay in my washes, starting with the light values first, then the medium lights, then the medium darks, and finally the darks. Although my colors are subdued, I try to keep values clearly defined with a strong sense of design so that the result is a bold, forceful composition. I start with rather large abstract masses, then I become specific, with emphasis upon keeping my work simple, straightforward, and direct. I try to keep a fluid touch in the handling of the paint, keeping the paper showing through to retain the transparency that is necessary if watercolor is to be kept alive and luminous. I prefer to depict atmospheric deep space through the discriminating use of values.

I so enjoy the outdoors that I often sketch the countryside, including the Berkshire Hills where I live and other scenic spots in Maine, Vermont, and New York State, and the New England coastline. I paint many color compositions while on these trips and also take many color shots for color transparencies. However, my more serious and larger work is done in my studio (often with compositional changes to improve the overall pictorial effect).

These works are gleaned from many on-the-spot outdoor sketches and color slides. In the past I made the mistake of leaning too heavily on my color slides, neglecting my outdoor sketching, only to discover, to my dismay, that my subsequent outdoor work suffered. So now I make it a point to paint on location as much as possible.

For more freedom, I stand while painting and usually keep my paper vertical on a portable, folding, wooden, watercolor easel so that the blinding light of sky and sun is not directly reflected in my eyes.

I painted *The Swamp* in southern Berkshire County on a rainy day, just for practice. It was hard getting started; in fact, I made three tries. In the first I was dissatisfied because the sky was too dark, so I started a second. This was not much better, so I then tried a third on Strathmore regular surface paper. It seemed to be coming along when rain started and fell on my painting. I immediately took it off the easel to shield it. After the rain stopped, I put it back up and was pleasantly surprised by the happy accident caused by the rain drops. I left it

27

Above: *Railway*, 1972, 15 × 22. Working from light to dark, the artist develops the background by allowing underlying washes to show through and accenting the texture of the paper.

Left above: *Thaw*, 1972, 15 × 22. Flynn highlights the loosely painted foreground area by contrasting it with a more detailed linear treatment of the background trees.

Left: *Midwinter*, 1971, 22 × 30. Carefully placed values in a strong design develop a sense of atmospheric space.

alone and finished the painting, grateful for a happy accident that I could not have accomplished on my own! I try to have the good sense to take advantage of happy accidents.

In passing, I would like to mention that I prefer neutral colors, as they are less tiring than bright colors. Also regarding subject matter, while my approach is realistic, my finished work often bears little resemblance to the exact literalness of the scene, because I am more concerned with my emotional reaction to the subject. In the past, while learning the craft of painting, my work tended to be tight. As I learned more and gained more confidence, my work took on an authority and a looseness that I much prefer, and my interpretation became freer. In the past I was more concerned with literalness of the subject; presently I am interested more in the abstract qualities of a subject.

I keep my equipment simple for field trips and take along as little as possible. Regarding brushes, I have no favorites and find that one is easily substituted for another. The sizes range from No. 8 to No. 20, including riggers. Generally I use a 1½ inch flat brush for a half-sheet and a 2 inch flat brush for a full sheet. I use a folding palette and studio tube colors, both warm and cool. I never use dried up colors because they are weak and lifeless. I generally use nine colors but sometimes use others for a special effect. When I paint and pull fresh colors from my palette, I seldom use only one or two alone but rather arrive at a rich color tone by an intermixture of several warm and cool colors, letting time and accidental effects give freshness.

I am interested in new art items and am forever buying the latest kind of brush, pen, or pencil. I like to experiment by changing my tools, such as using different kinds of brushes and colors. While painting is a serious craft, it also can be fun.

George Gansworth

BIOGRAPHY

George Gansworth is a native Philadelphian now residing in suburban Wynnewood, Pennsylvania. He began to draw at age six, saw his first published drawings in the Philadelphia *Evening Bulletin* by 16, and later, as an undergraduate (Gansworth earned a B.F.A. from the Philadelphia College of Art in 1956), collaborated with Herb Valen, writer for the *New Yorker* magazine, to produce a cartoon strip, "Otto," which was syndicated by the *Los Angeles Times Mirror*.

After working for a number of years as a commercial artist and art director with advertising agencies and publishers, Gansworth decided to devote his energies to watercolor. He became a full member of the A.W.S. in 1970, but has been an active member of the Philadelphia Water Color Club, Pennsylvania Academy of the Fine Arts, and other Philadelphia art organizations for many years. His work has been exhibited throughout the country and belongs to several museum, university, corporate, and private collections in the U.S. and abroad. His biography appears in *Who's Who In The East*.

I CHOSE WATERCOLOR for my medium because its use fascinated me, and it continues to do so. It is the only medium where in a few minutes you can paint an angry sky or a peaceful sea on paper and neither appears labored — if you are an expert. You can paint a watercolor of a stone wall in a few minutes; on the other hand, you can render a stone wall "until the cows come home" if you want — and probably an oil painter would do just that (some watercolorists, too)—but not me.

At one point in my life I did most of my painting on location, spending perhaps, just 20% of my time in the studio. But one can tire of strange bugs, dogs, people, and bad weather conditions. Once I was even attacked by a swarm of starlings near an old, deserted migrant camp. The birds let me know that I was near their territory and that I had better leave.

Today I am basically a studio painter. When something appeals to me—a subject bathed in early morning sunlight for instance, or unusual late afternoon shadows playing across a form — I try to capture the moment with either sketches made on location or a 35mm camera and color film. Catching the subject as it appeared to my eye in that one split second which attracted me in the first place is essential, since otherwise time generally alters the entire picture before I would have a chance to paint it.

I use all sizes of watercolor blocks in rough 140 lb. paper (d'Arches) and 22 x 29 sheets of rough 300 lb. paper (d'Arches in particular, other high quality papers for special uses). I prepare each sheet of paper by washing its entire surface gently with a clean sponge and clear water. This helps to dissolve the thin coating of starch which, if left on the paper, can create thousands of tiny air pockets that create tiny uncolored spots of white on the paper. In addition, your color will remain much truer to the original wash if you eliminate the cause of these air pockets.

A painter's choice of palette is influenced by many things; for instance, I have always been a strong admirer of the Dutch Masters and the

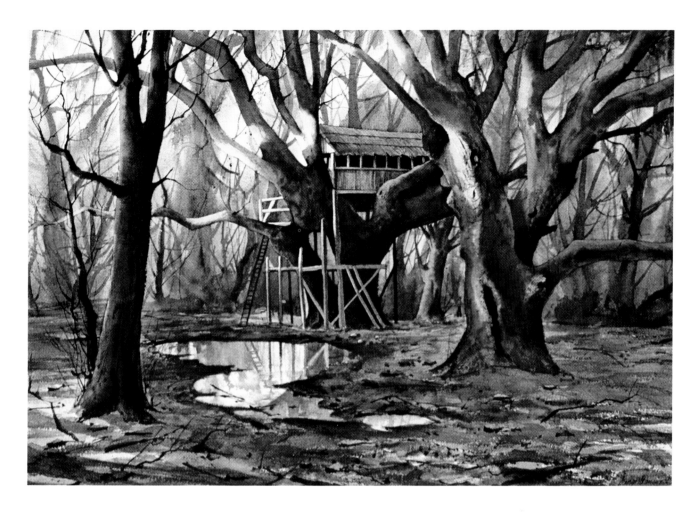

Above: *Island Tree House,* 1974, 20 × 28. Courtesy Rutgers University, College of Arts and Sciences, Camden, N.J. Stedman Fund Purchase. Notice the abstract rhythm of lights and shadows.

Left: *Morning Sunshine,* 1972, 16 × 20. Courtesy Edgartown Art Gallery, Edgartown, Mass. The artist often develops watercolors from black and white pencil sketches that are almost abstract in design. Here the rough-textured paper lends itself to various effects.

Thomas Eakins school. They used warm, golden colors with interesting sepias, which make dark areas mysterious and excite the imagination. With these influences, the palette I use today includes lemon yellow, yellow ochre, sepia, Winsor red, and Winsor orange as my warm colors; Winsor blue and Winsor green for cool colors. For special effects I may add cerulean blue and cobalt violet.

Most of my skies are started with a wash of pale yellow ochre. Before the wash dries I apply the blue, or whatever color effect I am after. One might think the sky would turn green, but amazingly enough the paper holds its blue and the sky comes off with a warm feeling rather than a cool feeling.

My tools are as basic as one can get. Colors from the tube are squeezed onto a large, inexpensive porcelain tray. About ten years ago a surplus store in Philadelphia had a pile of 16 x 20 white porcelain Navy medical trays that sold for 50 cents each. I bought several and recommend them to any watercolorist. (On today's market they are probably worth about $18 each.) The large size of the tray leads to discovery of many lovely color variations, which I use to advantage.

Principally I work with flat sable brushes ranging from 1½ inch for large washes to ⅝ inch for small areas of work. The largest round brush is a No. 7, used for areas that need more tip control than a flat brush can give and yet will supply plenty of water. For fine details—such as birds in the distance, dead branches, or trees in the distance—I use a No. 3 round sable.

All watercolorists have special tools for special effects. For instance, I use a No. 6 badger hair fan brush for grass, weeds, tree bark, or whatever a badger fan brush can do to make a watercolor more interesting.

I round out my repertoire of aids with a No. 2 lead pencil, a sponge, X-acto knife No. 1, Miskit (an orange liquid used for masking), a kneaded eraser, and a rubber cement pick-up eraser (for removing the Miskit). A small jar of Pro white is used when I

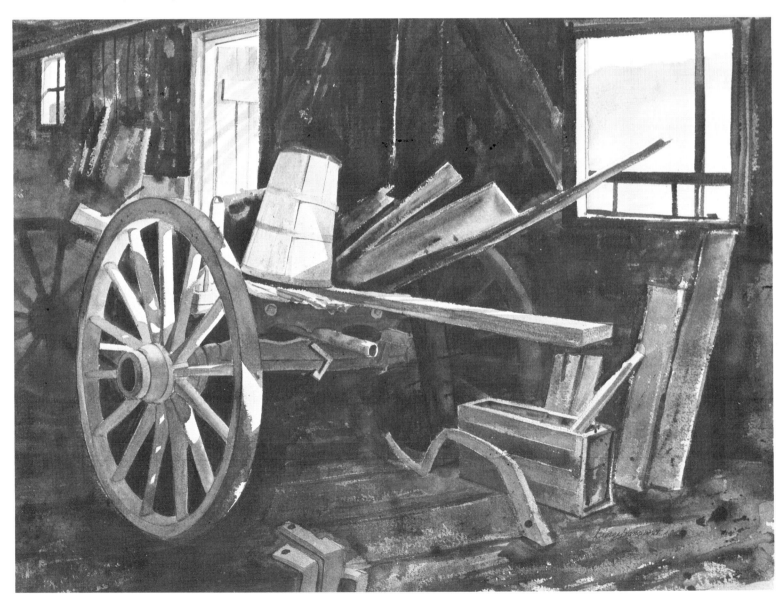

No Longer Needed, 1975, 20 × 28. Collection the artist. Photo James Laverty. Gansworth used color slides taken at a South Carolina plantation for reference.

The Widow's Watch, 1974, 19 x 28. Courtesy of the Edgartown Art Gallery, Edgartown, Mass. Arched reflections bring the viewer back inside to the "watch."

want to get sharp, white details, such as snow flakes or white sea gulls against dark cliffs or storm clouds. As a general rule, though, I use the white paper itself for white areas in the painting.

I have added one foreign element to my list of materials: acrylic retarder. I use this very sparingly. Since the retarder slows up the drying of acrylic, and acrylic is thinned out with water, I reasoned it certainly should have some kind of effect with watercolor. And it does. I find it slows the washing process down to about two miles per hour and holds the strength of the color to about 85%, more or less. I use the retarder for dark areas where I want a dark-value scrubbed-in effect. If anyone wants to experiment with acrylic retarder, the use of acrylic brushes is strongly advised.

Often my watercolors are developed from black and white pencil sketches, which are almost abstract in design. I establish gray forms to pull the dark and light together. If this appears to be working, I do a small watercolor for color impression. If the small impression pleases me and holds together in color as well as in pencil, I transfer the color impression to a large paper using the grid system. The grid system retains, as much as possible, the composition of the original sketch and is essential when you feel that slight deviations in composition will ruin the painting.

Not all of my watercolors are started in this way.

Many times I work directly on a full sheet of paper from start to finish, keeping some reference material close at hand if I feel this is necessary. But before I lay a brush on the paper, I know in my mind exactly what I hope to achieve on the waiting paper.

The *Island Tree House* was painted on a full sheet, 22 x 29, of 300 lb. rough d'Arches watercolor paper. A small pencil drawing was made for composition, then scaled up by the grid system. The large trees and the tree house itself were the only elements of the actual setting on Hilton Head Island that were used for the painting. I chose to eliminate several pieces of playground equipment, paved walkways, and other useless details. I wanted a simple subject of intense interest. I wanted to achieve that atmosphere of serenity that follows a rainfall, when the sun's rays first break through the clouds and bathe portions of the trees with sunlight. The sheet of watercolor paper was washed down with a clean sponge and water, then fastened to a drawing board with masking tape. I painted from light to dark with wet washes of light blues and blue greens and proceeded from the background to the foreground. I painted wet-in-wet wash over wash to achieve the misty feeling in the trees and branches. The darks in the trees were brushed on later, along with the foreground detail. Finally, the reflections were added to the puddle of water.

Lawrence Goldsmith

BIOGRAPHY

Lawrence Goldsmith was born in New York City and brought up in its suburb, Westchester. He was introduced to watercolor by Eliot O'Hara at the Yale School of Art. Later he studied in New York under Mario Cooper at the Art Students League and with Reuben Tam at the Brooklyn Museum Art School.

Goldsmith is a member of the American Watercolor Society and an artist member of the National Arts Club. He has taught watercolor at Queens College of the City University of New York and at workshops in Vermont and Florida. He has had a number of one-man shows, most recently in New York and in New Hampshire.

Paintings by him appear in the books *Acrylic Watercolor Painting* and the *Complete Guide to Acrylic Painting*, both published by Watson-Guptill.

He and his wife now live and work in Fairfax, Vermont, and spend their summers on Monhegan Island in Maine. He is a member of the professional Monhegan artists and takes a few pupils.

He is represented by the Four Winds Gallery in Ferrisburg, Vermont.

THAT FATAL FIRST stroke of a watercolor brush on clean white paper is *always* a winner. The painting can go downhill immediately thereafter, but that's another matter. I claim that the first unworked-over stroke, even more than many later strokes, is always dramatically expressive, because it is a personal statement of the artist, given freely, without the inhibitions that set in later. But even then, the work is a spontaneous reflection of his personality. He can, if he chooses, hide his emotions behind some other medium — oils or acrylics, for example — but he cannot do so with watercolor. On watercolor paper, he stands naked.

I look for a *motif,* not a scene. This gives the work an abstract quality. I try to give a strong impression of sky, water, forest, or whatever, without ever getting specific.

Spring Festival, shown here, grew out of my response to a clump of birch outside my Vermont studio window. The air was warm with that pollen-full haze of tree-budding time. To me spring always has a painful and underlying pang of pain, indicated here with a slash of rose madder. Mostly the feeling is one of exaltation; hence the preponderance of vertical lines and upward-moving passages, where the foliage is hardly differentiated from the sky.

Working on the site encourages me to pare my equipment down to essentials. In a small canvas duffel bag I carry my 10 x 15½ inch white enamel palette along with 18 compartments, into which I have squeezed my colors from tubes. My usual colors are lemon yellow, Indian yellow, raw sienna, chrome orange, cadmium scarlet, Winsor red, alizarin crimson, Winsor violet, cobalt violet (sparingly used), burnt sienna, burnt umber, raw umber, Winsor green, olive green, cerulean blue, French ultramarine blue, Winsor blue, and Payne's gray. Not all are used in every painting, of course. I also get temporary passions for other colors, such as cobalt blue, warm sepia, brown madder, rose madder, and manganese blue. Recently I rediscovered cobalt

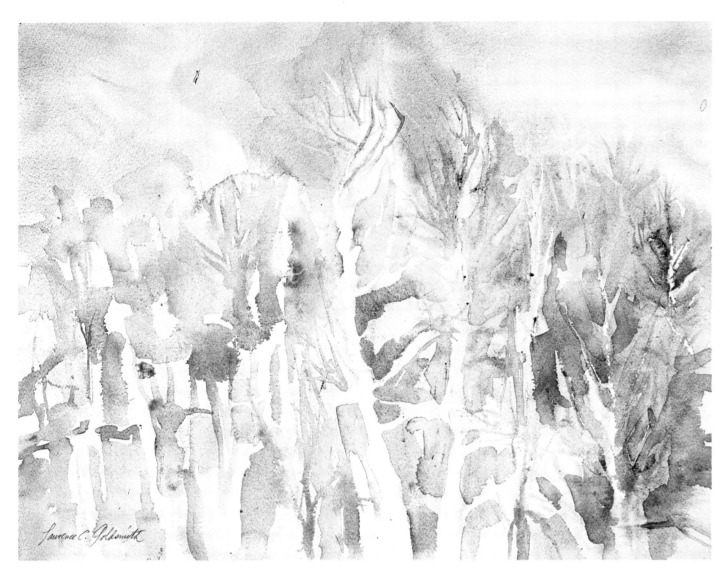

Lawrence C. Goldsmith

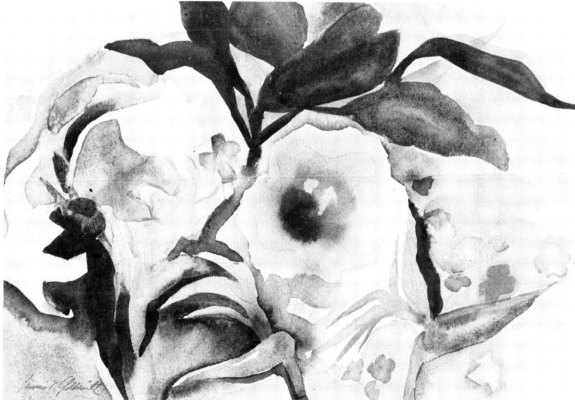

Above: *Spring Festival*,
18 × 24. The artist
translates the mood of
a clump of birches into
free washes punc-
tuated by ascending
lines.

Left: *Copa de Oro*, 14
× 21. Poetic or tumul-
tuous, each watercolor
is a personal declara-
tion of the artist.

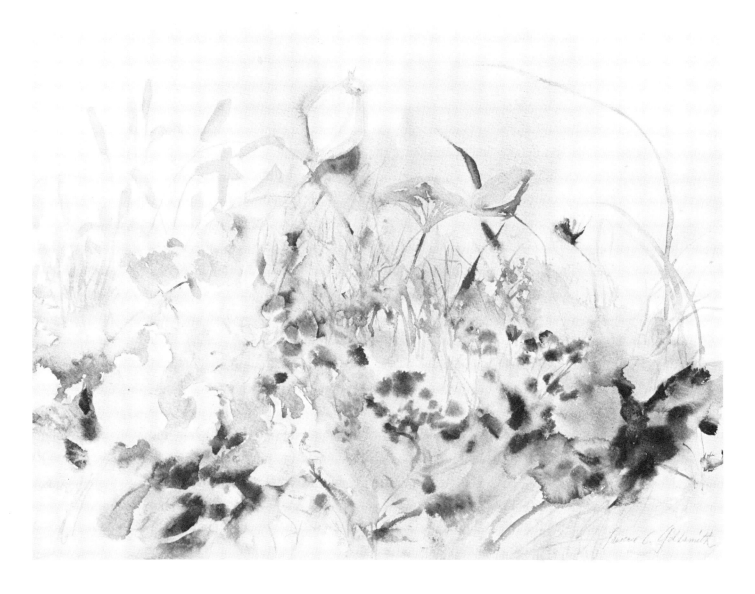

Above: *Autumn Grasses*, 18
× 24. Goldsmith has de-
veloped a personal style
that avoids representation
and approaches pure ab-
straction.

Right: *Fir Against Sky*, 18 ×
24. The artist looks for a
motif and paints his impres-
sion, not a specific scene.

Opposite page: *Rolling Sea*,
18 × 24. Collection Lamont
Gallery. The artist senses
the contrast and competi-
tion in nature and records
this response.

green — a grainy pigment that flows poorly, dissolves reluctantly, and gets muddy if touched after being applied, but oh, what an exalted color it is!

I carry my brushes, pencils, kneading eraser, and other small items in a small, zippered, cloth, army-surplus bag that cost 29¢. Sponges, two plastic water buckets (refrigerator boxes, actually), a plastic-topped coffee can for water, a huckaback towel, and a box of tissues complete the contents of my duffel bag. For working outdoors I find an 18 x 24-inch sheet of paper handy.

Most of my paintings are started by wetting the surface entirely with a 2 inch housepainter's brush—the top surface only, unless I am working in the studio, where I often wet both sides. I begin working wet-in-wet and occasionally rewet some areas. As the paper dries, I work more tightly.

For brushes, I like good sable. (Cheap brushes are a foolish economy.) Mostly I use flat brushes. For larger washes, I have one that's 1½ inches wide, but I do more of the work with a ½ or ¾ inch brush. I pick from an assortment of round sable brushes for some of the later strokes. Often, towards the end, I choose a long, thin, red sable brush that's called a "scriptliner" (No. 6 or 8). This makes a delicate line of varying thickness that has one special virtue I ordinarily don't look for: the line is virtually unpredictable. The hairs are so long and flexible that your stroke is at, the mercy of the uncontrolled whim of your fingers. Results can be disastrous—or delightful!

Although I don't feel comfortable using liquid frisket or other gummy masking material, I have done a good deal of experimenting with simple facial tissues to give similar but less exact effects. While a wash is still wet, I roll a bit of tissue and squeeze it into a passage or take a sheet of tissue and lay it on the wet painting, pressing the back of the tissue with the handle of a brush, my finger, or the dull side of a table knife to make whitened lines. These techniques are haphazard, since you can't see exactly where you are applying pressure. But the results can be all the more personal and exciting. Often I will repaint one of these lightened lines to give more definition. Some of these techniques were used to lighten the density of the woods in *Spring Festival*.

Walter Gonske

BIOGRAPHY

Walter Gonske was born in Newark, New Jersey in 1942. After graduating from the Newark School of Fine Art in 1969, he went on to study with Frank Reilly, and later at the Art Students League.

He has worked as a free lance illustrator in New York, and his work has appeared in *Esquire, Life, McCalls, New Yorker Magazine, Gentlemen's Quarterly, Senior Scholastic, Men's Wear, Playboy,* and *The New York Times.*

Since becoming a full-time watercolor landscapist, Gonske's work has received First Prize and Honorable Mention from the Southwestern Watercolor Society, and the $2500 Stacey Grant. His work is exhibited at the Brandywine Gallery in Albuquerque and Blair Gallery in Santa Fe.

Gonske is a member of the Southwestern Watercolor Society, and makes his home in Taos, New Mexico.

I WAS A FASHION ILLUSTRATOR in New York City until the end of January, 1972. At that time, after months of weighing the possible consequences, I decided to chuck illustration, move out to Taos, New Mexico, and take a crack at landscape painting in watercolor. It was the best move I've ever made.

I work exclusively in my studio, drawing and painting from 35mm slides taken with a Nikon FTN camera. I use a wide angle lens—35mm to be precise—which gives great depth of field, so that everything from 20 feet to 20 miles is pretty much in focus. My version of going out on location is to hop into my van with the camera and go check out adobe structures or little used roads, driving slowly and stopping often to look for interesting subjects and lighting. I might fire off that Nikon a hundred times, or until the lens gets hot. Later, I pick out several shots for paintings and generally use them pretty much as they were taken, changing composition, values, or color when necessary. Sometimes, however, I work from two slides, using the background from one and the center of interest from another. I prefer late afternoon sunlight and, since that time of day is so preciously short, using a camera in this manner has become a necessity.

I've built a rear screen projection unit back in my studio, to facilitate my use of slides while painting. It allows me a full color image two feet square. I project this image about four feet in front of my drawing board and refer to it for drawing and for color. One common error I've noticed when photographs are used by artists is that values are copied from the photograph into the painting. Invariably the photos used have black or near black shadows—even if it happens to be a white house in light and shade. In reality, the shadow area would be a lot closer to white than to black.

Although I use acrylics rather than watercolors— they are a bit more chromatic and hold up better

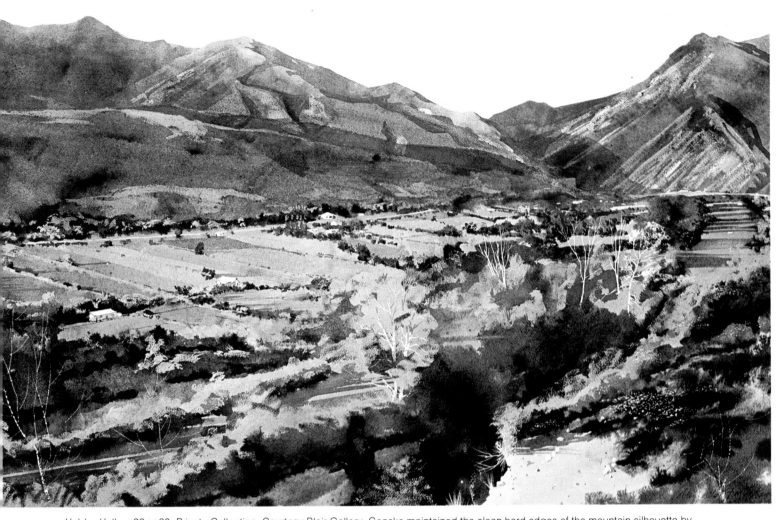

Valdez Valley, 22 × 30. Private Collection. Courtesy Blair Gallery. Gonske maintained the clean hard edges of the mountain silhouette by covering the sky with a maksing agent. This allowed him more freedom when applying his washes for the mountain.

Arroyo Seco Wagon, 1973, 20 × 38. Courtesy Brandywine Gallery. Using a razor for tree shapes in the background, and a natural sponge for foliage in the foreground, the artist produced an illusion of textural variations that contrasts with his main subject.

under my procedure—I use them in the transparent manner. My palette consists of cadmium yellow medium, cadmium red light, alizarin crimson, dioxazine purple, phthalocyanine blue, Hooker's green, permanent green light, and the four basic earth colors, burnt and raw umber, and the siennas.

For watercolor surfaces, I prefer d'Arches 140 lb. cold press, which has to be stretched (fastening the paper to Masonite with gum tape all around the edge works fine.), and d'Arches mounted boards with cold press or rough surfaces. Other tools I use include: sandpaper, razor blades for scratching out tree shapes in the middle distance, and twigs and pebbles up close; natural sponges for foliage; a paper towel in my left hand for trouble; and a masking agent that I use extensively. It produces clean hard edges, which is how I view the Southwest on late, sunny afternoons. I also use a drawing board that will change angle and height, if necessary, with one very quick lever adjustment. This allows washes to flow either up or down, depending on which direction I want them to go. My brushes include an assortment of flat sables.

I begin a watercolor with a detailed drawing done with a No. 6H lead pencil. Then, as in the case of *Valdez Valley*, I mask out whatever shapes I want left completely white. In *Valdez Valley* I also masked out the silhouette of the Taos mountain range by applying the masking agent — about an inch wide — to the sky, down to the edge of the silhouette itself. This allowed me to throw as many washes over the mountains as I chose without having to carefully paint up to this edge.

I use this technique extensively to develop foreground subject matter. When painting an adobe structure in sunlight, for instance, I would just mask out the area around the outside of the entire silhouette, allow it to dry, and then put down a wash of the sunlit side but carrying it completely through the shadow side. As the outside of this silhouette has already been protected, I can be rather careless with my masking agent. Next comes the masking of the sunlit portion, carefully protecting bits and pieces of broken adobe that catch light along that edge between light and shade. Then I apply a wash for the shadow side, allow it to dry thoroughly, grab my rubber cement pickup, and rub off the masking agent, exposing the adobe with nice clean edges all around. This process, although time-consuming — up to 15 hours per painting — gives my work a crispness I can't achieve by working directly.

New Mexico Landscape, 1973, 26 × 38. Courtesy Brandywine Gallery. The artist feels that broad, hard edged, clearly defined areas of shadow that sharply contrast with stark sunlit areas characterize the Southwestern landscape.

Above: *Forgotten Hotel in Madrid, N.M.*, 1973, 20 × 29. Courtesy Brandywine Gallery. By placing the foreground and most of the building in a shadow —broken occasionally by spots of sunlight that lead to a vacant sky—Gonske creates a mood of solitude.

Left: *Abandoned Adobe Church*, 1973, 21 × 29. Courtesy Brandywine Gallery. Many hours spent carefully masking out first the church shape, and later light reflecting cracks in the adobe, permitted Gonske to develop clean, hard edges between light and shadow and side to side continuity with his washes.

41

George Harkins

BIOGRAPHY

George Harkins was born and raised in Philadelphia. He attended the Philadelphia College of Art, where he received his B.F.A. He majored in illustration and studied with W. E. Heitland, an early influence on his work.

Subsequently, he worked as an illustrator while serving in the Army. Following his discharge, Harkins spent eight years working as a commercial artist in Philadelphia and in the Southwest. In 1966 he attended the University of Arizona and received an M.F.A. in painting. Since then, Harkins has taught college-level courses and with other artists established an independent school program in the arts on a ranch site near Tucson, Arizona.

Harkins's work has been in numerous regional exhibitions, including the 108th Annual of the American Watercolor Society.

Harkins lives in Vermont and is represented by Larcada Gallery, New York; Carlin Gallery, Fort Worth, Texas; Shelburne Gallery, Shelburne, Vermont; and Mission Gallery, Taos, New Mexico.

WATERCOLORISTS IN AMERICAN ART inspire me whenever I come in contact with their work: especially the immediacy of their imagery, which gives me the feeling of looking over the artist's shoulder. Many painters strive toward this synthesis of images, but only the best achieve it. My imagery develops through the study of nature, which is essential to the development of my work, and by constantly questioning the act of painting, a process that offsets safe mannerisms which can easily develop.

I seek to build an image from the juxtaposition of color shapes, as in a mosaic. I attempt to see natural forms as color shapes rather than merely as objects in space. This facilitates translation from the three-dimensional world to a two-dimensional surface. A puzzle effect happens in watercolor as a result of the crisp edges of color absorbed by the paper and overlapping of brushstrokes. I like this effect and don't try to paint it out by blending. Certainly the viewer is aware of the edges and, thus, the individual shapes, when standing close to the painting. This is fine with me; the color shapes have a life of their own. In the act of painting, I am concerned with the look of individual shapes as they are painted onto the paper. When I stop, and step back to view my efforts, this concern shifts to the hope that things will hold together, colors harmonize, and the total image have excitement. To this end, I am not overly concerned with the surface textures of objects in my work, and whatever texture evolves is in the relationships of the varying color shapes.

My procedure for the painting *Morning Sun, Rocks,* shown here in color, is typical of my approach to painting landscapes. To begin with, I climbed around one area for what seemed like an hour, squatting down a hundred times to see how things would look if I were seated. I found some great points of view, where setting up was impossible, and beautiful work areas (flat, with plenty of room and shade) that had lousy viewpoints. I especially liked the view from the middle of the stream

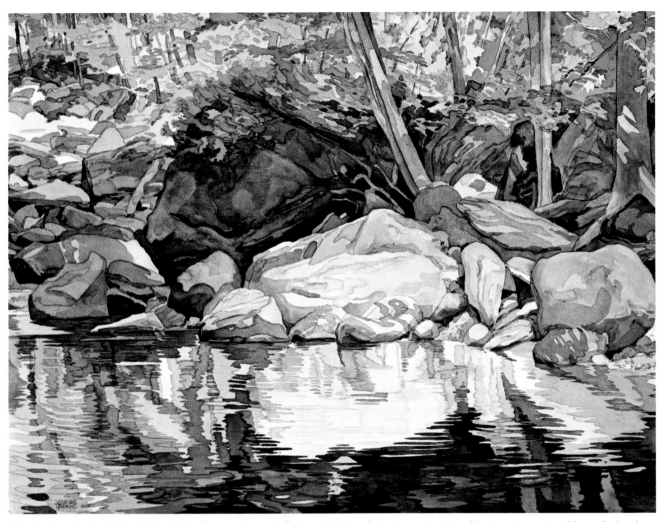

Morning Sun, Rocks, 1974, 22¼ × 29½. Courtesy Larcada Gallery. Harkins perched on a boulder mid-stream to capture this particular view. Working without preliminary drawings, he began by locating major linear movements, then made his color selections, keying most of the painting to one particular area.

— naturally — and while perched on a boulder studying the situation, I decided to try things from there. I built a support for my board with a fallen limb and some piled up rocks. The spot proved comfortable enough after I settled down (in fact, I was able to do two other works there before a storm wiped out my work area).

Meanwhile, the idea that launched *Morning Sun, Rocks,* changed. As the sun moved higher in the sky, its light hit upon a group of rocks in front of me and transformed them into a dazzling display of colors, which almost knocked me off my perch. Now moments when extraordinary visual things occur before you can be difficult to manage, because the impulse to "get it down" is hard to ignore. But too often, something that explodes visually before you will explode the painting if you try to include it in the scheme you have already started building. In this case, however, since I had only made a few light location brushstrokes, for composition, it was possible to change course and include the more dynamic color relationships of the sunlit rocks reflected in the water. My time to paint this subject was limited, and after the sunlight moved on, I began another work more in keeping

with my original impulse. I made several return trips to the area at the same time of day as is my normal practice when completing a watercolor.

In the beginning stage of a painting I am concerned with locating major linear movements in the subject. In deciding where to put the line of the edge of the rocks and water in *Morning Sun, Rocks,* I took into consideration the amount of light visible in the tree patterns above; in placing the large dark boulder to the left of the composition, thought was given to the space between the diagonal line of its left edge and the edge of the paper; in addition, tree shapes on the right were important foils to the painting's overall horizontal movements. Each of these considerations was measured against others as the marks on the paper began to indicate the major compositional forces.

Early color selections are tentative, because there is nothing else on the paper with which to relate them. My first color selections are usually based on something I can see with maximum certainty and I key my other selections to it. By the word key, I mean relating colors on the page *to each other*, after making the translation from "seen" colors. For example, I may decide certain blues are to be painted

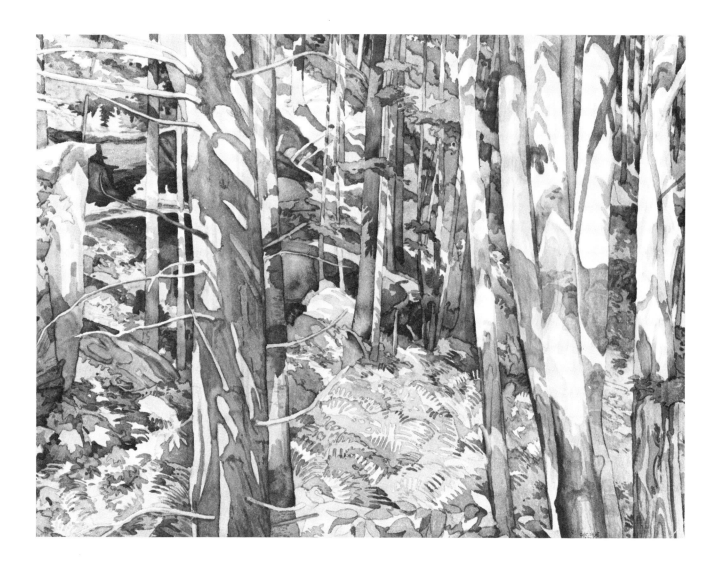

Above: *Sunlight, Shade, Trees,* 1974, 22¼ × 29¼. The artist is concerned with the textural relationship between varying color shapes, rather than local texture.

Right: *September Lakeside,* 1974, 22¼ × 29¾. Harkins views a landscape not as a collection of objects but as color shapes, assuming a life of their own.

Opposite page: *Autumn Creek,* 1974, 22½ × 30¼. Crisp edges create a mosaic-like effect.

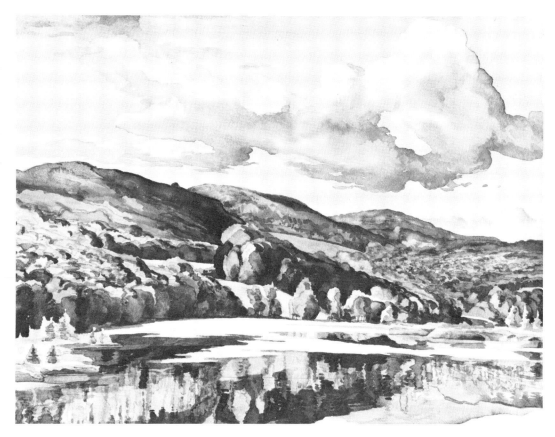

in the cerulean range, rather than ultramarine, and the selection of surrounding colors relates to this choice. In areas of neutrality, the keying process operates the most consciously. I use it to determine warmth or coolness of subtle colors, which has a powerful effect on the more brilliant and seemingly obvious selections.

On location I carry two 12 x 16 plastic palettes, each containing 40 slots for color. I fill one palette with my selections and mix in another. I lay out a wide range of colors, because I prefer to mix from many choices rather than from a few. These choices include: lamp black, ivory black, Payne's gray, Davy's gray, neutral tint, olive green, Hooker's green dark, Winsor green, viridian, manganese, cerulean, French ultramarine, Winsor and cobalt blues, cobalt and Winsor violets, alizarin carmine, alizarin crimson, Winsor red, cadmium red, cadmium scarlet, bright red, cadmium orange, cadmium yellow deep and light, Winsor yellow, Naples yellow, yellow ochre, raw and burnt sienna, raw and burnt umber, sepia, Indian red, Venetian red, brown madder alizarin.

Lighter areas are painted first, with surrounding darks added later to avoid bleeding. Since I like the color to go down on the white paper for maximum brilliance, I don't usually lay in large wash under-painting areas. If there are to be small color spots or lines inside a larger area of another color, I work the larger area around and between the smaller color shapes, maintaining density and evenness when desirable. (I often wonder about the sanity of this method.)

Round sable brushes in the larger sizes are my favorites. Most of my work is done with sizes between Nos. 10 and 14, although I carry a No. 24 with me for large areas of paint and some smaller sizes for special needs. A simple holder made from corrugated cardboard protects the tips when being transported.

For larger works I prefer 300 lb. d'Arches paper, which doesn't need to be stretched. I just clip some sheets to a piece of Masonite before going out. I have no real preference between the rough or cold press surfaces: I find both very responsive to my needs. For smaller work I like the blocks of 140 lb. paper.

When I'm painting on location, an inexpensive knapsack holds these materials: the palettes fit in perfectly, and there is plenty of room for a water jar (plastic is best for outdoors; you won't have the bottom drop out if it's plunked too hard on a rock), pencils, erasers, knife, paper towels, cushion, and repellent for the insects you are bound to meet.

Joseph Ireland

ALTHOUGH THERE ARE INNUMERABLE approaches to the art of painting, the transparent watercolor has for most of my life offered the greatest satisfaction and pleasure. To me, watercolor's freshness, spontaneity, and clarity far outweigh its lack of solidity, a quality oil painting possesses to a greater degree. However, for a number of years now, I have observed what I feel is a limitation that most water-

BIOGRAPHY

Joseph Ireland was born in 1936 in Montrose, Pennsylvania, the sixth of eight children. He studied at the American Academy of Art in Chicago, and has worked as an illustrator both in Chicago and Seattle. Since moving to Seattle in 1962, his work has steadily gained a well-earned reputation in the fields of commercial illustration, as well as watercolor painting and drawing.

Ireland has exhibited at the Seattle Art Museum, Charles and Emma Frye Art Museum, and Haines Gallery, Seattle. Honors include the Northwest Watercolor Society Transparent Watercolor Award, 1971, and the Frye Museum Arturro Ricci Award, 1972.

colorists put on themselves. This limitation comes about from a lack of appreciation of watercolor's true range, and in practice tends to produce pictures that look superficial, showy, or slick, with a somewhat less than substantial character. We are fortunate that those qualities which belonged to the transparent watercolor have continued and improved down through the centuries, but I feel that most watercolors simply look too much like watercolors! If this sounds like so much nonsense, then let me give an example of an artist who has managed to give the feeling of solidity, as well as freshness in his watercolors. Thomas Eakins, an American, was best known for his oil portraits.

It appears that Eakins thought more like an oil painter when he did his watercolors, and as a result managed to extend the range of the watercolor while still utilizing the unique qualities of the aqueous medium. There have been others, no doubt, who have extended the limits of watercolor painting, but this man's work stands out in my mind, and his life has been an inspiration to many artists as well.

With this introduction, let me say that a watercolor can be fresh as well as solid, spontaneous as well as soundly designed, and as deserving of position in the history of art as the finest oil.

When working, I try to think in terms of depositing pigment on the painting surface, rather than "laying a wash." A watercolor simply uses water as its medium rather than linseed oil and turps (mediums for oil). I do this not because there's anything wrong with a wash — even oil painters do washes — but rather to orient my thinking away from the purely traditional academic "wash" look. Pure pigment can be scrubbed right on with stiff bristle, or scraped and pushed around 'til one gets blue in the face. All I'm saying is that the artist can manipulate watercolor and the warning "once down forever down" is simply untrue. With good quality paper, one can be rough with it and not worry about going through to the other side. Stiff bristle brushes really grind the paint in so that it feels and looks solid. Sometimes a little dirt helps to get the right feel, or maybe a little coffee is preferable. Once I asked my ten year old son to "pre-

Tarantella, 1972, 18 × 24. Private collection. Although Ireland often begins work on location, this painting was done solely in his studio. Preparation included several graphite studies and photographs to develop the composition and drawing. The written comments upper right, used to break the stark whiteness of the unpainted paper, have become a design element.

pare" some paper that I planned to use for a portrait of a friend of mine. He laid the sheet of paper on the back driveway and threw stones at it from point blank range. He got the neighborhood kids to walk and stamp on it, ride their bikes over it, do anything they wanted to with it, just so long as they didn't wreck it. I said to them: "After all, a rule or two is good practice." Anyway, they were good to their word, didn't wreck the paper, and that portrait turned out giving the feel I wanted.

About half my work is done directly from life, the other half being done in the studio; each helps the other. I find painting outdoors with real sunlight, real air, and real distractions produces a freshness and spontaneity that is complementary to the more controlled situation found in the studio. The artist designs more carefully in the studio; yet, if too much studio work is done, the paintings tend to become dull and lifeless. One feeds the other it seems.

The painting *Tarantella,* reproduced here in color, was done in the studio, yet I did a good deal

of preparation before beginning the actual painting. The young child is my daughter. I did several studies of her in various positions, using graphite pencil. I also took a number of photographs of her playing her harp. With these drawings and photos, I carefully designed and delineated the composition on a d'Arches pad, spending as much time with the drawing and composition as with the application of pigment. Then, I played tic tac toe on the drawing, using a ballpoint pen, extinguished a cigarette on it, and wrote a thought or two on it before starting to paint. This was done mainly to get over the fear of wrecking a very good delineation on a piece of pure white paper—an occupational hazard among artists.

On the other hand, I recall doing a painting on location that turned out to be quite a complete composition before the day was over. I was wandering about the University of Washington Arboretum in Seattle, looking for a little inspiration, when a police helicopter appeared overhead. I was annoyed

Above: *The Intruder*, 1973, 17½ × 23. Painting directly, with no pencil drawing, Ireland expresses his anger at the helicopter's noisy intrusion. The loosely painted background and relaxed activity of the figures contrast sharply with the harsh shape of the helicopter and the scrub-like strokes around it.

Right: *Canal Family*, 1973, 18 × 24. Ireland achieves solidity of form while maintaining the freshness and clarity natural to watercolor.

Last Flight of the Shenandoah —Daughter of the Stars, 1973, 25 × 40. To develop an accurate historical setting for this work, Ireland first investigated the properties of weather, lightning, and dirigibles, and then spent a week reenacting this precise moment in time, before beginning to paint.

by the loud roar of the machine, and as the minutes ticked on I became more and more ticked off. After 15 or 20 minutes I was fit to be tied and began shaking my fists in the air. I was dumbfounded as to why that chopper chose to remian just overhead, destroying the otherwise peaceful loveliness of the arboretum. Suddenly inspiration came to me! I scribbled a drawing of that helicopter on the back of an old receipt I found in my billfold, then ran to the car where lay some heavier guns; that is, paints, brushes, and paper. Setting up quickly, near a few equally disgruntled black fishermen, I began to paint *The Intruder.* The painting was done directly on a Strathmore pad, with no penciling whatever, white helicopter hanging just overhead, two or three men fishing, one looking up, with a white goose flapping its wings in irritation. I was pleased. It had helped to express those feelings, and I had learned how to work in a somewhat different manner out of sheer frustration. It is doubtful that had this painting been done in the studio, a better piece could have been produced, even though the studio allows more time to consider, conceive, and compose. I think the important thing to remember is that there are a thousand ways to paint.

A few words should be added concerning the more technical aspect of how one might go about making a picture. Right off, I feel the technical is too much emphasized nowadays; the feelings, emotions, the experience being the more important. But of course, the artist must have the ability to use his tools and materials as skillfully as possible in order to evoke the feeling or experience effectively. What I fear in this respect is a blind attempt to imitate the methods of another artist. So with this in mind, I venture to reveal my "secret weapons" and if I hear of someone in Newark who does a masterpiece using just an old banana peel, I'll try not to over-react.

My palette is madeup mainly of alizarin crimson, raw and burnt sienna, olive green, and some sort of dark blue. Paper is mostly d'Arches pads, 140 lb. rough, but occasionally I use Strathmore, or a gessoed surface, or giant sheets of d'Arches when I get carried away. I use flat and pointed sables, oil brushes, house painting brushes, razors, knives, sticks, boards, cigars, banana peels, hands, and sometimes feet. When working outside I use a light collapsible easel made from a camera tripod. It adjusts to all situations, from lying on the ground to standing on the side of a steep hill. In the studio I use an adjustable wood drawing board. It's important to have mats ready as soon as the painting is started, sometimes even during the drawing stages. This also applies to having a frame ready. Laying a frame over the mat and painting at different stages of development can be very helpful.

Ed Jagman

BIOGRAPHY

Born in Chicago in 1936, Ed Jagman studied at the American Academy of Art, Chicago, and began participating in juried exhibitions in 1957. In 1968 he adopted Denver, Colorado, as his home, where he now lives with his wife and daughter.

Jagman's exhibitions include, in part: The American Embassy Traveling Exhibit, a one man show at the Chicago Public Library, the Vincent Price Collection, the New Jersey and Pennsylvania National Watercolor Exhibitions, the Denver Art Museum, Mainstreams '74 National, the Colorado Foothills National Watercolor Show '74, the traveling show of the American Watercolor Society's 102nd Annual Exhibition in New York. He is listed in *Who's Who in American Art*.

Jagman is represented by the following galleries: De Colores Gallery, Denver, Colorado; Blair Galleries, Ltd., Santa Fe, New Mexico; The Artist Den, Valparaiso, Indiana; Saxon Mountain Gallery, Georgetown, Colorado; Valley Forge Gallery, Vail, Colorado; East West Gallery, Steamboat Springs, Colorado. And in Massachusetts: The Garret Gallery, Wayland; Squarey Barn Gallery, Falmouth; Wellesley Gallery, Wellesley.

AFTER SPENDING much time in the vegetable garden and landscaping our home with six-foot trees, I've come to realize an even greater enjoyment in painting. In my studio I can move mountains and 40-foot trees with the stroke of a brush. Much easier on the back! While reworking nature in watercolor, I find myself completely involved not with academic principles nor technique but with the temperature of day, the sound of water in rushing streams, the crunch of leaves beneath the feet, or the caress of trees overhead. I choose to paint first-hand experiences by actually hiking the trail, riding the bicycle, or feeding the birds that are painted.

All my watercolors are finished in my studio on a cast-iron based tilt-top table. There I work from slides, photographs, or a rough thumbnail sketch. For me, I've found that setting up on the spot and working with a full range of equipment at hand restricted my getting in touch with the subject. Painting on the spot compels me to work in an exacting manner, but back in the studio I allow my imagination full play. A quick photograph or super rough sketch gives me time to roam around an area and really take part in my subject. I must see, hear, touch, smell, and mentally taste my surroundings.

In my approach to *Where Aspen Flourish*, no preliminary sketch was used. Instead, in my mind I visually divided the sky, aspen, and pine tree area, from the path the partially snow covered creek was to take. Rather than paint the sky in later, I most always prefer to achieve a softer effect by applying it first; however, on occasion I have left this area completely void of pigment for an especially bright effect. This day there was a solid misty look to the sky and the trees jumped with color.

.As the light wash of the sky dried, I applied a tonal wash of yellow ochre for the aspen trees. Traces of cadmium yellow and raw sienna were allowed to flow into the wash and blend by tilting the

Where Aspen Flourish, 1973, 26½ × 15. Collection Leslie B. Arnold. Brilliant gold behind muted greens and white, with smoky blues in the foreground; one can almost smell the autumn air and feel its stillness.

Foot of Jones Pass, 1974, 15 × 15. Collection Mr. and Mrs. William P. Denious. The straight angular lines of the bridge subtly reflect Jagman's basic composition, provide contrast, and develop the spatial dimension of the painting's middle ground.

board. Lifting out the aspen trunks I then sponged in and shaped the trees. The water was next laid down very quickly, pulling my brush from a distant wet area into the dry foreground for a frothy effect. The creek banks were scumbled in with the side of a wide flat sable. The rocks were placed during the wet and dry stages of the water to allow the illusion of some being submerged. The pines and deadwood were added last with the very distant pines painted over and into the stand of aspen. I was after clarity of the scene, concerning myself not with details like woodgrain, preferring to capture all with simple but planned indications.

The success of a work lies in knowing when to stop, which is usually sooner than one realizes. For me, a painting usually takes from one half hour to three hours, rarely over, and is completed in one sitting. At that point I place a rough mat on the watercolor and leave it in the studio for a few days of daily reviews to be sure my brush said what I wanted it to.

Only under close scrutiny of my palette will you find yellow ochre, raw sienna, burnt sienna, raw and burnt umber, cadmium red light, cadmium yellow deep, Payne's gray, sepia umber, Hooker's green, cobalt and cerulean blue, Indian red, and ultramarine violet. The butcher tray palettes I use are far from being laid out in the traditional cool and

warm spectrums. A Japanese artist friend once told me as I hovered over his shoulder, "The sky is not just blue; its hue is constantly changed by particles of earth." Thus, usually a blue and an earth tone share a common glob on my palette.

I am very hard on my brushes and never seem to keep them as clean as one could, but I do work my best in a relaxed atmosphere. Brushes used the most, as far as I can determine through paint crusted handles, are a 1½ inch flat sable and two round sables, Nos. 6 and 10, and a Sumi brush. Other color manipulators in much demand are pencils, straight pens, twigs, sponges, facial tissues, razor blades, a butter knife, an eraser, and my fingers.

I have used most of the watercolor papers from light to heavy weights, watercolor boards, butcher paper, bags, mat boards, and cardboard, but now prefer the quick drying quality of illustration board. Also, being too eager to paint to go through the tape and stretch method with watercolor papers, I am presently using cold press, 100% rag surface illustration board, Nos. 5 and 110.

Above: *Watching the Hawk*, 1974, 19 × 14½. Courtesy De Colores Gallery, Denver. The artist establishes the illusion of textural variation through a variety of means, from sponging in tree leaves to scratching in twigs with a razor blade.

Right: *The Three of Us*, 1974, 34 × 9. Collection Pam and James Driscol. Subtle background washes—wet-in-wet—create an illusion of an infinity of mountainous slopes.

Zygmund Janowski

AMERICA IS ONE of the few countries where decadence can masquerade as "nostalgia" and get away with it. Whether it's a masochistic streak in the American public or a misunderstanding of what art means, the fact remains. Too much attention is paid to regionalists, men obsessed with detail and finish —our latter-day Bouguereaus. On the other hand, people who pretend to a greater sophistication praise "avant garde" works, which are, many of them, actually *anti-art* statements. At one end of the spectrum we have painters who can see nothing but craftsmanship and drawing; at the other end, painters who completely ignore these fundamental values. Between them, we've lost the *human element,* the element that should always be foremost in the mind of the artist.

For many painters, technique has become an end in itself. They try to teach it; they try to learn it. But a technique isn't taught and can't be learned. It's part of you, like the way you breathe or eat or get up in the morning —your quickness at a particular moment, your slowness at another. It doesn't exist in and of itself but is always a means of *personal expression.*

So my advice to those painters is: try to think less about technique and more about your subject. Remember that the subject is the starting point. What you're interested in is your reaction to it. You stand as a referee between the scene, your emotions, and the watercolor paper, juggling emotion and logic, intuition and analysis. Your goal is to experience a feeling of excitement from the first stroke to the last.

I also believe that watercolor's the only medium that lets you be yourself. It records the way you feel and move at a particular moment. With oil, you work and labor and can spend all year on a painting if you want. But watercolor's dry in about 20 minutes, and I think that's as long as you should spend on it. Don't worry about "finishing." Painters who tell the viewer everything don't respect his right to an opinion —his right to live! The viewer can't contribute: he can see every nail in the barn, but he doesn't get a sense of the man who drove the nail, or of the life of the barn itself. So try to be true to your medium, take advantage of its fluidity—and don't make it into something it isn't. Spend a month on a watercolor, and you end up with a tempera painting. If you want to imitate another medium, *don't use watercolor!*

Another point: there's no right or wrong way to work outdoors. Everyone has his preferences. I use a 1 inch flat sable as my basic brush—plus a Winsor & Newton 8 and 12. I also use a French easel and paint with my paper at an angle. The water rushes downward, speeding the drying process and letting me see my values immediately. Upright, the paint won't dry lighter—as it does when the color floats in a pool of water. I also like to use a smooth paper (140 lb. Capri); it gives me a fluid stroke. But how important are materials? A good painter could do a masterpiece with mud and paint it on the floor of his studio. I like smooth paper; others like rough paper. After all, it's interest you're after, and there are a hundred ways to get it.

As for "rules" —the important thing is to know when to use them and when to break them. Take the academic rule that you should always block your corners. Well, that just leaves you with *another* area in the middle of the paper, and another set of corners to block. I sometimes draw my students a diagram of square within square within square, the rule finally negating every inch of space on the paper. But it's not a bad rule. It's a *good* one! Only, Degas broke it all the time —and got away with it. So nothing's set.

I find that the drawing is the most important part of my watercolor. Nothing can replace the drawing.

Hardings Castle. 1974, 15 × 22. Jankowski's paintings are done in series: they begin with the traditional and evolve into an Expressionist idiom. Here his use of color alludes to a certain joyfulness.

BIOGRAPHY

Zygmund Jankowksi was born in South Bend, Indiana. He attended the California College of Arts and Crafts, where he studied with Victor Dewilde, Otis Oldfield, and George Post. He is a member of the Rockport Art Association, the North Shore Arts Association, and the Philadelphia Water Color Society. He is an associate member of the American Watercolor Society, the St. Joseph Watercolor Society, the Sarasota Art Association, the Copley Society.

Teaching has occupied a central position in his life. He has instructed at Indiana University, South Western Michigan College, Hilton Leech School of Art, Bremen Art Center, and Niles Art Center. He conducts classes at his summer studio at Rocky Neck in Gloucester, Massachusetts. During the rest of the year he teaches workshops at the South Bend Art Association.

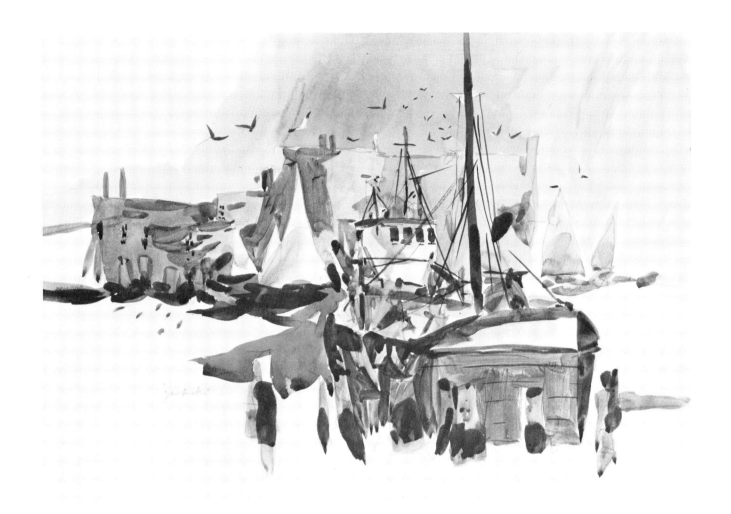

Above: *Gloucester Shipyard,* 1974, 15 × 22. Jankowski's use of space shows the influence of oriental art.

Right: *Ed. Herrmann —TrainStation,* 1975, 15 × 22. The artist explores silhouette values in controlled space.

Opposite page: *Zizlas House,* 1974, 15 × 22. Jankowski feels the relationship between spectator and artist is reciprocal: the artist displays his personal ideal, his approach to subject matter, and the spectator in turn gives him identity.

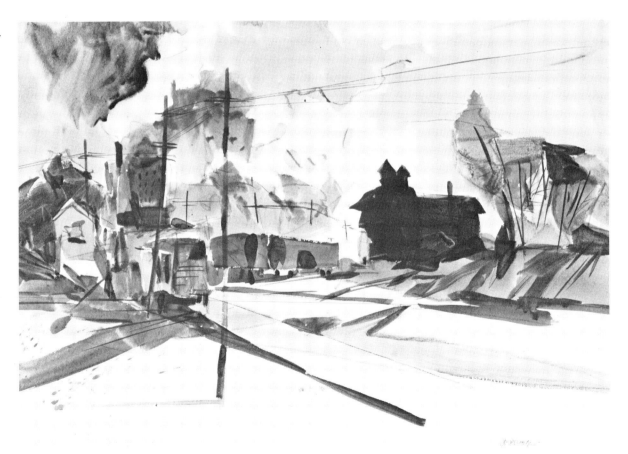

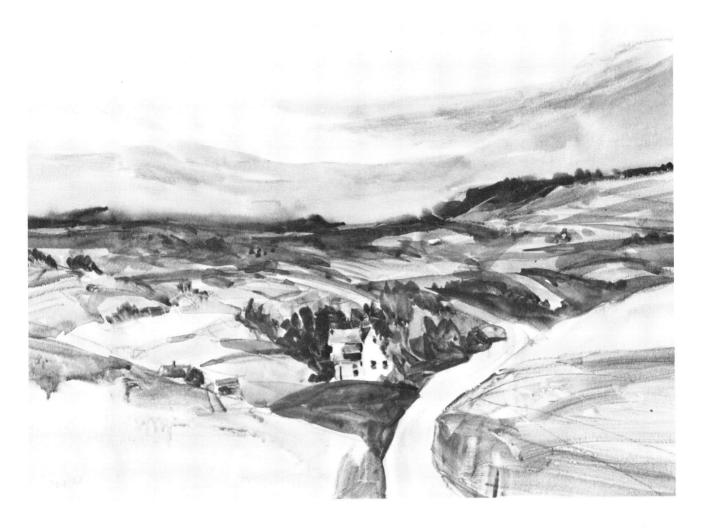

It's the greatest pleasure and the greatest challenge: if you can draw a hand, if you can draw one finger and get it right—then you can draw anything. So I spend about half my time considering the drawing; the other half, coloring it. I try to draw in an exploratory manner, pushing and pulling, teasing the line. I never erase. If it doesn't come out, I turn the paper over and work on the other side, I don't make preliminary sketches.

Once I'm into the painting and am stumped, I look at nature. I'm a question box, and nature has all the answers. Painters sometimes forget they're not trying to make a literal copy of what's in front of them. A beginner is afraid to move things around; he thinks Aunt Bessy won't recognize the spot. But if all the painter wants is an exact copy of the scene, he or she might as well take a photograph. My advice is: don't be afraid to move things around. And above all, don't be afraid of failure.

Color considerations arise only after your drawing has fully expressed your reactions to the scene before you. I like to use color, and I like to experiment. Some days I'm interested in investigating grays and browns. On others, I'm interested in complements: I may base some parts of the painting on the actual colors of nature—and substitute the complements in others. A blue sky is painted yellow-orange. A green building may end up red.

That way I slowly build up a knowledge of how complements work. And the results aren't as shocking as you might think.

In the last year or so, I've tried to use brighter color; I've tried to be less cerebral and more intuitive. And I'm not reworking the results, as I used to. I paint a lot, and I destroy a lot. I know what tricks make a work salable, but I've decided to paint for myself now, and less for the market. I had enough of that when I was in advertising.

After a few weeks of painting, I use up my encrusted paint by doing little flower pieces. Not much: just a subject to hang color experiments on. I work dry. I paint wet-into-wet. I watch how different colors behave. I paint petals and leaves and stems—and get plenty of brush practice. It's all experiment, all study. That's the important thing: to remain a student. That's what a teacher really has to do: he has to teach his student *how to learn*—and then hope he never stops.

People usually find my work cheery. "You must be a happy painter," they say. But I see more than just the sunny side of life. I think it's essential that every artist recognize the fact of death, recognize it so that he can go back to life with renewed interest and excitement—so that he can feel every day how little time he has and how much he has to do.

Robert Johansen

WATERCOLOR IS MY MEANS of communication to others. My subjects are usually local and intimately known to me. They record my nostalgia for the past and my basic belief that nature is man's truest source of peace.

BIOGRAPHY

Robert Johansen was born in Kenosha, Wisconsin, in 1923, and he attended Layton School of Art in Milwaukee. There he met his wife, Kathleen, and now, with their six children, they are living in Racine, Wisconsin. His studio is in their warm, busy, and creative home.

Johansen has received innumerable awards and prizes throughout the Midwest and has exhibited in the American Watercolor Society Annual, as well as being represented in their traveling show. He was the first award winner of "Watercolor Wisconsin 1972" and was selected to exhibit three paintings in Mainstreams 1974. He is represented in innumerable public and private collections. He has served as treasurer of the Wisconsin Watercolor Society for several years and is active in many art organizations.

I paint only scenes familiar to me, sometimes visiting and painting the same spot dozens of times, sketching, eliminating unneccesary objects, determining the mood. My personal expression of the everyday, the commonplace, will hopefully create a new awareness in the viewers: a new appreciation for the essential beauty of simplicity.

Most of my paintings are painted in my studio where I work from field sketches. This preliminary contact with nature, getting the feel of the scene, is where my paintings begin. Even though the majority of my paintings are done in the studio, for a change of pace I will also paint outside. My constant traveling companion is my sketchbook, and when painting outdoors, I also travel very light. My materials consist of a canvas bag filled with a canteen and cup for water, container of brushes, a small palette, a round tobacco can filled with my paints, a few rags, a block of 140 lb. paper, and a folding seat.

When sketching I use a small nylon tip pen on a layout pad. You can draw a fine line and also get a good drybrush effect on this paper. My sketches are simple, but they have enough detail to make good references. I record masses of color, lighting, and, if there are buildings, their relationship to each other. Cast shadows are very important to design. I will note unusual shapes, special characteristics, anything individual or personal that I responded to.

Sometimes the best paintings can come from the simplest of sketches, if that sketch has captured the elusive beauty that stimulated me originally.

There are several old farm homes, barns, and a lighthouse I especially enjoy painting, and I revisit them often. I'm always inspired by a change in mood or lighting, for a whole new concept of painting the scene can then be developed. I seldom use slides or photographs as an aid. It is essential for me to establish direct contact with my subject and the area surrounding it.

After 25 years of sketching, I've developed a mental reservoir of detail that is invaluable. This means that, when I'm painting in the studio, details develop automatically, without need for much preliminary drawing on the watercolor board. And if, as occasionally happens, an accidental effect develops, I take advantage of it.

Basilica, 1972, 12¾ × 20½. Collection Mr. and Mrs. F. J. Hoffman. The artist used a limited palette to create a moody atmosphere. Subtle variations in the intensity of each color create the illusion of a broader palette as well as a rich textural effect.

Fortunately, I live in Wisconsin, where all four seasons are equally beautiful, although winter is probably my favorite. It is the time of year for intense contrasts. Snowstorms and sub-zero weather do not deter me. Several paintings I prize froze while being painted. The effects that developed are most unusual. Stormy skies, the contrast of earth and snow, and moody days with fog or mist are most inspirational for the watercolorist.

My palette is fairly simple. It consists of alizarin crimson, burnt sienna, raw umber, burnt umber, sepia, yellow ochre, new gamboge, Payne's gray, Antwerp blue, Winsor blue, cerulean, and sap green. They are tube colors of the best quality available. However, my palette for each painting is usually made up of three or four of these colors. By intermixing, I develop a good range of colors. Also I find the colors always complement each other, and the end result will find the painting "hanging together."

My brushes include 1¼ inch, 1 inch, and ¾ inch flat sables, and, for details, a No. 4 fine round point. These brushes can be used in a variety of ways to obtain different effects. You can flatten the brush, twist, spatter, or use it dry. Of course, when painting I'm constantly drawing with the brush.

The only aids I use are a razor blade, for scraping out areas, and a straight edge. This latter item is a handy bridge for working over wet areas and drawing longer straight lines.

A good rag paper is essential, and I like the 140 lb. weight. I also have been using a mounted watercolor board. Both rough surfaced. I prefer the rough surface for its texture value when dry brushing and because it lends character to line detail.

Before using the 140 lb. paper, I stretch it. This means submerging the paper in water for about ten minutes, laying it on a board, wiping off the excess water, and taping down the edges with a good gummed tape. I allow the paper to dry thoroughly before painting. This process gives the paper a nice, flat surface. Of course, when you paint large, wet areas it will buckle, but as it dries it straightens flat. This is an asset when matting the painting: the surface will lie flat.

When using watercolor board, I just gently sponge the surface and allow it to dry. When ready to paint, I lightly sketch in my subject matter with a minimal use of line, just enough drawing to indicate proportions and horizon line, with very little detail. My sketch is a blueprint and color reference. It must supply the mood. By starting out very direct and knowing my subject well, I can usually eliminate thumbnail sketches. This results in a spontaneous feeling and a freshness that my watercolors are noted for.

I usually start by laying in the sky and establishing a color background to work against. From this beginning, I'll work forward and around to form a color pattern. I constantly play dark against light and light against dark to establish the strong contrast I want. Dark against light or vice-versa is the

Seven Oaks, 1972, 18 × 30. Johansen is constantly drawing when he is painting. Working forward and around, dark against light, he establishes contrast and the illusion of detail.

Miller Homestead, 1974, 16 × 24. Johansen uses the sloping diagonals of the fence and alternating dark-light-dark of the foreground to lead the viewer's eye to his main subject, the homestead.

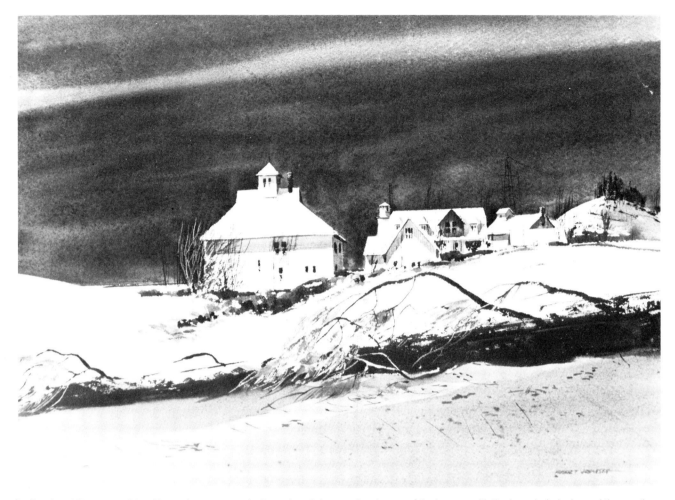

Pt. Betsie, 1973, 15½ × 23½. The artist contrasts the interplay of the angular shapes of the houses with the broad, dark sky and the gentle diagonals of the foreground.

only way to create a strong painting, and I cannot stress it enough.

My paper is dry when I start, but I wet areas with clear water, work in a wet wash, or mix color in a wet area to create a special effect. Usually it is best to lay in a good, strong wash and leave it alone. My work is always kept transparent. "Keep fresh, don't scrub," is my motto. I rework dry areas for detail or drybrush textures, but I'm also constantly drawing with my brush.

Many people are amazed at what they call "detail" in my work. Basically, my paintings are composed very simply, and it is how the paint was handled and, more so, how details were suggested that creates the effect of detail. I also usually try to finish a painting in one session, while the mood or inspiration is strong.

In my paintings of winter, I let the white of the paper work for me, but I never mask areas. I want the roughness of the paper to establish its own character, and masking results in rigid edges that lose a spontaneity I want to hold on to. When nearing completion, I'll try a trial mat and see how things are holding together. This probably will be the critical time; the time to stop and not pick away or overwork. Maybe just a thin wash, to push an

area back, is needed. Possibly a little more drawing with the brush, just a little more emphasis here or there. But know when to stop!

I feel my best work shows I've developed a fresh, strong painting style with good, clean color and no overworked areas. After years of painting, with many trials and errors, I have finally achieved a sound design quality. My work is creative, though representational, and makes a statement for me. I believe in the validity of realistic expression to communicate the artistic life of our time.

There is so much beauty in this world visible to all, but so often not really seen. As an artist, I interpret nature; I do not copy the landscape. Obviously, I can't paint every blade of grass or all the leaves on a tree, so I translate patterns and design with brushwork to make a visual presentation of what affects or has emotional appeal to me. Perhaps my sensitivity to nature will stimulate others to respond and enjoy living more.

It is difficult for me to write about my philosophy of painting, the need of self-discipline, the values by which I live. My work must speak for me. If the work is effective it communicates my approach to life, and I would like to think that my painting succeeds in this effort.

Carol Pyle Jones

MY FINISHED PAINTINGS are projections of my imagination—not reproductions of what I see or feel about a certain subject, but rather a systematic arrangement of form, space, and color designed to heighten and dramatize what I wish to say about it. This is, for me, the great adventure of painting: the exploitation of areas where the imagination can (along with all those accumulated tid-bits of technique) take over and intuitively guide the eager hand.

I often sketch directly from nature. It is then that I indulge my feelings about the subject before me. But even then, I try to let my brush or palette knife be directed not by any conscious prior knowledge of drawing or by a photographic vision of the subject, but rather by a desire to transcend all painting *formulae* and say something unique about what I am seeing.

If I feel that a painting has failed to achieve its dramatic potentials, I will nag it until it does. When I began the painting *The Sunken Cathedral* I was so bewitched by the idea of piling stone upon stone that I lost contact with the total composition. However, I did manage to hold onto a sound palette of colors, and the finished work went on to win an important award. Nevertheless, I kept feeling that there was something much more dramatic that could be said about those stones, so I traced a portion of them onto another panel and began the second painting called *Leila*. As I was still entranced by the texture of the stones and the possibilities of color variations, I fumbled for quite a while before I finally decided upon the dramatic starkness of the sky. This, I believe, is what gives the painting its real stature. I suppose the inclusion of the figure was inescapable, yet I was not conscious of having planned it that way. The *total* mood was what I was aiming at, and, when it was finally achieved, I realized how important a part the mysterious figure played in it.

Most of the paintings I have described were rendered on Masonite panels coated with gesso, but I have come to believe this board is too weighty to be useful for watercolor paintings. I enjoy the textured surface, over which I can drag a transparent wash, but by the time these panels are glazed, matted, and framed, the total weight of the paintings become a formidable challenge both for shipping and hanging. So I have recently begun working on illustration board or a good grade of Japanese paper. These surfaces are eminently suited to the wide selection of water-soluble pigments that I use in a semi-dry manner. For laying in an occasional large area I use a 2 inch varnishing brush, mixing my acrylics,

casein, or transparent pigments (sometimes all three) in an old teacup or saucer. Otherwise I find a No. 8 or 10 *flat* sable or squirrel-hair brush useful in laying down the fairly opaque colors; their chisel-edge, used fairly dry, is quite helpful in expressing linear shapes.

My method of developing a painting requires that much of it be rendered opaquely, for I quite often change my course once I am launched. I prefer to pursue the development of form without being bound too closely by original plans. If, in midstream, half of the painting must be changed to improve the total composition, I may shudder at the thought of making the sacrifice. But I usually end up by doing it. Quite often the overpainting produces accidental tonal values that I would never have had the courage to invent. These accidents often lead to the development of new and exciting shapes, which can be used to greatly enhance the work.

I use a very limited palette: yellow, yellow ochre, ultramarine, crimson lake, raw umber, and burnt umber. Working in the semi-dry state, I mix black and white, as needed, to achieve a variety of opaque tones. I find that a cheap, white dinner plate makes an ideal surface for mixing small quantities of quick-drying pigments. It can be rinsed frequently to avoid the clotting of dried pigments that might otherwise foul up the brushes.

I suppose my method of working with a fairly dry palette stems from my sketching out of doors. I have always found it easier to work there with a palette knife or dry brush on a hand-held sketch pad. I work from a small box of tube acrylic or casein paints, using the box lid for a palette. Traveling about the French countryside in a rented car, I have frequently found myself some distance from a water supply and have had to make do with a few ounces of water or reluctantly borrow wine from my picnic hamper.

I spend an average of about 25 hours on the development of a painting. In the early stages I am concerned primarily with transferring to my 30 x 25 paper, as faithfully as possible, all the details of the sketch. Even though I may have a strong feeling that I wish to alter some of those details, I refrain from doing so at that time. Later I put the sketch aside and study the work for balance and form. Large areas are often painted out so that shapes can be developed to better harmonize with the more interesting ones; at this point, only the total composition is of any importance. Color can be corrected later, taking advantage of the many accidental tones

Leila, 1972, 36 × 42, acrylic, casein, and transparent watercolor. Entranced by the texture of the stones and the possibilities of color variation the artist mixed transparent and semi-transparent washes with semi-dry brush techniques to create this enigmatic work.

BIOGRAPHY

Carol Pyle Jones, of Westtown, Pennsylvania, paints from her farm home and the fields and byways of southern France. She studied with Henry Pitz, Morris Blackburn, and Albert Gold. Her work is represented in the Wilmington Society of Fine Arts, the University of Delaware, and other public and private collections. Mrs. Jones is the recipient of the American Watercolor Society Medal of Honor, two gold medals from the American Pen Women, Certificate of Merit from Allied Artists, Purchase Award of the Wichita Centennial Exhibition, and first prizes at the Philadelphia Regional Art Shows and the American Artists Professional League. She has also received awards from the Audubon Artists and the Grand Prix of Painters of the Côte d'Or in Cannes, and was awarded the Gold Medal of Honor from the American Watercolor Society. She is a member of the Philadelphia Water Color Club and the American Watercolor Society.

Above: *Monastery,* 1972, mixed, 30 × 40. Repeated arches and broken shapes create a rhythmic effect of form upon form as well as a sense of mystery. Below: *The Abbey,* 1972, mixed, 24 × 36. Elements from a tiny chapel in France, often sketched by the artist on location, appear here in semi-abstract form.

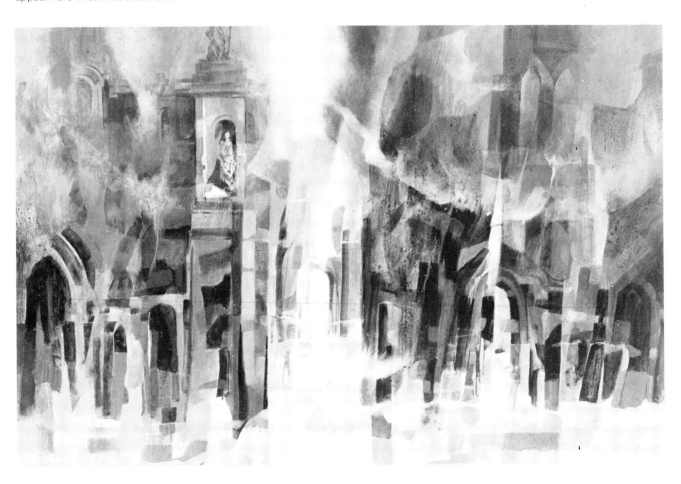

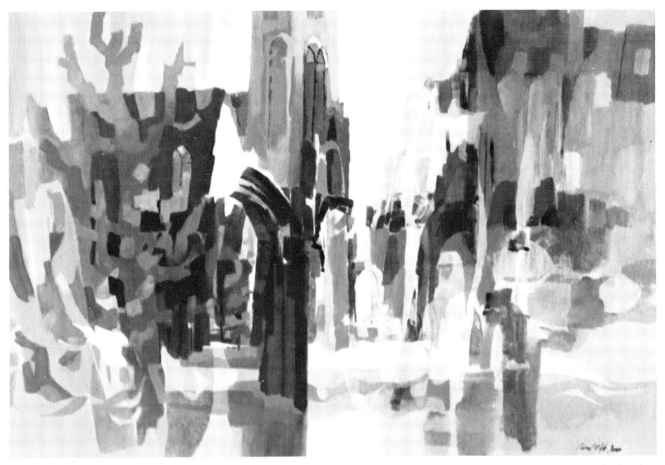

The Church in Combray, 1972, mixed, 34 × 42. One of two paintings developed from the semi-abstract sketch below. After projecting the sketch onto her painting surface, Jones allows the total patterns of light and dark to direct her toward a solution. Notice the further development of the light center sky shape.

that will appear during that early construction period. It is at this stage that I try to develop the interior shapes; a circular form that will bring the eye to an important area already being defined by a square or some other shape.

I paint from a table top with my paper taped to a board. If I envisage having to lay in large areas of initial wash, I soak the paper thoroughly in the bathtub and then tape it to the board with gummed paper. While it is still slightly damp I lay in the colors at random, knowing that a large portion of those color areas will undoubtedly be over-painted. If I get tired of standing at my table I put the board on the floor and paint from that position, but I seldom stay with a painting for more than two or three hours at one time.

As I work in a semi-opaque medium, I have use for only a few tools. A small palette knife or a No. 4 round brush is sometimes handy for accenting a point, and a piece of toweling or facial tissue is often helpful in correcting a tone. But a handful of flat brushes is my real stand-by.

Only when a painting nears completion do I view it inside a mat or frame. At this point such a device is eminently useful because this new definition of space by fixed boundaries can affect the appearance of the shapes within the painting itself.

Diana Kan

BIOGRAPHY

Diana Kan was born in Hong Kong and first studied with Professor Chang Dai Chien, later enrolled at the Art Students League in New York and the Beaux Arts in Paris. Since the age of nine, she has had 29 solo shows in major museums and galleries throughout the world.

The Metropolitan Museum of Art, The Philadelphia Museum of Art, Nelson Gallery—Atkins Museum, Kansas City and The National Historical Museum in Taiwan are among many public institutions that have collected her paintings. She has numerous distinguished private collectors, as well.

A director of the American Watercolor Society and The Pen and Brush, she is also a member of Salmagundi Club and the Allied Artists of America. She is listed in Who's Who in America, Who's Who in American Art, The National Register of Prominent Americans, and the International Who's Who in Art. Her book, The How and Why of Chinese Painting, was published by Van Nostrand Reinhold.

She is represented by Grand Central Art Galleries in New York and Hobe Sound Galleries in Florida. Her lectures are under exclusive management of the W. Colston Leigh Lecture Bureau in New York.

HISTORICALLY, THE ROLE OF COLOR in Chinese painting has been limited, perhaps because of the close relationship between writing and drawing and the consequent reliance on black ink.

Originally, all Chinese colors were derived from natural sources and were classified as either mineral or vegetable. Today many of these colors are synthesized, and we use the term "mineral colors" to refer only to those pigments that are actually prepared from the same natural materials as in the past. The most brilliant of these colors are made from semiprecious gems: mineral green from malachite, mineral blue in various hues from azurite. Two other bright mineral colors are vermilion, which is a scarlet red produced from cinnabar, and mineral yellow, a golden color produced from orpiment.

These precious and expensive pigments are exceedingly potent. Even when diluted and used as washes, they are exceptionally vibrant. Consequently, they have always been used sparingly. In my own work, however, I use these pure mineral colors almost exclusively for broadly painted landscape.

The brush is the artist's true friend and a major contributor to the magic of Chinese painting. I use four kinds of brushes in particular (shown here): a medium-sized, moderately flexible brush of white goat's hair, the equivalent of a No. 8 round; a larger, softer brush made of rabbit's hair, the equivalent of a No. 12; a brush smaller than the all-purpose brush and slightly less flexible, the equivalent of a No. 2; and a mountain pony's hair or sheep's wool brush, similar to a flat and short bristled Western wash brush.

A definitive characteristic of Chinese painting is the way in which the artist holds his brush. I hold a brush perpendicular to the painting surface between thumb and three fingers. My palm is open and relaxed. The movement of my fingers, wrist, elbow and arm is in perfect equilibrium and ease. The brush is held tightly so that nobody could pull it away from my hand, yet flexibly so that I can rotate it between my fingers. When I combine pres-

Top: *White Serenity*, mineral color on silk, 17¼ × 17⅛. Collection Dr. Norman J. Levy. Brilliant color and unstylized brushwork characterize Kan's personal approach to landscape painting, yet the traditional structure of ink drawing and pale washes underlies each work. Here the lustrous white is a mixture of white paint and pearl powder.

Above: *Riding with the Clouds*, vegetable color on silk, 14 × 50. Photographs by Sing-Si Schwartz. "It's hardest to paint the part that's not painted, the space or air," says Kan. "When painting clouds you can either leave the paper bare or use white paint and pearl powder." Here the paper was left bare. A sable brush was used for the dark wash lower right.

Brushes, from left to right: pony hair, wash brush; wolf hair; wild cat hair for extremely fine work; all-purpose goat hair brush; a sable, Kan's favorite for small, dark washes, "because it doesn't leave any lines"; rabbit hair for color washes, because it's soft; mountain pony hair for lotus leaves; sable for ink and color; deer hair for mineral color (smaller brushes are too fragile); goat hair.

Below: Holding chopsticks or a paint brush is basically the same, for "art is the food for thought." Below, center: Holding the brush perpendicular to her painting surface, the artist can use the tip for delicate lines or change the pressure for different shapes.

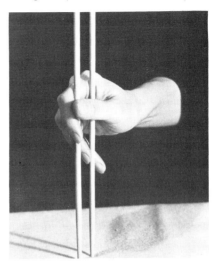

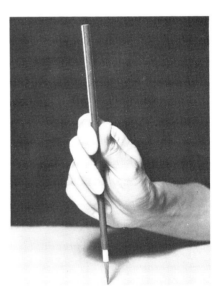

Chinese artists always paint on a flat surface. Notice the four brushes the artist uses most often. To paint, Kan dips her brush in clear water (dish upper right), brushes it against the side to remove excess water, dips the brush into the ink well (center right), and then tests the color in the white saucer before applying it to her painting surface.

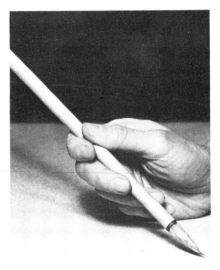

Above: Kan uses the oblique position for softer lines or when she wants more than one value.

Top: *Autumn,* mineral color on gold leaf. 24 × 48. Collection Mr. and Mrs. John W. Payson. Since the ground is gold, pearl powder was used for white, cloud-like areas. The artist describes her painting as "writing with brushstrokes," and her use of vibrant color, rather than subtle washes, as "expressing the self with color."

The Music of Nature, ink drawing on silk, 17 × 45. Here Kan demonstrates a more traditional Chinese approach to landscape painting. The foliage motif is precise; the mountain contours create an illusion of deep space.

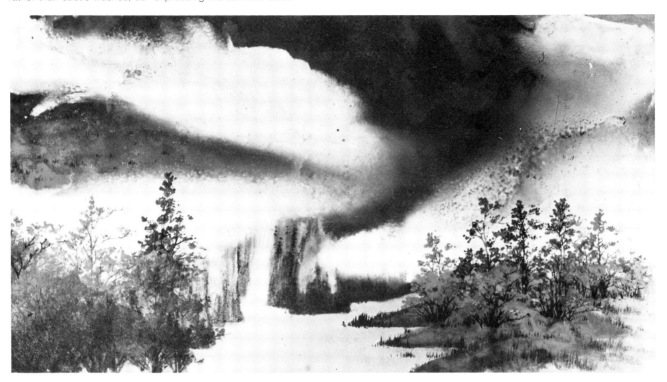

sure, position, and movement of the brush with a regulated amount of water and ink or color in the brush, I can achieve a great diversity of tone.

Chinese painting is not an easel art; I place the paper or silk flat on my worktable, with a paperweight at the top edge to hold it in position and prevent its pulling away under pressure of the brush.

Only after the ink structure of outlines and modeling strokes has been firmly established do I add color, in pale wash or as pure mineral colors. (In ink monochrome, light-toned ink washes are used in place of color.) The washes are built up in successive layers wherever I desire shading or inten-

sified color. The previous wash is allowed to dry before an additional one is applied, and the added washes are only slightly darker in tone than the initial ones.

I form the foliage, distant trees, and vegetation by various dotting techniques. Distant mountains are formed with unoutlined and unmodeled washes, and any human forms and man-made structures appearing in a landscape are "written" with the tip of the brush.

After I finish a painting, I let it hang on the wall for days or months so that I can see my paintings in the proper perspective. I seldom complete a painting in one sitting.

James Kramer

ONE OF MY PAINTINGS was hanging in a show recently, and a group of young people was standing thoughtfully in front of it. One of them said, "Mmmm, you can smell it. It just rained."

Watercolor in particular, and painting in general, are not just matters of technique. More important than technique to me is my subject, its character, and its effect. I do not dispute the need for practice and skill, but I believe that a painting displaying only technical skill is a very hollow thing and does not communicate. The display of light, space, and feeling which is part of a painting does not come from technique alone.

I find myself returning continually to the Mother Lode area of California, to the old gold mining towns, and to the once opulent silver mining towns of Nevada. There is a very special light that is typical of the Sierra Nevada, and there is a great deal of history and romance in these towns. I feel that here is something of the cultural background of the West, something worth painting. I hope through my pictures that I can convey more of the feeling of history and legend than just a good illustration of the subject would provide.

Every region has its own unique light, and it is there for the painter to see and to learn to use. The soft light of Britain and the lack of sharp contrasts require a different feeling for painting, and a good technique for one area is totally false for the other. My own commitment doesn't end with light, however. In spite of the damage we all inflict upon it, the world is still a beautiful place, and I find a lot of joy from it. I paint first to satisfy myself, not for the pure pleasure of painting or the results, but for the pleasure of reproducing some of this joy in paint. If it can be seen and captured, then those who wish can share this.

So much is said and written about style and identity of an artist's work. I can admire Bonnard or Turner, but I cannot honestly paint like either, because I am not either. I am concerned that I am honest in my craft, that what work I do is my own and not copied from others, that I use judgment and reasonable propriety in what I paint, and most of all

that I do all I can within my ability to show what I set out to do. If my work is recognizable, I don't try to make it so. I paint what I see with my eyes and my feelings. The style in which I paint isn't really important, but what I am painting is.

I follow a very traditional path technically and try to reach my goal within the traditional methods so long as these methods serve me, rather than I them. Tools and methods are a means of obtaining a good result. So whatever is available, if it contributes to making a good painting, is valid and honest.

Most watercolor painters use the same tools, such as colors, brushes, and papers, simply because the market offers only a very limited variety of good quality materials. Anyone who feels a sense of responsibility to the buyer would use only the best and most permanent materials. Even though I have at least one tube ·of each color made, I use as few colors as are necessary to get the result and character I want in a painting.

I happen to like brushes, and I have a rather large collection of all sizes and shapes. My favorites are a No. 8 round sable, a 1 inch flat sable, and a ½ inch flat sign painter's sable. The papers I select, like the colors, depend on the painting. However, for most work I like a 300 lb. cold pressed handmade English paper. Small studies and paintings are completed on a four-ply medium surface Strathmore paper, which I dry mount to illustration board when finished. A cold pressed 100% rag surface extra-heavy illustration board works well for small gouache or watercolor studies.

My studio is small but comfortable, with space for a small adjustable architect's table, an easel, paper file, and small work cabinet that has a white Formica top that I use for mixing colors. There is adequate light from the south, which is easily controlled with canvas drapes and translucent blinds. Although I have worked at night, I paint now only during daylight hours and reserve the evening hours for drawing.

All of my larger watercolors are painted in the studio from drawings or sketches made in the field. I use color slides for further reference, and since

Summer in Salisbury, 1972, 20 x 30. On a smooth sheet, Kramer obtained the character of the English lawn: forceful color, abundant in cool and warm mixtures.

BIOGRAPHY

James Kramer was born in Columbus, Ohio, in 1927. He attended Ohio State University and Western Reserve University, and at the Cleveland School of Art he studied painting with Carl Gaertner and Frank Wilcox. He exhibited with the Ohio Watercolor Society, at the Cleveland Museum of Art, and at the Columbus Gallery of Fine Art he won the Robert Wolfe Memorial Prize for watercolor. Kramer entered the architectural profession after his schooling and continued in that field when he moved to California in 1957. Several successful one-man shows, acceptance and awards in regional shows, and exhibition with the American Watercolor Society in New York encouraged him to leave that profession and devote full time to painting. His paintings are included in over 200 private collections in the United States, Canada, England, and Japan. He and his wife Barbara live in Carmel, California.

71

Westminster Abbey, 1972, 20 x 30. Using photographs and sketches made on location, the artist depicts complex architectural details accurately.

most of my subject matter is architectural, black and white photographs are especially useful as a record of detail.

A painting develops very slowly for me from my sketches, notes, and photographs. In the studio I begin to rework an idea, making small thumbnail sketches until satisfied with the composition. I then make a careful and accurate line drawing with some suggestion of the main value pattern, which I photograph for slide projection onto my watercolor paper. With a 6¾ x 10 sheet as a preliminary study, I proceed to work out color patterns and complete as much of this study in transparent watercolor as possible, but often I will make changes or additions with prepared designers' gouache. I may do three or four studies at this scale, making changes and adjustments until I feel I have something satisfactory.

Once ready to start my final painting, I project my drawing onto a full sheet of watercolor paper, making corrections from the study. I then wash the paper rather than soak it, just enough to get the sheet flat, and staple it to my drawing board. After the paper has dried, I begin by painting in the dark areas first. I do not work directly from my sketch or study, but only refer to it where I may be unsure of some passage. I paint from a sitting position and adjust my table as I work. Since I spend more time

sitting and thinking about the painting than painting, this seems most convenient for me.

When I have completed the painting, I trim the sheet and temporarily place the painting in a frame, which I hang in the studio or someplace in the house for a week or so. There are usually small changes required and sometimes major ones. If an area to be corrected can't be washed out cleanly, I find it best to start the painting over and destroy the unsatisfactory picture.

The painting *Nevada City* began a number of years ago before the State Highway Department rammed an unnecessary and unwanted freeway into the center of this charming and history-filled gold rush town. The painting is actually a composite of several sketches and photographs made over many years. I spent several weeks working intermittently on a number of drawings of the buildings and on the arrangement of the page. I followed my usual practice of drawing, to study, to final painting. My sequence of work on this particular painting was foreground pavement, sky down to the roof line of the buildings, cast shadows, background hills, trees, then the right side that was in shadow, and finally warmer local color in full light. Details were added where required, and lettering on the building at the center was an afterthought. I tried this on the study first and then added it to the painting. Colors

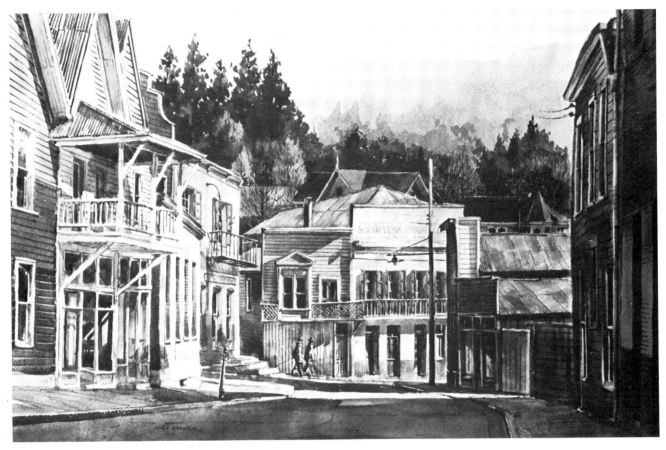

Above: *Nevada City*, 1972, 20 x 30. Photo Jerry Lebeck. Collection Mr. Ronald P. Tremain. Combining a series of sketches and photographs, Kramer pulled together a drawing (bottom) on a 9 x 14 sheet of paper. He also made a small 6¾ x 10 watercolor study (below) before painting.

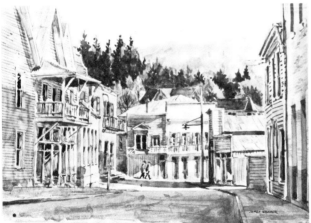

used in this painting were French ultramarine, cobalt blue, monastral green, lemon yellow, yellow ochre, burnt sienna, cadmium red, and Van Dyke brown. The paper was a 300 lb. English handmade cold pressed surface.

By contrast, *Summer in Salisbury* was painted from a sketch and study intended for an oil. The composition is only a fragment of the original sketch, but contains the essential parts of what I found interesting. I selected a sheet of 400 lb. hot pressed handmade paper and proceeded in watercolor as an experiment in which I wanted to show the character of an English lawn without having this dominate the painting. I used both moist artist watercolor and prepared designers' gouache: indigo, monastral green, cadmium lemon, light red, and Van Dyke brown, with ultramarine and cadmium scarlet for accents. Pure colors were applied to a slightly moistened sheet, superimposed or laid down side by side and allowed to blend. All of the dark areas were painted first, beginning with the bridge arches, then trees, shadows, and finally the figures.

I like to return to my source as frequently as possible so that I don't lose my feeling for it. If in my painting I can make people feel that it has just rained or that the sun is warm, if they can smell the air, then I know that I have been able to complete what I set out to do.

Mildred Sands Kratz

BIOGRAPHY

Mildred Sands Kratz was born in Pottstown, Pennsylvania, where she still resides. Largely selftaught, she has had 30 solo exhibitions from New York City to Palm Beach, Florida. Among her many honors are awards from Audubon Artists, Knickerbocker Artists, American Artists Professional League, National Arts Club, National League of American Pen Women, the Reading (Pa.) Museum, and the Catherine Lorillard Wolf Art Club, where she has won two gold medals. Her work has been a part of five traveling shows of the American Watercolor Society, and she has frequently exhibited with Watercolor U.S.A., Butler Institute, and the Pennsylvania Academy of Fine Arts. She is an elected member of the American Watercolor Society, Allied Artists, Philadelphia Art Alliance, National Arts Club, Philadelphia Water Color Club, Academic Artists, American Artists Professional League, American Artists Group, and National League of American Pen Women. In 1960 she cofounded the Pottstown (Pa.) Area Artists Guild. Her paintings are in private and corporate collections throughout this country and abroad. Her work is reproduced and circulated internationally.

A PROMINENT ARTIST once said, "A real watercolorist is one who has painted a thousand watercolors." Having passed that number, I suppose I could sit back and say, "I've arrived." I feel, however, that I must do another thousand before I might finally say that I have mastered the technique of watercolor painting.

While I frequently paint on the spot, I am more comfortable in my studio with the tools of my trade close at hand. My early attempts at watercolor were nearly aborted by using paper of inferior quality. Fortunately, I turned to 140 and 300 lb. cold-pressed French handmade paper for the majority of my work. For simpler exercises I sometimes use a smooth surfaced 19 x 24 inch block; however, this seems to rob me of the "atmosphere" I've found in the rough-grained loose sheets.

I soak up to a dozen full and half sized sheets in a large plastic photo-developing tray for several hours, hang them individually a few minutes for the excess moisture to drip, and place each on a Masonite board. Then I blot a ½ inch margin around the edges with paper towels and secure the paper with 2 inch wide gummed paper tape that I further strengthen with staples. If I choose to work wet, the paper is ready to use immediately. Otherwise I allow it to dry overnight.

My palette contains the finest transparent tube colors available: lemon yellow, cadmium yellow medium, cadmium red deep, cadmium red light, alizarin crimson, yellow ochre, raw sienna, raw umber, burnt umber, burnt sienna, sap green, Hooker's green, viridian, cobalt blue, Prussian blue, ultramarine blue, sepia umber, Payne's gray, and ivory black.

I squeeze a full tube into individual wells in a plastic tray. I cannot abide being limited by a skimpy amount, for if I'm excited about a passage I lose momentum if I must stop for a refill. The tray also has four large divided sections for mixing. When the tray is not in use, I store the palette, full of paint, in a deep freezer so that I always have soft, moist pigment.

My water container is a shallow divided vegetable dish. I clean brushes in one well and take fresh water from the other. My brushes range in size from a few slender hairs to three inches in width. My

Colosseum — Roma, 1972, watercolor on board, 30 x 22. Drybrush was used to develop an illusion of weatherbeaten, decayed stone. Months after the rest of the painting was finished, the pigeons were added with opaque white to relieve the abstract starkness of the dark arches.

Above: *8:15 This Morning*, 22 x 30. Courtesy Piccolo Mondo Gallery, Palm Beach. Kratz uses an unusual angle and strong contrast to emphasize the building facade.

Right: *Along the Towpath*, 21 x 29. Courtesy Drs. Ford, Diaz, and Lichtblau. The rough grain of the paper emphasizes the surface texture of the building.

Opposite page: *Dark Shadows*, 1971, 12 x 28. The blurred edges and looser treatment of the ground area emphasizes the structural effect of the old house.

favorites are squared lettering brushes. An eye-liner brush is great for fine details. Paper tissues are indispensable and have become an extension of my left hand for blotting, altering, cleaning, and hastily picking up an accidental splash of color. A few sponges of various sizes and shapes are handy for painting, texturing, and rewetting dried areas.

Colosseum-Roma was conceived on a Grand Tour of the Continent. Accompanied by my twin daughters, allowing little time to sketch, I gratefully turned to my camera for color shots of that marvelous, overwhelming structure.

Then four years later, referring to sketches, slides, and notations, I worked out a full-sheet value study in Payne's gray, emphasizing the graceful arches and dramatizing the overpowering strength and height of the edifice. From this study I carefully drew my final results on a 22 x 30 rough watercolor board.

Using a limited palette of burnt sienna, burnt umber, sepia umber, and Payne's gray, I applied a wash over the central portion of the drawing, leaving the marble squares untouched. With dry brush I gradually "built" the features of the wall.

For the sky, I wet the paper and flooded in clouds of the same colors for harmony. The background buildings were drawn in freely with a brush, and since the theme of the painting was arches, I repeated arches here for emphasis and continuity.

It was at this point that I decided the pavement must be simply done to avoid conflict with the wall textures, and the sky suggested that wet walks might be acceptable. A light tint was brushed on and, while still wet, local colors were applied. When the sheet was dry, a rigger added some distinguishing calligraphy. A few figures completed the scene.

I placed the painting on the floor and surrounded it with adjustable white mats. I studied it in its temporary frame for another two or three months and one day decided an additional interest was needed to relieve the starkness of the dark arches, whereupon the pigeons were hatched on the spot! They could have easily ruined the painting, for while it is true that errors can be corrected in watercolor, I knew in this instance they could not easily be eliminated, once started. I made several cutouts and placed them on the painting in various positions until I found places where they fit in with the overall design. Opaque white was employed to paint the birds over the dark areas.

John Maxwell

IT'S PROBABLY BEST to admit at the outset that I am an *experimental* painter. No one asked me to be; it has just worked out that way. As to a personal style (if I have one), be assured my own is a mere by-product. I'm certainly not aware of any structured quest for style—and, anyway, isn't that a silly goal when every artist has an inborn "look" to his work as impossible to disguise as his own handwriting?

BIOGRAPHY

John Maxwell, N.A., A.W.S., was born in Rochester, New York, where he studied painting and design at Rochester Institute of Technology and art and art history at the University of Rochester. He has traveled and painted extensively in the U.S., Europe, Mexico, and the Caribbean, has served on national, regional, and local juries, and lives in Wynnewood, Pennsylvania.

Maxwell's awards and honors are numerous. He received six awards from the American Watercolor Society, including a Silver Medal in 1974; won the Dana Medal from the Pennsylvania Academy; won two first prizes from the Philadelphia Water Color Club, to name just a few. He has been invited to participate in major national and regional shows, including those of the Smithsonian Institution, National Academy of Design, and Butler Institute of American Art. He has had numerous one-man shows, including three in New York.

His work has been featured in major publications and is included in major collections, both public and private. Maxwell is represented in Palm Beach, Philadelphia, Cleveland, and Miami.

My brushes are the usual round and flat sables and oxhairs, most prized after outrageous use and misuse. As for painting support, I generally prefer the smooth side of untempered Masonite for mixed-media techniques, but not necessarily for transparent watercolors or oils. For mixed techniques I use clear acrylic mediums as adhesives in applying my materials. These adhesives are indispensable but powerful and can hopelessly warp heavy, costly papers and even the thickest watercolor boards—hence my dependence on Masonite. If there's a likelihood that applied materials might be incorporated as the painting progresses, I thoroughly brush out three coats of acrylic gesso on both sides of my panel. The smooth (working) side is sanded between coats to enhance adhesion of subsequent applications. Also, the gesso will minimize warping, a prime consideration. (Yes, even Masonite can warp!) When I do not intend to apply materials to my panel, I still stay with the three-coat gesso formula. Gesso provides a safe and sympathetic painting ground whether for transparent acrylic effects, or for textured passages, or for a gradual buildup of surfaces that can be made to look almost like an oil.

First I apply the usual three gesso coats on my panel. When that's completely dry, I quickly coat its smooth side—then the back of my watercolor paper (never both sides) with acrylic matte medium and, while both are still wet, immediately mount the paper to the Masonite. Now, with hands and surroundings clinically clean, I smooth out the paper, working from the center outward. Next I cover the mounted sheet with Kraft paper, slightly larger than the panel, then roll out the surplus adhesive with a brayer, again from center outward. The Kraft paper is now discarded, using care that it doesn't transfer any medium to my watercolor surface. The panel is then placed face-up on a hard, smooth table, with a clean piece of wallboard on top. On it I put evenly spaced weights and allow 24 hours for the mounting to dry. (To avoid undue waste or frustration, it would be advisable to experiment in advance, with a few scraps of Masonite and heavy watercolor paper.)

Incidentally, I have thus far tried to minimize the use of the word *texture*. This is quite intentional. You see, I'm really not very interested in texture *per*

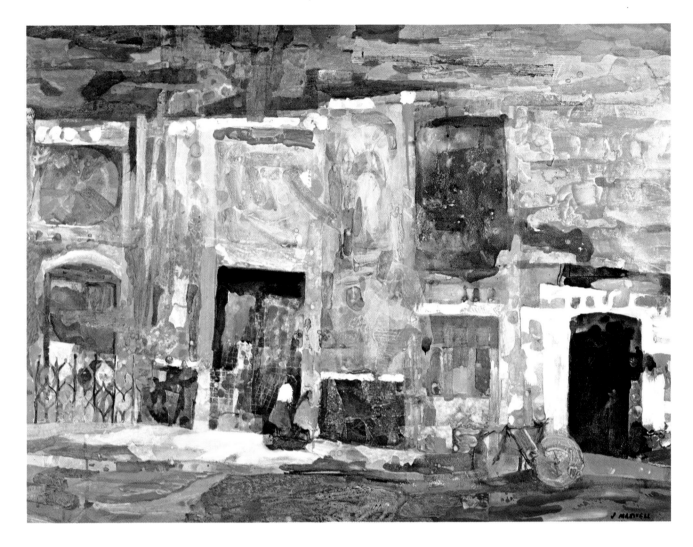

se. That is why I've adapted the application of very thin papers, then do my best to disguise these surfaces with judicious overpainting. It is simply that experiments via this method have revealed a path to clarity and brilliance that my direct painting alone often fails to produce. It is this quality that I value —not just texture for its own sake. Above all, in going after a kind of surface articulation, *I am emphatically not trying to make a collage.*

Paint on location? For me, no. Quick little "feeler" thumbnail sketches and snapshots? Definitely yes. For those artists who value convenience, abhor insects, windstorms, and chafing bulls—and like me are inherently unadventuresome—the studio is where it's at.

My love affair with Mexico rages unabated and *Casitas* is just one result of that affair. On one particular trip through the primitive "interior," we stopped in tiny Dolores, where I made two or three thumbnail sketches followed by a couple of amateurish Instamatic snapshots. I'd never seen more marvelous, dazzling color: even Dolores's myriad, endlessly varied grays sang out in a hundred clamorous hues. The two-dimensional surfaces of the structures were interesting too: they seemed more like a facade or backdrop for a Carmen opera than a poor little segment of a remote tropical

Top: *Casitas*, 1972, mixed media, 27 x 37. Private collection. Although Maxwell uses snapshots—notice the photo below, which was used for this painting—the process of a Maxwell painting is not preplanned. For instance, the variety of unusual surface tensions at upper right and center were created by the reaction between casein and acrylic matte medium, a mixture the artist used to paint over a watercolor-ink underpainting.

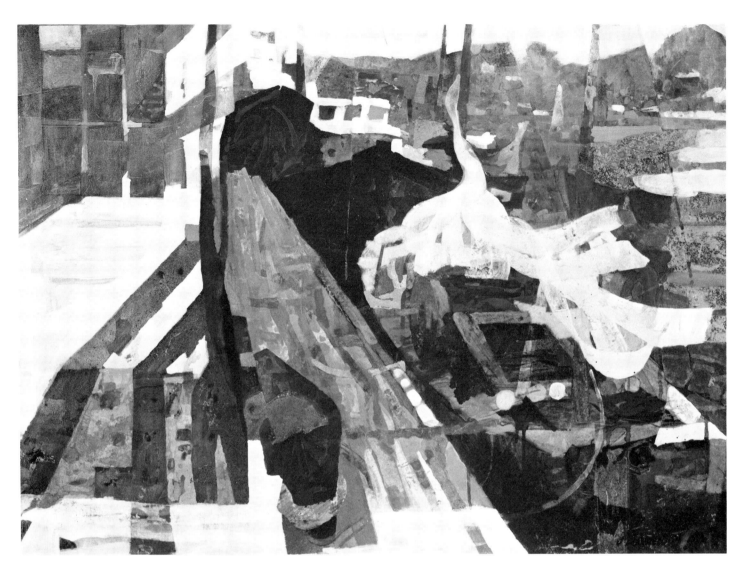

Above: *Maine Morning*, water-color, 27 x 38. Collection the artist. If you look closely, left of center, you can see where the torn paper dissects the dark boat.

Right: *Month of May*, watercolor and acrylic, 20 x 31. Courtesy Piccolo Mondo Gallery.

Opposite page: *Home Town Still Life*, mixed media, 18 x 24. Collection Mrs. Alva Ramsdell. Maxwell began drawing with oil pastels, knowing that the gouache washes painted over it would be repelled, and create an interesting effect.

world in the interior of Mexico.

If you depend on photographs, there is one caution that never seems to be mentioned. It is that even the most striking photographs rarely convey the scope of outdoor space—the breadth and depth of nature. It's easy to demonstrate this. Visit a site you admire: compose and shoot the best picture you know how; then return to the scene with it. You will probably have a useful color, value, and detail record—but your photograph will utterly fail to convey the magnitude of space that's right there before you. Personally, I prefer to rely on sketches, notes, and impressions whenever possible. But I always make a point of taking a couple of routine snapshots while on the scene, as I find these do buttress my memory back at the studio. They were especially valuable on this trip, because when we arrived back in Mexico City, the Dolores sketches were mysteriously missing and still are. *Viva la Instamatic!*

In using the little Dolores snapshots as reference for the painting *Casitas*, design and some key drawing were penciled lightly on heavy, rough-surface Whatman board I'd been hoarding. I next underpainted with colored inks, adding a little matte medium so I wouldn't smear them with subsequent overpainting. The major part of the work was then painted almost to completion in casein. Knowing that I might eventually wish to apply a few paper areas, I took the precaution of adding a bit of medium to my casein as I worked. This of course was to avoid dissolving the casein later. (Since I was working on a board and not Masonite, to keep from warping it I limited the number and size of my applied areas.) Right then, as I painted with my casein-matte medium preparation, a completely unexpected and pleasing side effect appeared. Apparently, the reaction between paint and medium brought forth a kind of crazed and interesting variety of surface tensions—and all quite by accident! At the very end I did apply a few paper sections I'd prepared, using these same caseins with the usual matte medium for adhesion.

I do not have a favorite medium. Watercolors, acrylics, oils, all continue equally to hold my enthusiasm. In my view, whatever your medium, if you think your work has merit, if you think it just might be passed along for others to enjoy, you should never be careless about materials or procedures. Whether a traditional or experimental worker, use the best tried and proven materials, but use them properly.

Robert Moesle

CHARENTILLY IS A SMALL, picturesque village in the Loire Valley, France, where I have lived with my wife and two children for several years. Our old farmhouse dates back to the 15th century and is an ideal location for a watercolorist. In contrast to my

BIOGRAPHY

Robert Moesle was born in San Jose, California, in 1932. After graduating from San Jose State College, he studied at the Ruskin School of Art, Oxford University, England. For the last several years Moesle has been painting the château area of France where he now lives; he considers the outdoors his studio.

Moesle has participated regularly in group shows in the western United States and Paris. He received second prize at the Monterey Arts and Crafts Show, 1966; first prize, 1967.

Since 1959 Moesle has held numerous one-man shows in London, Paris, and throughout the U.S., including over 20 in California. In the U.S. his yearly one-man show is at the Perry House Gallery in Monterey, California.

His paintings are in private collections throughout the world.

native California, where almost all the subject matter has been slowly bulldozed away in the last 20 years, modernization, with its cement and plastic, is coming to the French countryside much more slowly. The variety of interesting old farmhouses, barns, castles, manor houses, villages, and churches is unending, and I've used our own farmhouse and barn for scores of paintings.

Usually I paint outside. I carry a canvas "drag bag" that holds my drawing board, the illustration board I paint on, my tubes of paint, brushes, fold-up chair, and miscellaneous material. For the first few years my subject matter was within walking distance. My way to a neighboring farm for fresh milk or to a friend's farm across the road for freshly laid eggs brought many beckoning subjects into view: old stone buildings, weathered fences, trees, and grass.

Since the four seasons are quite different, the same subject matter changes in appearance throughout the year. Snow usually comes several times each winter, and it is a most exciting time. I paint from the interior of my Volkswagen bus during the very cold weather. And if it is too cold, I paint the inside of our house, such as our old stone fireplace.

Usually I begin with a detailed pencil drawing directly on the illustration board. I don't use sketches unless the weather changes too quickly or time is limited. Next I wash in the sky with a large 2½ inch bristle brush, and, working from light to dark, I cover the large areas until most of the white of the board has gone. For this—and the detail work too—I use pointed sable and chisel brushes Nos. 12, 6, 5, and 3. Then, working out from around the center, I adjust colors and values, going darker and richer with the color. Most of the time I work on a dry surface. To correct colors that do not seem right, I either sponge up a bit or go over the color with more watercolor paint mixed with white gouache.

Contrary to many watercolorists who take "the frantic watercolor approach," I take my time. Weather permitting, I absorb myself in the subject —which usually has been there for a very long time

Polperro, 1973, watercolor on board, 18 x 24. Courtesy Mr. and Mrs. Harry Deutschbein. Moesle used a more rapid approach than usual to capture the harbor at low tide; for example, he completed only one of the three boats, lower left, planning to use it as a model for the other two if the light changed. It did.

—trying to capture the feeling of durability and the solidity of a certain reality. I am excited, but relaxed and uninhibited, as I can—if necessary—redraw into the watercolor with ink, add more gouache, sponge or scrape out with a razor blade. In other words, I keep working until it is either right or finally beyond repair, and in that case I throw it away. However, the board has a strong mat surface that permits quite a bit of reworking.

My palette consists mostly of burnt umber, burnt sienna, raw sienna, yellow ochre, Naples yellow, olive green, Hooker's green dark, Davy's gray, Payne's gray, and sometimes some Prussian, cobalt and cerulean blues, cadmium and chrome yellow, and cadmium red.

When I return to my studio, I put a trial mat over the watercolor, set it in a frame, and then check how it looks from various distances. Little details that are not quite right show up at this time. Then I take the paintings out of the frame and rework the needed area. I repeat this until I am satisfied. For a

final check I hang the watercolor in the house for a few days to live with it.

My wife and I love to travel and camp, and we have visited a good part of Europe. It was during a visit to England that I painted the watercolor reproduced here in color. It is the harbor of Polperro in Cornwall, a picturesque and romantic fishing village with quaint old cottages perched on the sides of a narrow gorge, one of the most delightful spots in Cornwall. It was most pleasant to revisit this harbor, for I recalled earlier trips to Cornwall while studying at the Ruskin School of Art at Oxford University.

I tried to capture the charm of the harbor at low tide. I sketched in the details with pencil, then started painting in a flat manner. The effect of the reflection in the foreground attracted me most. I washed in a very clear color, leaving some of the white to show through. Then, in order to tone down the background, I washed over the houses with Naples yellow and Davy's gray, and a wash of olive

Above: *Chateau Chissay*, 24 x 30. Collection Mrs. Mary Lee Shephard. After absorbing himself in the special reality of his subject, Moesle begins a detailed pencil drawing directly on his painting surface.

Right: *Azay-le-Rideau*, 30 x 24. Collection Mr. and Mrs. Cecil Murphree. Moesle used strong shadow areas to delineate the intricate shapes of the facade and unite the shapes of the Chateau with its reflection.

Opposite page: *St. Pierre de Cheville*, 22 x 28. Collection Mr. and Mrs. Berk Summers. Winter suggests a more abstract treatment of this village. The artist contrasts the simple geometric shapes of the buildings with the linear tracery of the trees.

green for the hill. I concentrated on the center boat, painting it with the reflection and shadow underneath. From there I moved across to the left and worked on the second boat. Since the other two were similar, I could work on them later, using the first as a model if the light changed too much or the tide started coming in before I finished. This type of subject matter needs a more rapid approach than the stationary buildings I usually paint.

Now, working across to the right, I painted the smaller boats, reflections, and shadows in the shallow water. Working forward and then back up the small stream, I then went to the other boats. The dark areas at the side of the harbor are a mixture of burnt umber, Payne's gray, and Prussian blue. When the light changed and the tide came in, I painted the two larger boats, using the third as a model. Then I had to stop for that first day.

The next day, at the same time, I started painting the houses around the harbor, using Payne's gray, Davy's gray, yellow ochre, and Naples yellow. Then, using olive green and raw sienna fresh from the tubes onto my surgical tray palette, I mixed them together and applied the paint in a rather thick manner, which gave a good textural effect. Putting in a few finishing touches, I left it. Later, at the studio, I put the watercolor in a trial mat and frame. After looking at it, I decided to take out a house on the hill that bothered me. I sponged up most of the house color and pencil line, and then, when it was dry, I painted the same green color over the area, blending it in with the hillside. A few more minor adjustments, and I decided it was finished.

Marc Moon

BIOGRAPHY

Marc Moon was born in Middletown, Ohio, in 1923. He attended the Applied Art Academy in Akron and later Moon became an instructor and, subsequently, the owner of the Academy. In 1960 he decided to become a full-time artist.

He has won over 50 national and regional awards and is a member of the American Watercolor Society, Salmagundi Club, Hudson Valley Artists, and The Society for Painters in Casein. His works are represented in numerous public as well as private collections.

Moon lives in Northampton Township, Ohio, where he also maintains his studio and gallery. Each March he conducts a watercolor workshop at the Hilton Leech Art School in Sarasota, Florida.

He is represented by the following galleries: Imperial Gallery, Virginia Beach, Virginia; Center Street Gallery, Winter Park, Florida; Grand Central Gallery, New York City; Four Winds Gallery, Kalamazoo, Michigan; and Trailside Gallery, Jackson Hole, Wyoming.

MY LIFE AS AN ARTIST has precluded many usual considerations that other people face daily. I don't write letters. (My wife does it for me.) I don't keep the books. (She does that too.) I even try not to get involved in selling my paintings. It's a great life style, and I feel I'm very fortunate to be in this position.

Mine is a very abstract, undisciplined life that shifts and flows as I respond to situations and people. I make no plans, because plans are restrictive and binding, and I'm at my best when confronted with a situation I can react to immediately and emotionally as I feel at that particular time, rather than with a preconceived commitment.

So far I haven't said a thing about the way I paint, and yet I feel that I've said everything about the way I paint: you are what you paint. In other words, my approach to painting is the same as my approach to life: I don't keep any schedule, and I can't measure in terms of hours what is required to paint successfully. I work spontaneously and can maintain a high key of excitement on a subject for two or three hours. Beyond that I'm wasting my time.

It is difficult to determine whether my philosophy of life is a result of my painting or if my painting is a result of my philosophy. *The Dirt Farmer* is a result of a trip my wife and I took several years ago near Roanoke, Virginia. One dreary, rainy day, we were traveling on a little dirt road in the mountains when we came upon a log cabin, which I stopped to photograph. On the porch of the cabin was a man named Joe, holding a blue fly swatter and surrounded by buckets that had been placed to catch rain water; he was watching cars go by, his usual pastime—which wasn't much of a pastime, because on a good day he wouldn't see more than three.

After meeting Joe I forgot about photographing the cabin. I was drawn to him; I have never met anyone who affected me so much. It's hard to describe what I saw in his face; it seemed to mirror the whole world. I hope my painting tells it all.

I took some Polaroid shots and gave them to him; he was excited to see colored pictures of himself

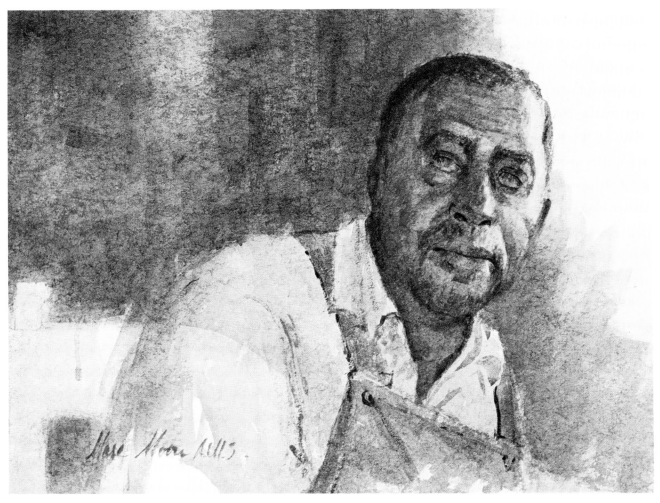

The Dirt Farmer, 1974, watercolor, 22 x 30. Moon prefers to maintain a loose, direct, sketchy quality when doing a character study. However, in this case he felt his concept called for a careful, studied drawing and deliberate plane development.

come right out of the camera. My wife tried to get his last name and address so that we could send him a photo of my painting, if it was successful, but he wasn't completely sure of his last name or his postal address.

This painting was so special to me that it took two years of thought before I had the courage to tackle it. I had painted several studies of Joe that turned out well, but I felt that this painting would require special effort. Although I said earlier that I painted directly and rapidly, in this case I felt I would have to change my approach in order to achieve what I wanted.

When I do a character study I try to maintain a loose, direct, sketchy quality. With Joe I felt a need for a careful, studied drawing and very deliberate plane development.

Knowing that I would build the planes through a series of washes, I decided to paint with polymer medium mixed into my water along with my usual Winsor & Newton tube watercolors. The purpose of the polymer medium, of course, was to waterproof each preceding wash so that it would not lift off or bleed into subsequent washes.

I used Strathmore's Aquarius paper in this case, and it worked well. I have found Aquarius very re-

sponsive for many of my paintings, but not for all of them.

To avoid pickiness, which will generally ruin an otherwise good painting, I always force myself to use the largest brush possible for a particular passage. The brushes that I rely on the most are a 2 inch, flat, badger hair, sign painter's brush and my pointed red sables: Nos. 12, 10, 8, and 6. However, for my acrylic painting I also use oil painters' bristle brushes, since my acrylics are done on Masonite or Upson board that has been given a brush texture of thinned down modeling paste.

Once the texture has been applied, I scumble on a warm or cool tone, depending on what will be the painting's predominant color. Then, using a No. 4 bristle brush, I design the shapes: I rub on a tone of the darks that will let me visualize the tonal mass. Satisfied with this, I develop the lights and finish this stage with any details that are necessary. At this point I will begin to use a pointed sable for the first time.

As I mentioned before, the method I used to paint *The Dirt Farmer* was unique. Usually my watercolors are painted in a single two or three hour session. The work is placed upright on a portable French easel (which I also use on locations). I am

Outer Banks, 1973, acrylic on Masonite, 24 x 32. Private collection. When Moon works with acrylics, he prepares an initial ground of thinned-down modeling paste, which gives the work an overall planar texture.

All That's Left, 1971, acrylic on Masonite, 32 x 48. Collection Taylor Library, Cuyahoga Falls, Ohio. After scumbling on an overall tone, Moon blocks in the darks, then works positive to negative, designing with mass.

Yellowstone, 1974, acrylic on Masonite, 32 x 48. Moon draws inspiration from his immediate, emotional response when confronted with a situation. Here he develops a feeling of vastness by his broad treatment using the largest brush possible for painting a given passage.

mobile and not tied to the painting: much of my "painting" time is spent at the other end of my studio, making decisions on tone, shape, and color.

My studio has well-balanced artificial light, and I often use 35 mm. transparencies taken on trips around the country as my reference. There is a trap here for many student artists. Generally they are prone to be too literal when working with slides. However, this pitfall can be avoided by making value sketches and painting from them, rather than the slides. These sketches are nothing more than small 3 x 4 inch statements of tone, shape, position, and size. Later, this information is drawn in lightly on a good watercolor paper with a number 2H pencil. (I still love to paint on location but do not often get the opportunity.) The drawing is never so complete, however, that I feel bound by it. As the painting develops with masses of tone, rather than line, I make much better judgments concerning the design, so I just go with it and enjoy it.

There is no set procedure to my paintings. I feel each subject has its own problems and often requires a new approach, rather than an established procedure. My first decision is whether it will be more effective in watercolor or acrylics. I use both and find it refreshing to change back and forth. My technique for using transparent watercolor is so different from the scumble that I use for acrylics that, by using both, I seldom become bored with painting.

Although I have no hard, fast rule as to where to start a watercolor, I often start with the sky when it's an important part of the painting; at other times I may start with a focal point.

This size of a watercolor will dictate the weight of the paper I choose: 300 lb. cold press for paintings larger than a half sheet, 140 lb. paper for smaller studies. I prefer a hot press surface when I want effects that cannot be achieved on the rougher paper.

I use a "thirsty" brush to lift off or a palette knife to squeeze out color from an unwanted area. I very seldom use a masking compound.

I have two plastic John Pike palettes: one for watercolor and one for acrylics. The cover on these palettes will even keep acrylics moist for days, if you put a wet sponge under the cover when you're not painting.

I use the best pigments, brushes, and paper that I can get. I don't believe in sacrificing a good painting by using inferior materials.

The pigments I generally depend on for both watercolor and acrylic are cobalt blue, French ultramarine, raw sienna, burnt sienna, raw umber, burnt umber, cadmium red, cadmium orange, Payne's gray, and green oxide. However, I use whatever pigments necessary to show others what I see. If their appreciation of my work matches my appreciation of what I see, then I have succeeded—both with my paintings and my philosophy.

John Pellew

BIOGRAPHY

John C. Pellew was born in Cornwall, England, where he received his art training. Since 1934, Pellew's paintings—in oil, acrylic, and watercolor—have appeared in major art exhibits.

His awards include the Allied Artists Gold Medal for Watercolor, 1951; Gold Medal for Watercolor, Hudson Valley Annual, 1954; Marine Painting Award, Connecticut Watercolor Society, 1958; the Adolph and Clara Orbig Award and the Henry W. Ranger Purchase Award, National Academy, New York, 1961; the Butler Award, American Watercolor Society, New York, 1964; the Syndicate Magazine Gold Medal, Allied Artists of America, 1967; the Silver Award, American Watercolor Society, 1970.

At the present time, Pellew instructs numerous painting workshops along the New England Coast. He is a member of National Academy of Design, Allied Artists of America, American Watercolor Society, and Salmagundi Club. Pellew is also the author of three books published by Watson-Guptill.

I HAVE USED ACRYLIC in the transparent technique for several years, both in my studio and on location. Acrylics have certain advantages over the regular watercolor paints, the greatest being that the painter is able to superimpose one wash over another without disturbing the underwash. This trait is invaluable to any painter interested in clean, non-muddy color tones.

My palette for acrylics—roughly the same for watercolor—includes Hansa yellow, yellow ochre, raw sienna, Thalo blue, burnt umber, and titanium white. That's nine colors, if you include the white. As I always work as simply and directly as possible, I seldom use all nine. The white I sometimes use for a few final lights when painting outdoors, where speed is essential and there's no time for careful rendering. I have no prepared greens on my palette. I prefer to mix them as I work. Raw sienna, yellow ochre, Hansa yellow, and even burnt sienna in mixtures with blue give me a variety of greens.

I use oxhair brushes for painting with acrylics. It's not that I prefer them over sables, but they are cheaper, and in my student days—when I had to make every penny count—I learned to use oxhair brushes. Even today nothing could make me put a good sable brush into acrylic. I do use some old, well worn sables, but even these I wash in warm, soapy water as soon as I've finished painting. Flat nylon housepaint brushes in the smaller sizes are also useful—and cheap. I get along with a 1 inch flat oxhair, a ½ inch nylon housepaint brush, a No. 9 round oxhair, and a couple of old, almost worn out round sables that can no longer come to anything even faintly resembling a point. For fine lines, however, I do have a small round sable, a No. 1. For outdoor sketches I use paper in small sizes: quarter and even eighth sheets. Despite their small size, I've developed many full-sheet and even larger paintings from these sketches.

My favorite paper is 300 lb. cold-pressed, but, with its price going higher and higher, I'm using more 140 lb. paper these days. For my small outdoor sketches it seems to work quite well. The makes I use are RWS (Royal Watercolor Society),

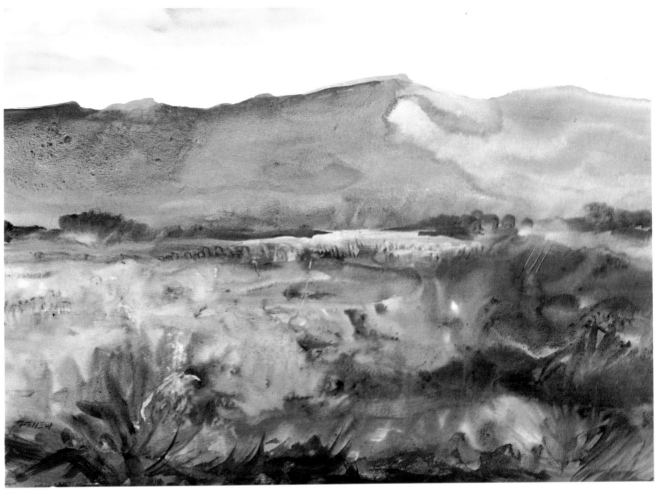

North of Phoenix, 1973, acrylic on illustration board, 14 x 20. Developed from a quick before-breakfast sketch. The foreground colors were painted onto paper pre-wet with clean water and allowed to blend. The sky was the last element painted.

Capri, and d'Arches. Another surface on which I get interesting results with acrylics is illustration board. It's much smoother than the usual watercolor paper and because it's so smooth and the surface hard, liftouts are easy. A damp rag, or sponge or a squeezed-out brush and clean water is all you need. I've used this board a lot in recent years. I find I can easily obtain certain textured qualities on it that would be much more difficult on the regular rough surface watercolor paper—for instance, light areas scratched into wet washes with knife, brush, handle, or fingernail.

The last is the one I favor most, because the finger is more flexible than any tool held in the hand. It's a direct contact between artist and picture. Anyway, I feel that the overuse of tools other than brushes when painting a watercolor leads to trickery.

When working indoors in winter, I use the studio gas stove as a dryer by simply holding the painting over it for awhile. In summer I open the door and lay it on the grass in the sun.

My procedure when working on location isn't very complicated. Experience has taught me to travel light, so I carry as little as I can get by with. My paint tubes, brushes, folding palette, stool, water container (army canteen), and the bottom half

of a plastic detergent bottle for a water bowl all go into a small knapsack with a shoulder strap. The plywood board and paper are carried in a canvas envelope under my arm, and that's it: simple and sensible.

If my subject is straight landscape, and by that I mean there are no complex shapes such as boats or buildings, I simply indicate my composition with a few lines that place the big main shapes within the four borders of my space. When working in watercolor, I most always start with the sky, let it dry and then go ahead with the landscape: first painting the distance, then working toward the foreground—from light to dark—with the darkest darks the final step. However, with acrylics I find I can leave the sky until last, because there's no danger of the background area bleeding up into the sky when I overlap layers of paint at the horizon. The part of the landscape having dried, my sky wash won't disturb it.

When working outdoors I paint directly on the dry paper; that is to say, I don't soak my paper. I may run a wash of clean water over an area such as the sky in order to create soft edges or to blend one tone into another, but I'm not one of the paper-dunking fraternity. I believe a watercolor should be executed with a series of consecutive steps, not ac-

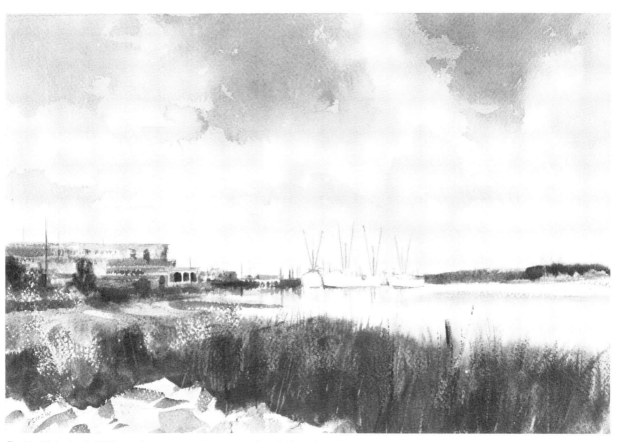

Florida Waterfront, 1972, acrylic on watercolor paper, 12 x 18. Here the artist permits the rough surface of his watercolor paper to show through, adding texture variation to cloud formations and the waterfront area.

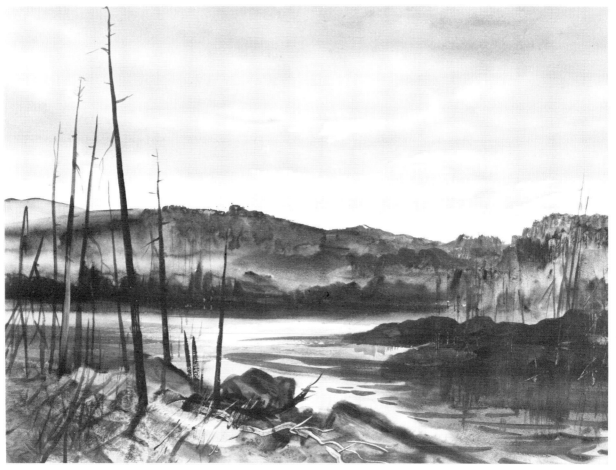

The Barens, 13 x 18. 1973, acrylic on illustration board. The artist painted this work in his studio from memories of a burned-over area he saw in Canada—the result of a forest fire. Notice the fluid cloud formations.

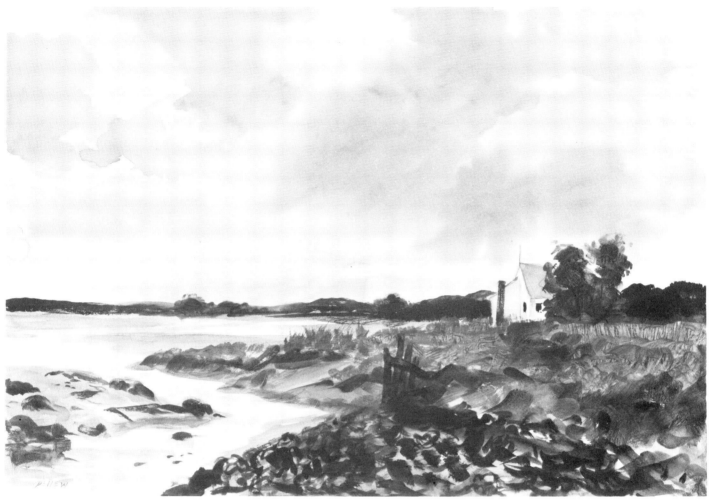

Down East, 1973, acrylic on illustration board, 15 x 22. Pellew worked this from top to bottom starting with the sky and finishing with the rocky foreground. It was an outdoor class demonstration, time 45 minutes.

cidents, each step taken at the proper time. In the studio I sometimes, not often, indulge in a bit of wet paper painting, but I don't think it has any place in trying to capture an impression from nature.

I'm a fast worker. I complete half sheets, outdoors or in the studio, in 45 minutes, and eighth sheets in half that time. When I paint a full sheet in the studio, I complete it in one sitting, seldom working longer than two hours.

The picture reproduced here in color was rapidly painted with a good deal of wet-into-wet treatment. The entire mountain range was first painted with a wash of cadmium red light. When this reached the stage of dampness, but was not flowing wet, a wash of manganese blue was painted over it. A part of the first red wash not covered by the blue can be seen at the upper right. The next step was the darker, more intense blue (manganese) accent on the upper left top of the mountain, seen against the sky, which as yet had not been touched. There was no attempt to obtain perfect superimposed washes on the mountains. I was quite willing to accept the accidents that occurred, creating a variety of tones suggesting the rugged surface of the mountain range. My aim was to keep this part of the picture

simple but at the same time to create the illusion of the mountain's solidity and majesty.

Up to this point I had used only one brush, a No. 9 round oxhair. The desert floor, from the base of the mountains to the foreground, was painted next. All of this area was handled very wet-in-wet. Using a 1 inch flat oxhair brush, I painted the entire space with a pale wash of Hansa yellow. Switching back to my round No. 9, I rapidly painted the other colors into the very wet yellow wash: yellow ochre, raw sienna, cadmium red light, burnt sienna, and a few touches of manganese blue to flow into and mix with the warmer colors to create tones suggesting sunburned desert greens. A few crisp touches, when the above had dried, completed this part of the picture.

The final step was the sky. First the area was wet with clear water that overlapped the mountain tops; then I brushed in the blue at the left and blended it off into the wet paper on the right. The two large brushes mentioned were the only brushes used in painting this picture.

Both outdoors and in I place a trial mat on my painting from time to time as I work. I think this is a good thing to do. It can tell you when to stop, and that's important.

Bruce Pierce

Up a Gothic Stair, 15 x 16½. The timeworn steps of a simple staircase that leads to a belltower provided good material for Pierce.

FOR ME GOTHIC EUROPE was listening to my mother read about the knights of old from a Scribner's book for children. As a child, coming from a small town in Maine, I was very attracted to the High Middle Ages; it was a time when man first started to look up. The Gothic artisans used the full potential of architecture, driving their art and the stone to incredible limits. One is struck instantly by the tremendous surge upward: tall steeples, not unlike proud 11th century fingers. Cities were being established, pulling farmers to a new urban life. Universities formed; tough feudal princes began to lose their hold. A new kind of prince stood on the horizon — the merchant — and with him came money and the finest talent, which was directed toward the building of the cathedral. The cathedral was to be the center and showpiece of town.

An American has certain disadvantages when viewing the Gothic cathedral for the first time. It is fast and easy to fly 7000 miles, but the Gothic influence has been in Europe for seven centuries. The use of design and counter-design at first looks abstract. Centuries of symbols are hidden in the geometric forms. The first problem was to find the transcendental spirit of the form, the visual how and why. For instance, the rose window in the watercolor *Winter Rose* (reproduced here in color) is framed by the symbolic wheel of fortune; Mark, Luke, and John are represented as a lion, ox, and eagle. It must be remembered that the people of the Middle Ages believed in dragons.

The second problem was to edit and simplify the forms. What to leave out is as important as what to put in. I don't wish to pretend that I could ever fully understand the Gothic spirit. But I did have to resolve the visual problem. It's easy, once out of your own element, to get lost and have your painting turn to scribbles and mud. And I had seven centuries to catch up with! To help me understand the Gothic, I turned to tight pencil drawings, sometimes going so far as using a straightedge, drawing

Winter Rose, 20 x 20. To Pierce, the grand rose window of the Strassburg Cathedral posed a challenge because of the subtle distorted values of winter light playing on the symbolic Gothic forms.

BIOGRAPHY

Bruce Pierce has been painting the landscapes of California, where he lives, for many years. He considers the West Coast his studio. He received his degree from the Art Center School of Design. He has participated in several group shows, including Watercolor West, California Expo, and annuals of the American Watercolor Society and the California Watercolor Society. He received first prizes at the S.A.C.A. Exhibition I (1970) and at the Marina Del Rey Art Association (1971), and a purchase award at the California National Orange Show (1972). He has had several one-man shows on the West Coast.

stone for stone. This was against my watercolor nature, but it forced me to see and concentrate visually. Also, I was able to gain a better understanding of the Gothic by some side benefits: listening to the north wind slip through the buttresses, watching pigeons making a nest in part of a grand rose window.

I didn't hunt down the classic Gothic forms; they can be found in most books. Instead, and for more personal reasons, I chose Gothic cathedrals at random. The weather, busy intersections, or tourists dictated where I was to set up my portable studio.

The most impressive cathedral of the Rhineland was the Dom or Cathedral of Cologne, begun in 1248 and now looming up in Payne's gray stone in the heart of town. Once inside, it was as though I were walking into a huge man-made stone mountain. That's why I could think of no other title for my cathedral than *Reflections of a Gothic God*.

I paint on Strathmore No. 112 rough watercolor board. I find the reflective white surface works for my watercolor glazing technique. It's good when traveling; its strength makes a good portable table, no warping occurs, and it can be mailed quite easily. I usually start with a medium value wash in the general color theme I intend to use. (The most rewarding advantage of watercolor is the happy accidents that all watercolorists delight in, watching puddles or washes give out that accidental surprise, just by tipping the board!) If texture is needed, such as grain in stone, I use sandpaper or a palette knife while the wash is still semi-wet. I never use white paint, more out of tradition than practicability. If white or a high key is needed, I dig, scratch,

sponge, and sometimes mask away the color.

After finishing a tight line drawing, I start with color. It is not my sole intention to copy, although I do favor realism. I'm looking for a general image, which is why I concentrate on pattern for an overall grand design. It is the total visual that concerns me. I try to leave detail out. I begin with a wash in what some call the "English Gentleman's" style. I don't like the term, but it means transparent watercolor. I prefer to call this procedure "glazing washes," an expression borrowed from oil painting. This building up, or glazing, reflects the hue, tint, and shade that I can't get with color straight from the tube.

My palette is all transparent, but I sway toward the earth colors, terre verte, siennas, ochres, Davy's gray, Indian red, French ultramarine, and carmine. Bright, shiny colors wear thin, so I mute my brights, even if it means a slight distortion of color. Watercolor has an extraordinary persuasiveness if the rules of freshness, spontaneity, and simplicity are followed. I favor two brushes: a 1½ inch red sable flat (which gives me broad washes and, also, with just the tip, lets me reproduce thin lines) and a No. 7 Japanese oxhair brush (which stops me from becoming too involved in detail).

Since painting the Gothics, I have found that the most important thing is to bring out the individual dignity inherent in all things, whether I am painting a seven century old cathedral, a tree, or a one bedroom ranch house in Riverside, California. This is the challenge I set up for myself, and this is why art can never be dull. I have never forgotten those bedtime stories.

Gothic North, 20 x 20, pencil. A tight line drawing helps the artist gain a better feeling of the complex Gothic form. Over this drawing a wash was applied.

Gothic North: St. Nikolai of Hamburg, 18½ x 22. Once a basic understanding of the form is obtained, Pierce can develop a watercolor, eliminating unnecessary details.

Above: *Reflections of a Gothic God*, 20 x 30. According to Pierce, this cathedral, the Dom of the Rhineland, was the most impressive Gothic structure of all.

Left: *Gothic Window*, 10 x 18. This highly unusual subject, a Gothic Mogan David, is the only Gothic temple still standing of this period and is found in Prague. Some of the warm ochre colored stones come from Jerusalem.

Steve Quiller

BIOGRAPHY

Stephen F. Quiller was born in Osmond, Nebraska, in 1946. At an early age his family moved to Colorado, where he grew up and attended Colorado State University on a four year Creative Fine Arts Scholarship. After graduation he and his wife, Charlene, taught in the secondary schools of Oregon and California. They returned to Colorado during the summer months to start a gallery in the small mountain community of Creede. After four years they moved permanently to Creede, where they continue to operate the gallery and Quiller devotes full-time to painting.

Quiller has exhibited and won awards in numerous regional and national exhibits including National Academy of Design Gallery, 1974 and American Watercolor Society Traveling Exhibit, 1973–74.

He is a member of Watercolor West, Watercolor Society of Alabama, and Southwestern Watercolor Society.

Quiller's work may be seen at the Tom Thumb Gallery in Aspen, Colorado; Morton Galleries in Hutchinson, Kansas; and his own Pen and Quill Gallery in Creede, Colorado.

I HAVE FOUND THAT I WORK best in an environment of relative isolation. My wife and I live in a mining community located high in the Colorado Rockies. The isolation allows me to work without interruption, while the natural beauty of the area—rugged, awesome mountains with bountiful forests, rushing streams, and delicate flowers—offers superb natural stimuli that inspire my imagination.

Generally I have a clear viewpoint and definite concept in mind before I start the actual painting. After the painting is begun, however, I try to be flexible, allowing myself to react with the media and letting the paint modify my original concept.

A couple of times each week I make extensive sketching forays into the wilderness. I consider drawing to be the backbone of my painting, and I work at it continuously. (A hard-bound sketchbook is constantly at my side.) My drawings are of two distinct types: working sketches to be used later as ideas for paintings, and finished drawings in which the drawing is an end in itself.

My basic palette, regardless of media, consists of earth colors, which include burnt umber, burnt sienna, raw umber, raw sienna, yellow ochre, sepia; warms, including alizarin crimson, cadmium yellow light, cadmium orange, cadmium red light; and cools, such as cerulean blue, phthalocyanine blue and green, and Hooker's green.

For each painting I select four or five colors—sometimes only one or two. Limiting my palette permits me to express myself clearly.

I use a variety of round and flat red sable brushes, continually experimenting with different sizes, and numerous other tools with which paint can be applied or removed, such as toothbrushes, knives, razor blades, and paper towels. Although my choice of paper texture varies, I am partial to 300 lb. d'Arches, both cold press and rough, and to smooth No. 240-4 Strathmore illustration board.

My approach to the painting *Snow Shadows*—mixed-media painting combining acrylic, gouache, and casein—is representative of my working process. The idea for the painting came to me on a cold, winter morning while I was walking through a snowy meadow in the mountains. I noticed the

Snow Shadows, 1973, acrylic, gouache, and casein, 29 x 20½. Working transparent to tranlucent to opaque, the artist takes advantage of specific qualities of several media to enhance the illusion of space.

Right: *Flight Theme No. 5*, 1974, watercolor, 21 x 29. Collection Mrs. James T. Daniel. Quiller used wadded tissue to pull out cloud shapes, top.

Opposite page: *Aspen No. 1*, 1974, acrylic, 29 x 21. Collection Mr. and Mrs. Charles Wallick. Theme: a detailed object against a semi-abstract background.

Below: *Back Alley, Creede*, 1973, watercolor, 29 x 21. Collection Marge and Earl Deacon.

snow and frost coating the thistles and weeds and the intricate play of the sunshine and shadows. After a few preliminary sketches, I gathered some thistles and took them to my studio for further observation. In the studio I did some compositional sketches, placing the thistles in various positions to create exciting movement and fluidity. I then did further sketches, working on the value pattern. When my sketches were completed, I laid out my painting materials and began to paint. Wetting the paper completely, I "fused in" the background trees by applying acrylic paint transparently and letting it bleed throughout the surface of the paper. As it became semi-dry, I painted in the dark, blue-green trees with translucent and opaque handling of acrylic. When the surface dried completely, I laid in the snow wet-in-wet, using gouache. After again allowing the paint to dry, I painted the white aspen trees and the positive white areas of the snow with casein. Finally, the weeds and thistles were worked in, using gouache.

As I worked on *Snow Shadows*, I gradually referred less and less to my sketches, allowing the paint and the painted surface to influence the progress of the work. Occasionally I would place strips of mat board around the edges and stand back for an overview. I always stand when painting, to allow my entire body to move with the brush and to give myself the opportunity to move easily in or away from the painting. I can thus keep continual check on details of the shapes, colors, and patterns, their interrelationships, and also on the work as a whole.

Paul Rickert

"IN SHORT, I WANT TO REACH SO FAR that people will say of my work, he feels deeply, he feels tenderly," as Vincent Van Gogh put it. Emotions, moods are hard things to explain. The impetus for creation varies with a synthesis of feelings within: the impressions that are sometimes deeply hidden. Simply and directly stated by Vincent Van Gogh this is a communication to others that reveals a human warmth, a caring. Painting is closely related to life, to caring, to love. Responding to life around me, I try to say something about the things I care about, the things that I am close to. Responding as a creature in God's creation, I try to say something about the beauty, the meaning of life, with the emotions and order that are all God-given.

What I want is to communicate a feeling, something deeper than the surface. Art's beauty lies in the artist's expression, his arrangement. His mood is put into the subject. I guess this is derived by being immersed in nature, a very involved, aware state. I love to be out in the wind, in the cool air, to be sensitive to the sounds and smells as well as visual aspects, to be totally involved in the effect of that moment, to assimilate it all, to express an intimate, very personal response. With this subjective response I try to use my sensibilities in an objective way. By doing this, coupling the subjective side of personality (one's imagination) with the objective side (one's insights), one hopefully develops an evocative power of expression.

When I painted *In Her Sagacity* (reproduced here in color) I wanted a specific quality, my friend's keenness in her perception of life. I had been looking for something—not sure what—to express that attribute. One day while we were resting after viewing an exhibition, I noticed her sitting in this position, and it seemed to click inside (a very exciting time for me). Later I made a quick sketch from memory and analyzed it in my mind for awhile before asking her to pose.

So I begin with an idea, an emotion, and look for an approach, a spark, a glance, a pose: whatever reveals that person's inherent reality more than the surface reality and also solves the problem of designing the idea into a painting, a unit complete within itself. Then I can get into the actual painting process.

I have no specific approach in the painting process. Sometimes I make studies in pencil, sometimes color sketches, because I'm too afraid to get into the paint and mess it all up, or I'm not sure exactly what I want in my mind, and the pencil or color sketch gives me time to think while I get involved.

I spend a great deal of time on the final drawing, placing the subject on the watercolor paper. I make the drawing in pencil, dark enough to see through my washes. As I paint I think in terms of cools and

Expecting, 22⅞ x 16¼. Courtesy FAR Gallery. The light from the right creates a distinctive profile against a subdued background.

In Her Sagacity, 15¼ x 22⅜. Selecting the pose that best characterized the subject was the key problem in this painting. Once this decision was made, the painting went smoothly.

BIOGRAPHY

Paul Rickert is the son of Pennsylvania illustrator William Rickert. Rickert has been exposed to art, painting, and music all his life. His grandfather was an engraver and painter, his grandmother an organist, contralto soloist, and choir director. Rickert has studied with his father and with Nelson Shanks of New Hope, Pennsylvania, and he received his B.F.A. with distinction from the Art Center College of Design in Los Angeles. While in the service he was a combat artist in Vietnam.

Rickert's work has received awards at the Allied Artists (Gold Medal of Honor); American Watercolor Society (Edgar Whitney Award); National Arts Club (Winsor Newton Award), and the Woodmere Art Gallery in Philadelphia.

His work is exhibited at the FAR Gallery in New York and at Sessler's Gallery in Philadelphia. Rickert makes his home in Philadelphia.

Above: *Chestnut Hill*, 17 x 26¾. Collection Mr. Lloyd Wells. Although there is very little drybrush here, the artist has obtained careful details by working into a damp surface.

Right: *Mill Inn*, 22 x 21. Courtesy FAR Gallery. Working on a nearly square format provided a more interesting composition for a familiar scene.

Opposite page: *Burning Off*, 12⅞ x 20½. Courtesy Sessler's Gallery. The artist painted this on a smooth paper, a surface that enables the watercolorist to obtain clean edges and bright distinction of color.

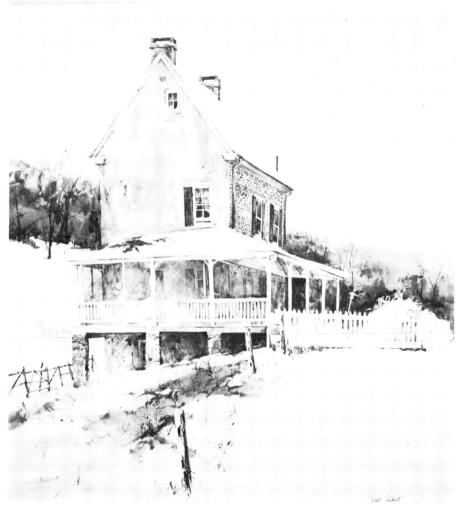

warms simultaneously with value, establishing the area in value first.

As a person who believes in the freedom and importance of the individual, I also believe in the integrity of the subject: the small area of woods I paint, and the people that I know. For example, when I paint a person, my real purpose is not simply to create a portrait, the rendering of a head, but to create a mood, a moment in time, using all the elements in the picture: the person, the pose, the color, etc. In creating the mood, if I leave the source of inspiration—say the person's physical likeness, a look in her eyes, or the way she holds her head—I lose something. The significance of the statement lies within the person. The artist must express the person's uniqueness, the character. It's a very delicate balance. I have this person standing there, alive, a physical entity, and I also have my inner feelings, a subjective appreciation within me, within my imagination, that makes me want to say something about that person.

Hopefully, all this is planned in my mind before, so that my goal is clear and I simply respond to the paint—controlling the washes—and respond to the subject, the changes in expression and light, while I work.

I don't normally complete the painting on location, but try to catch the essence of what I am after first before I continue into the painting. With the figure, this is usually the head. I bring the painting back to the studio and think about it, to see if it is what I want. If it is, I can go back and continue; if it is not, I start over or discard the idea altogether.

I like to handle watercolor in a wet-into-wet technique as I work in different areas, adding paint to damp areas to obtain a variety of edges ranging from soft gradations to nearly hard edges. This is the most exciting part because of the uncertainty of the washes. Later, when the painting is dry, I can come back with more control and make other decisions.

I use a variety of papers from smooth to rough, and only the finest materials. There is something exciting about using a high quality fine-pointed round sable that is very conducive to good painting.

I have been taught that the power of watercolor lies in suggestion and spontaneity. I have taken this further with more control on smooth papers, trying to get behind the immediate excitement into a more contemplative quality, expecially in my figure work. So instead of being light and fresh, my paintings are becoming more ponderous, seemingly more appropriate to another medium. I hope to balance a freshness in watercolors with a medium and approach that lets me get behind the surface.

Morris Rippel

Cliff Dwelling, 22½ x 16. Collection Mr. and Mrs. James Disney. A smooth sheet enables the artist to obtain massive areas of texture with the brush.

BEING A NATIVE of the Southwest, I do not lack subject material. Very frequently I will paint a subject that has been familiar to me since childhood and quite often one that I have studied years previous to the date of the actual painting. I always attempt to convey a sense of familiarity and personal involvement with the subject that I have acquired through lifetime first-hand observations, experiences, and personal contacts with the heritage that is New Mexico. I have no real desire to travel extensively to obtain "new material," realizing that it is all here within my easy grasp.

In the studio I do series of black and white value and compositional pencil studies from a sketch made in the field. These studies are approximately one sixth the finished painting size. I select one for enlargement on the watercolor paper which I accomplish by lightly drawing the basic shape on the paper. The remaining details are finished in the painting process. I do not make preliminary sketches in color either in the field or in the studio because I find myself trying to duplicate the sketch in the painting and completely losing sight of the real "mind-image" that needs full concentration in the final work. Invariably, work from a color study is a failure and must be destroyed. So I work only from pencil studies.

Questa House was painted using procedures which pretty well apply to all my work. I placed the pencil value study directly in front and at the top of my watercolor table for constant reference during the painting session. First I painted the sky, using the wet-in-wet technique, floating in color over the entire upper half of the paper. While this area was still very damp, I laid in the lighter background trees, allowing the color to bleed into the sky, tilt-

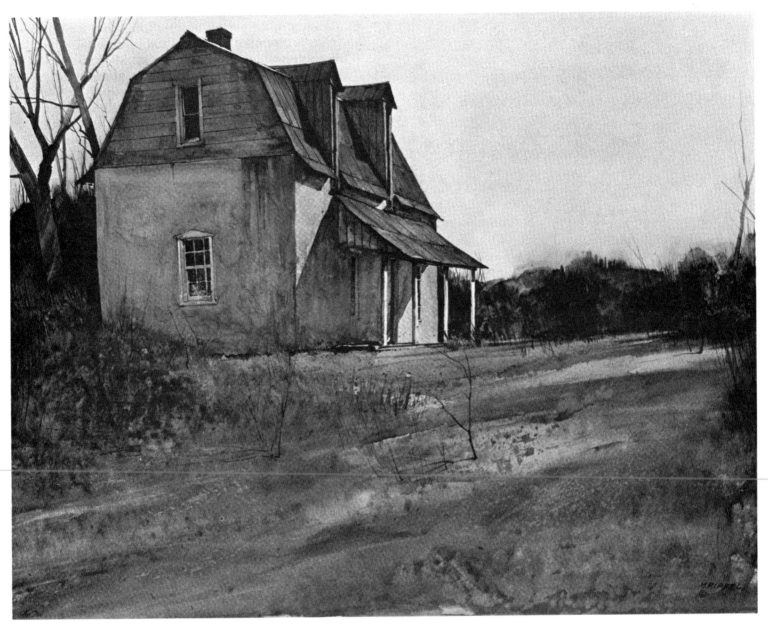

House at Questa, 17½ x 24¼. Courtesy Ettinger's High Plateau Gallery. Referring to a pencil sketch he had made nine years previously, the artist developed this highly controlled watercolor in his studio.

BIOGRAPHY

Morris Rippel was born in Albuquerque, New Mexico in 1930. He has a degree in architecture from the University of New Mexico and practiced in this field as a registered architect until 1967. Since that time he has devoted his full time to painting in watercolor. Other than two drawing courses taken at the University, he is self-taught. He has been represented in the American Watercolor Society Annual Exhibition and shown in the New Mexico Art Museum. He is included in the Diamond Museum collection, the Denver Art Museum, Eiteljorg Collection, Valley National Bank of Phoenix, and has work in several hundred private collections throughout the United States. He is a member of the National Academy of Western Art.

Winter at Trampas, 22¼ x 17. Collection Boettcher and Company. The artist contrasted block-like structures with the fine, delicately rendered fence and brush.

Cordova House, 17¼ x 23½. Courtesy Sandra Wilson Fine Arts Gallery. The artist has treated the foreground area loosely by freely manipulating the paint on the smooth sheet.

ing the board to control its movement. I waited for the sky-background area to dry thoroughly before doing any further work.

The darkest values were next established to bring the building forward. While this area was drying I built the middle ground and foreground over a tonal wash, working both right and left sides simultaneously until the textures and values met the requirements established in the sketch, and then I allowed this to dry.

I indicated the wall, porch, and all other details on dry paper, adding the window and door framing and shadow areas to correspond with the original field sketch. I used an adjustable trial mat as I worked: two L-shaped natural linen covered mats. This helped me determine if the painting related well to its mat and final frame. The painting was completed in one sitting.

My regular palette contains raw umber, raw sienna, burnt sienna, and burnt umber, colors which make up the earth tones that prevail through my work. Cobalt blue, alizarin crimson, cadmium yellow, and lamp black are all used, but sparingly, as my personal means of expression are usually based on the earth and neutral colors that I find less tiring. The occasional use of black is only to add intensity to the darker colors.

My brushes are mostly rounds. I use Nos. 12, 10, and 6, all red sables of shorter hair lengths for the additional spring they afford. I use a 1 inch wide varnish brush for wetting an area for a wash and to cover broad flat areas rapidly with color. A ½ inch flat sable brush is also used occasionally to lift unwanted color and to clean an area for hard edge effects.

I work in the studio at a 24 inch high table which holds my water, paint, butcher tray palette, brushes, and any other tools necessary. With a working surface placed as low as 24 inches I am able to stand during the painting process. By standing I am able to move freely and to get enough distance from my painting to assess values and contrasts as the work progresses. All equipment is placed at my left, since I am a left-handed painter.

I have always worked in a dry technique, concentrating more on detail and absolute control than on a loose wet-in-wet technique. For this method I have found that a 100% cotton rag fiber mounted paper is most suitable. Colors can be lifted from it for corrections with brush and water quite easily without using sponges and scraping, which are so often necessary with rougher and more absorbent papers. I have also found my colors appear much brighter and clearer than on rough or absorbent papers. Using a mounted paper eliminates the necessity for stretching. There is no buckling here, a hazard which occurs from uneven stresses in the paper when it is framed, especially in a humid climate.

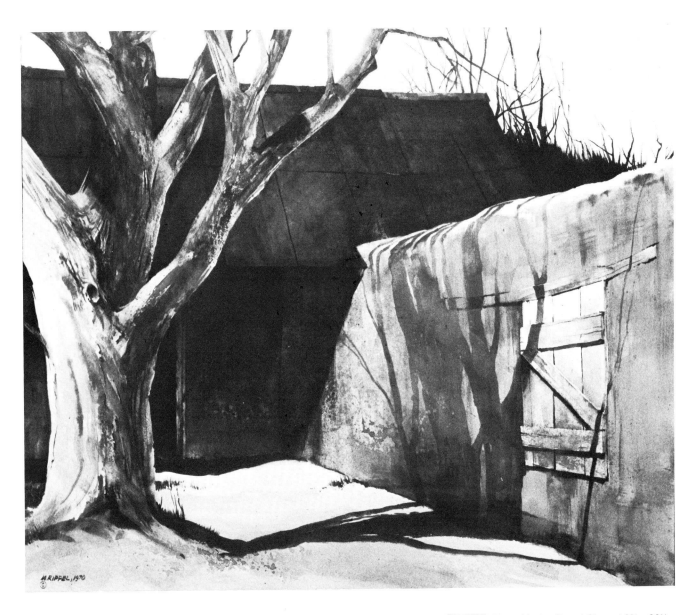

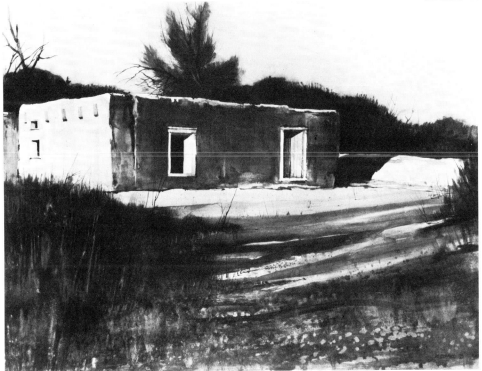

Above: *Swept Clean*, 16⅝ x 20¼.
Collection Mr. and Mrs. Charles S.
Pearce. The strong, clear, South-
western sunlight is a significant
factor in Rippel's watercolors.

Left: *Corrales*, 17¼ x 23½. The art-
ist is particularly intrigued by the
austerity of the landscape in New
Mexico.

Carl Schmalz

BIOGRAPHY

Carl Schmalz was born in 1926 in Ann Arbor, Michigan. He studied at Harvard, where he received his B.A., M.A., and PhD., and is now a professor of fine arts at Amherst College. Having studied water-color with Eliot O'Hara, he continued to teach in the Eliot O'Hara Watercolor School in Maine for several summers. He now conducts his own watercolor workshop in Kennebunkport, Maine. He has had numerous one-man shows in New England and received first prizes for his watercolors at the Cambridge Art Association Annual (1947) and at the Virginia Beach Boardwalk Show (1965). His paintings are in countless collections throughout the United States. In addition to his work as a painter and teacher, he has also written numerous essays, reviews, and exhibition catalogs, and a book entitled *Watercolor Lessons from Eliot O'Hara* (Watson-Guptill).

LIKE MANY AMERICAN WATERCOLORISTS, I am a "semi-pro." I feed my family as an art historian and teacher—work which I thoroughly enjoy — and I paint whenever I can. By happy fortune, my job obliges me to travel. Europe can aptly be described as an art historian's laboratory, and the vagaries of architectural style are of interest everywhere. Consequently, though I do not travel to paint, I travel frequently and paint when I travel.

For me the chief obstacle to overcome in painting beyond my own territory is the lack of that immediate resonance and real understanding that characterizes one's relationship to well-known turf. There is a danger of substituting for it a simple and superficial romantic appreciation of the new and strange. This tends to result in paintings merely picturesque. A wholly open, passive attitude must be cultivated by the serious traveling artist. There is normally not a lot of time to get to know the new land: its essence has to be courted by outer receptivity and inner silence.

For related reasons I like to paint on location, both at home and abroad. So much of an artist's special "feel" for a place is linked to his complete reaction to sounds, the touch of air, rock and weed, fragrances—those containing and defining circumstances of his vision—that on-the-spot painting works best for me. In a new place, I find I must rely especially heavily upon these non-visual responses to help me discover the authentic quality that excites me and that I wish somehow to embody in my painting.

For many years I painted on the standard shape of paper, half or full sheets. I realized, though, that what centrally concerned me occupied only about two thirds of that shape, so I started cutting off a long slice, using sheets about 10½ x 22 inches and 16 x 30. (I also like a relatively wide vertical shape; for example, 17 x 22.)

Though an illusion of appearance is at the heart of my painting, I want a picture to have the marks

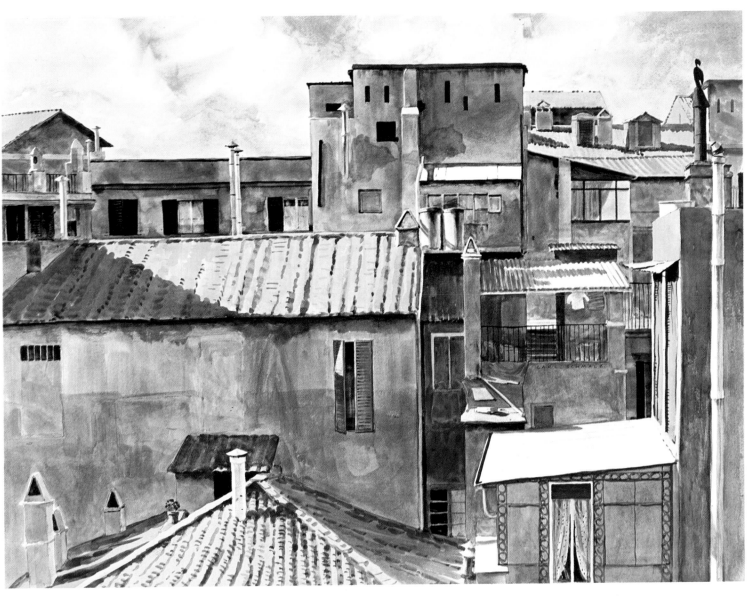

Roman Prospect, 20 x 30. Southern Missouri Trust Purchase Award, Watercolor U.S.A. Courtesy the Southern Missouri Trust Company.

of the maker on it. I do not cultivate the "happy accident" or rely upon the "transparency of the medium." I want a paper that is a record of my engagement with it, as well as an evocation of a time and place. Consequently, I nearly always use a smooth, hard-finished paper (except when demonstrating for students who prefer rough). Almost every brushstroke remains visible on this kind of paper. It has several other advantages as well: brighter, clearer color, and also more subtle tones, very easy wipe-outs, and hospitality to abuse.

My palette is composed quite deliberately of relatively transparent paints, and very opaque ones. I especially like heavy-bodied mixtures, like Venetian red and cerulean blue, in which the brushstroke leaves a prominent track. My main transparent colors are alizarin golden, brilliant orange No. 1, hansa yellow, Thalo green, Thalo blue, accra violet, dioxazime purple, brilliant brown light, and sepia-umber mixture. My most used opaque colors are cadmium vermilion, cadmium yellow medium,

cadmium yellow light (or pale), cerulean blue, cobalt blue, ultramarine blue, Venetian red, burnt sienna, raw sienna, and raw umber. In addition, I sometimes use accra red, alizarin crimson, and various prepared mixtures among the transparents, and black and cadmium orange among the opaques. I never use opaque white in mixtures, and rarely employ it alone. Infrequently, I find a masking product helpful, but my objections to it are akin to those I have to opaque white: the brushstroke is positive, and if the result is a light over dark it is inconsistent with the build-up of brushstrokes elsewhere in the picture. I much prefer to reserve lights, as in the smokestacks in *Roman Prospect,* or to wipe them out.

My brushes are mostly round. I especially like large ones: Nos. 16, 20, and even bigger. Other favorites, though, are ¾ and ½ inch flats. For some purposes, I use bristle brushes, and for others, 2 and 3 inch wide varnish brushes.

When I am painting on-the-spot, I sit with my

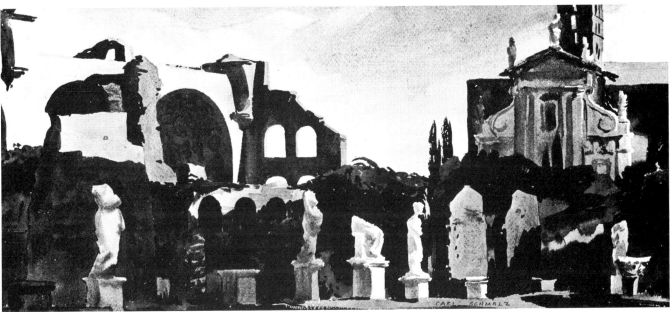

Left above: *Stonehenge*, 10½ x 20. Courtesy Nicholas N. Solovioff.

Left center: *Temple of Apollo, Rome*, 10½ x 20. Note brilliant Italian sunlight.

Left below: *Old City, Rhodes*, 12 x 22. Strong afternoon sunlight casts sharp shadows.

Above: *El Escorial*, 10½ x 20. By painting on a smooth sheet, the artist retains the mark of individual brush strokes.

Top: *Figures in the Forum, Rome*, 10½ x 20. The colors appear brighter on a smooth stock.

paper clipped to an aluminum board on the ground between my legs. I find this gives me free arm movement and control of the cockling of the paper. In the studio, where I do paint occasionally, I like to stand. I do not paint terribly fast, taking an hour and a half, usually, for a small picture. *Roman Prospect* was done over a period of ten days. I painted it from the kitchen window of our apartment in Rome and had to wait for the right light, which only lasted about an hour each day. Overcast days so frustrated me that I painted a half sheet picture of the same subject in overcast light, to fill the time.

Because my way of working requires a relatively dry surface, I do little wet-in-wet painting. My manner also encourages a great deal of careful drawing *with* the brush, as a part of the actual painting. Hence, I do not usually carry my preliminary sketch very far, preferring only to indicate broad shapes and anything—like shadow positions, animals—that might move or change. Especially in winter, I draw in a sketchbook, and sometimes paint from sketches or snapshots. This is less satisfactory, I have found, when the subjects are foreign, because my mental store of references is insufficiently rich.

Georg Shook

BIOGRAPHY

Born in Mississippi in 1932, Georg Shook attended the University of Florida, Ringling Institute in Sarasota, and studied with the late H. Bernard Robinson of Orlando, Florida. Besides several one-man shows, Shook has exhibited in the American Watercolor Society, Watercolor U.S.A., Tennessee Watercolor Society, Central South, and Mid-South Exhibitions. He is the recipient of many awards, including three consecutive purchase awards in Watercolor U.S.A. His paintings were selected to be part of a two-year touring exhibition for the Memphis Sesquicentennial. Georg Shook is a member and co-founder of the Memphis Watercolor Group, Tennessee Watercolor Society, and the Artist's Registry of Memphis. He is past president of the Tennessee Watercolor Society and the Art Directors Club of Memphis. Shook makes his home in Memphis with his wife and son.

SOME REFER TO ME as a regionalist. I would prefer to be known as a realist, in the traditional sense. However, having been born and raised in the South, I naturally have an empathy for this part of the country and its people. I make this point because I believe that how the artist feels about the subject determines the outcome of a painting. The artist must relate to the subject matter, his feelings projected through the finished product.

I select and most enjoy painting those subjects that are vestiges of the rural South. Today's rapidly changing Mid-South brings mixed emotions to its people; the exhilaration and pride are in direct counterpoint to the melancholia of a culture lost to growth. The delta plantations and small hillside farms are sometimes only fading remnants of an ever changing South. I especially enjoy painting scenes that touch the viewer with nostalgia, like half-remembered places or forgotten times.

Watercolor lends itself to this subject matter. Each painting becomes an experience. The dynamic and active medium of watercolor is and always has been my first love. I have worked in other media, such as oil and acrylic, but find watercolor the most flexible. With it I can more easily capture the feeling I have for a subject as I participate actively in its creation. Watercolor can be fluid or tight when required, but it always gives a feeling of spontaneity.

I start with an accurate drawing so that when I begin applying the color it isn't necessary to make substantial changes in the painting. I make several thumbnail sketches before doing the detailed drawing on the board. The compositional problems are worked out in the thumbnails. Because I work very realistically, I want to direct my efforts to the subject rather than to composition.

I sometimes use an overall toner or wash to color key my paintings. This is done by applying a color over the entire area of the board before the painting is begun. This gives an overall color cast to the painting and is most helpful in achieving the late afternoon or early morning one-color glow. I've also

used a toner over a painting after it has been finished, to tie everything together. When this is done, enough toner should be mixed to cover the entire painting. It must be applied carefully in light, single strokes, with the completed painting laid flat, never going over the same area twice.

My mixing palette is a butcher's tray with plastic spray fixative caps epoxied around one side and one end. This provides a sufficiently large working area, and the cap containers allow colors to be kept moist easily. The colors I use are mostly earth colors arranged as follows: lamp black, sepia, Van Dyke brown, burnt umber, raw umber, burnt sienna, raw sienna, yellow ochre, cadmium yellow, cadmium red, cerulean blue, Winsor blue, olive green, and Davy's gray. Olive is the only tube green I use, because it is the only green that does not react like a stain or dye when I have to wash off color. I mix any other green that I need.

For painting outdoors I use the John Pike watercolor easel. I find that this self-contained outdoor easel is one of the finest on the market. I carry the necessary supplies, with the watercolor board clipped on the outside of the box. There's even room inside for a collapsible stool. This unit unfolds to make a very sturdy easel and is adjustable for painting while standing or sitting.

A 30 caliber army surplus ammunition box is my water container. This unbreakable container is completely spillproof, as the top clips tightly into place. Inside the container I folded coarse hardware wire to form a platform about two inches below the water level. This is used to scrub the color from the heels of the brushes and prevents the brushes from slipping to the bottom of the container.

The brushes I use range from a 4 inch wide oriental brush to a No. 3 red sable. I also use hog hair brushes commonly used for oil painting and stencil brushes to achieve certain textures and effects. My 1¾ and 1½ inch sable lettering brushes are invaluable. I also have the usual assortment of round red sables, ranging from No. 12 to No. 3. I razor cut several layers of bristles at the end of the metal ferrules of my older round sables, making a

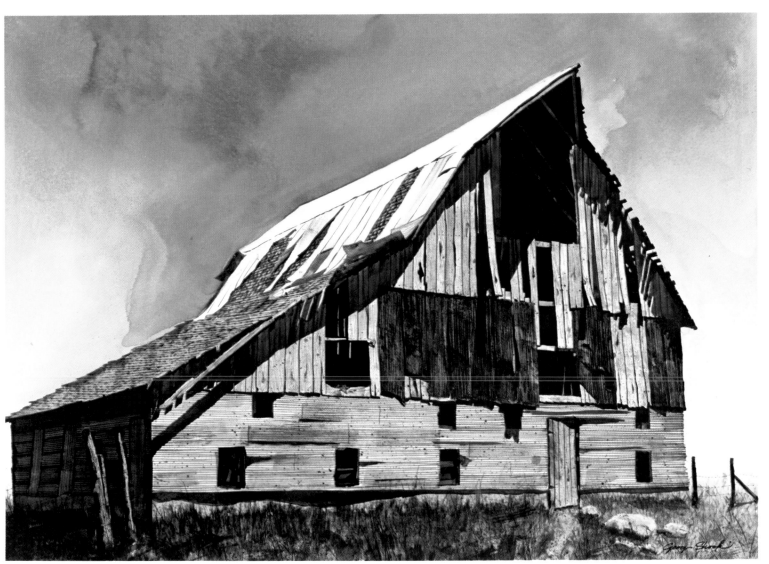

New Tin, 30 x 40. The entire painting was completed with a limited palette on smooth paper. The smooth surface allowed him to create his own texture and the paper's low absorbency allowed him to lift colors from the surface to create highlights. The sky is the only area that is not carefully controlled.

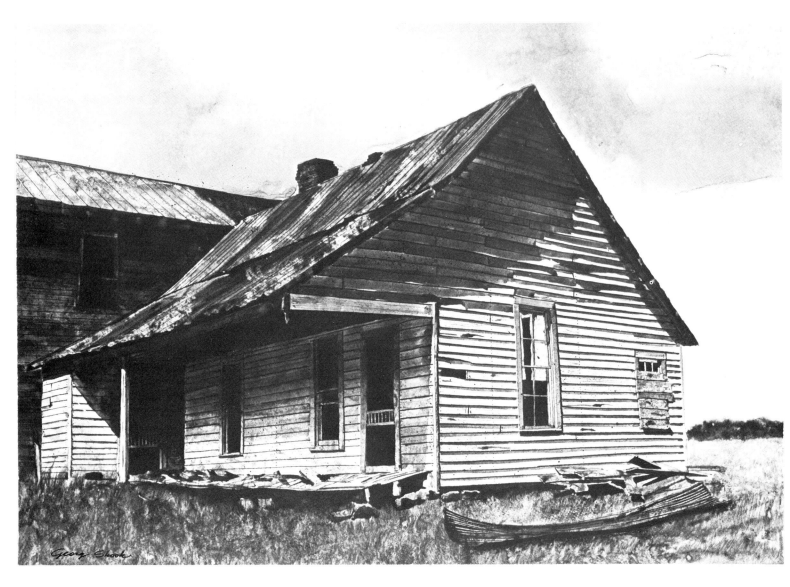

Above: *Part of the Big House*, 30 x 40. The artist is particularly intrigued by the subjects he calls "vestiges of the rural South."

Right: *Reflections of the Birds*, 17 x 25. The artist used the strips of wood to establish a sense of direction and movement in the painting.

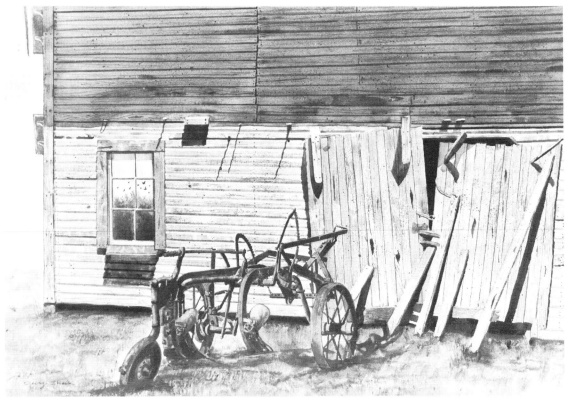

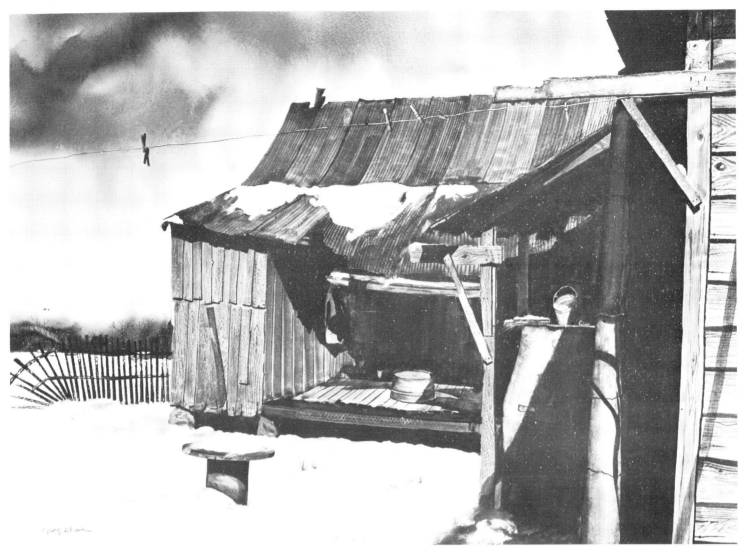

Benjamin's Snow, 30 x 40. Collection Louise Woerner. A strong contrast of light and dark values form a pattern through this watercolor.

long, tapered point which is excellent for detail work. This sometimes salvages a brush that has begun to separate.

The surfaces I prefer to work on are Strathmore's Nos. 115, 114, and 112 watercolor board. I prefer the No. 115 hot pressed, smooth surface board to watercolor paper because I enjoy creating my own textures. Another advantage of this board is that color can be lifted quite easily from the surface where highlights are needed. The No. 114 surface is more color absorbent than the No. 115. The No. 112 is much like a rough watercolor paper and responds to color the same way. I use the No. 115 for landscapes and the Nos. 114 and 112 for portrait work.

For a change of pace I use a multimedia sheet as well. These papers require me to use a different approach and perhaps a different way of thinking, because they demand loose work. They have limited use for watercolor because of their characteristic bleeding. They will not tolerate a crisp, hard-edged painting. Fiberglas particles impregnated into the surface will not accept color. However, they do have a reflective quality that makes this paper ideal for a rainy day or snow scene.

I am equally comfortable doing studio or outdoor painting. However, I do prefer to finish painting in the studio. Returning to the studio enables me to view the painting with a fresh eye and matted with an adjustable trial mat I keep for that purpose. Seeing the painting under artificial lighting conditions helps to determine if proper color value and balance have been obtained while painting in the bright sunlight.

In my travels I always take a camera, as there often isn't enough time to do a rendering. The camera is an invaluable artist's tool. However, one must guard against letting photographs become a crutch. I have used both black and white and color photos as a reference for the preliminary drawing. I would not suggest using slides or color photographs as a color guide, since these colors are usually intensified and not true-to-life color representations.

Watercolor to me is a bridge of communication through which I make my statement about the world around me. I suppose every artist has a goal. Mine is simply to bring one closer to an unappreciated heritage, or to help someone rediscover the familiar, through my paintings.

Morris Shubin

BIOGRAPHY

Morris J. Shubin was born in Mansfield, Washington in 1920 and has lived in Southern California since the age of two. He attended schools in Los Angeles and served in the U.S. Navy during World War II. Shubin is frequently called upon to judge art exhibits and demonstrate watercolor methods. He is an instructor at the Hewitt Painting Workshop.

Shubin has had several one-man shows and has participated in numerous group exhibits throughout the U.S. and Sweden. He has received purchase awards from California National Water Color Society's 48th and 53rd Annuals, Watercolor U.S.A. 1969 and 1970, Los Angeles All City Art Festival, and others too numerous to list.

He is a member of the California National Water Color Society (also a past Board Member), American Watercolor Society, artist-member of Laguna Beach Museum of Art, West Coast Watercolor Society, Pasadena Society of Artists, Watercolor West, and other art groups, and is listed in Who's Who in American Art.

His paintings have been reproduced in various publications, and he is represented in the Home Savings & Loan of Los Angeles, Hallmark Cards Inc., Lowenstein Collections, and other public and private collections.

I FEEL WATERCOLORS vary mainly in the methods and techniques of applying pigment to the painting surface. Lately, I have been using the "lift-off" technique, aided by a sponge, tissues, and brush. Although many watercolorists are familiar with this method, I feel that I have gone a step beyond the usual to give my watercolors an added "dimension," greater substance, and depth. I like to think of this method as a "glazing in reverse," since colors are lifted out, and the staining colors that have penetrated into the surface of the paper remain to give it a luminous quality, which is an important characteristic of transparent watercolor.

I derive much pleasure and a great feeling of accomplishment using this method. Although I have the greatest regard for the traditional ways of watercolor painting, I find that experimenting in this method is more challenging to me. By lifting and carefully scrubbing out paint, I discover a shape, color, and texture that I have not anticipated.

The lift-off process was used to some extent in painting The Arches. It was created in my studio over a period of several days; "distilled" from numerous sketches of structures in the "Little Tokyo" area of downtown Los Angeles. The arched windows, doorways, and railed balconies were from sketches of the north facade of St. Vibiana's Church. Other portions were borrowed from shapes with many tonal ranges of color and textures that were revealed when old buildings were razed by city renewal projects: old bricked-in windows, doorways, and old faded signs of a bygone era.

I used a full sheet of d'Arches 140 lb. rough paper that was stretched on a light basswood board by first soaking it for about 15 minutes, then laying it flat on the board, and taping it down with brown packaging tape reinforced with a few staples. I selected a cool color scheme to get the mood and feel of the area with its overabundance of marble and concrete. For the actual painting I began working directly on a dry surface with a loaded brush, a large, flat, 1½ inch sable. Loading the brush with a mixture of Payne's gray and Prussian blue, I painted in varied abstract shapes, then added more pigment to these wet areas to blend. Some Hooker's green,

The Arches, 22 x 30. Private Collection. The artist utilizes the rough texture of the paper to create an illusion of dimension. Strong vertical darks provide an exciting contrast to Shubin's complex of shapes and colors.

alizarin crimson, and Winsor red were flowed into the wet areas.

The painting was left to dry in an almost flat position to keep the colors from running off the sheet. After it was dry, more shapes were superimposed to create more interesting interwoven patterns. After viewing it in a mat for a day or two, I worked in needed shapes with color and modeled shapes directly by lifting off (with sponge, etc.) unwanted portions, instead of using a penciled guide. The final washes were applied with more color to strengthen values. Burnt umber mixed with Prussian blue was used for my darks; yellow ochre, cadmium orange, and Winsor red, my warm accents, were applied last.

When painting outdoors, I try to travel as light as possible, taking along only the essentials such as a lightweight board large enough to accommodate a full sheet of watercolor paper; a folding camping stool; two large, flat sable brushes; one long, mixed-hair, Japanese bristle brush; water in a plastic topped coffee can; plastic palette; sponge; pencil; sketch pad; pen, and the tube colors mentioned above in painting *The Arches*.

Once at the location, I make several sketches to get the "feel" and to study various shapes and textures. This sketching is done with a pointed fibre tip pen on a sumi-type handmade rice paper pad. I find this sketching paper very absorbent and conducive to the ink pen. I place a piece of cardboard between the thin, almost transparent sheets to keep the ink from bleeding through onto the next page.

Because of the hours spent sketching, I lose the sense of time, which usually limits me to only one or two finished on-the-spot paintings. After sketching, when I've decided which subject matter to paint, I loosely work out a composition on the sheet of paper, using a soft pencil or a Japanese pointed brush with a little bit of Payne's gray. The paper is usually sponged with water while on a tilted board that is set on the ground or any solid surface. Next a color scheme is selected, and a large 1½ inch flat sable loaded with color is applied to the wet areas. Since my board is tilted, the top of the sheet is painted-in first, and I work downward. More pigment is added to the wet areas, and then, using the heel of the brush, I lift and shift colors about, trying to create some interesting shapes while building up values. I try to remember to use my earth colors last to avoid muddiness and to keep in mind the importance of

Above: *Ghirardelli Square*, 22 x 30. Here Shubin developed a high degree of transparency by applying flat washes, wash upon wash, over a period of several weeks. Each day he placed the work in a mat for viewing.

Right: *Boat Storage*, watercolor mounted on watercolor board, 30 x 40. Here, except for the bottom portion of the painting where opaques were used, the transparency is developed by extensive use of the lift-off method.

Coffee Break, 30 x 40. The artist used Crescent No. 112, a paper whose surface he finds especially durable and conducive to the lift-off method. Often Shubin becomes involved in the abstract shapes created wtih this technique and departs from his original concept.

keeping the white of the paper. Details are always added last, along with color accents.

Because of the warm days and sunshine in this area, the paint will dry very fast, so consequently areas may need to be moistened again and more washes of color added. A few darks are established early so that I can work within a given value range. After the washes have been developed and the warm California sunshine has dried the sheet, a few more darks and bright color accents are added to complete the painting.

In my studio painting I work on a large, adjustable-levered easel. Although my usual method of painting is similar to the handling of *The Arches*, many times I make many preliminary composition and value studies on a classified want-ad section of a newspaper. (When unfolded it is the same size as a full sheet of watercolor paper.) These studies are done with india ink line and wash applied with an old brush. A line study is made first.

Then, working from light to dark, values of the ink washes are built up. A design is formulated by many exaggerated lines and shapes. I find this excellent for value and calligraphy brush studies.

Several of these wash paintings in india ink are made until a suitable design is arrived at. Only then do I proceed to the expensive rag content paper. I am now using mostly d'Arches 300 lb. paper, because it does not need to be soaked and stretched. All I use are large thumbtacks or clamps to hold it in place.

During my rendering I often use the opposite end of an aquarelle 1 inch flat sable, which is chisel-like in shape, for certain textural effects. An old toothbrush is used for a speckle effect, and small pieces of left-over mat board are used to get a straight line while lifting with a sponge. I know the importance of using these tools at times, but I try to discipline myself from relying on them too much.

Hubert Shuptrine

IT WAS SOME 300 YEARS AGO that pioneer settlers first came to the Southern Appalachian Mountains. History records these settlers as a people who for one or more reasons wanted to escape the restraints and authority of society's laws. That they were a stubborn, independent, and ofttimes ruthless breed of men was in their favor in surviving on this equally rugged frontier. Within the protection of these formidable walls and dense profusion of never-ending growth, they staked their claims on the steepest ridges, in the most distant coves, and in the narrow, twisted valleys below. They made their moonshine whiskey, fought their feuds, and suffered the hardships of harsh, uncertain weather.

Generations of isolation by distance, by hazardous roads, and more especially by choice, produced the "Southern Highlander," with a folk culture and heritage truly distinctive and unique. It is, however, a vanishing heritage today. Old ways of doing things—such as canning, sulphuring apples, house raising, churning, soap making, clogging, buck dancing, water witching — are regrettably being abandoned. The mood is one of confusion and of strange urgency in a last American frontier. This is the call that brought me and my family from the city life of the foothills to live in our tiny community high in the Blue Ridge Mountains. I wanted to capture yesterday's people before they were caught up completely with today.

It is important that the subject be as natural as possible and in his own habitat, which is usually in the backwoods. Soon after beginning work here, I realized that the objects and people representing truth and the real essence of this culture were not to be seen from the roads, but only by walking or by horseback.

The "natural habitat" of Tommy Barnes of *Patient Turn* was his home at Buck Creek Community, which is about 15 miles outside of the town of Highlands, North Carolina. During my visits with

The New Puppy, 28 x 20. © 1972 Oxmoor House, Inc. Private collection. Photo Doug Griffith. Little Darla, Susie the treeing hound, and her tiny puppy while away the hours of shared companionship and undisturbed daydreams.

Mountain Gentleman, 28 x 20. © 1972 Oxmoor House, Inc. Private collection. Photo Doug Griffith. A friend and neighbor is the restless hiker of summits, valleys and forests. He collects gem stones. Indian artifacts, and mountain mushrooms.

Tommy, I learned much about his early life. As was the custom in days past, he attended school only a short while before joining the local labor force. He helped his father operate the community grist mill, and later, when he had his own family, he assumed caretaker duties in town. Each day Tommy walked to town and back again — a good three hours each way — and on Saturdays he and his wife carried fresh eggs, berries, and vegetables to sell, the produce of their small, rocky patch of garden. Though he never learned to drive a car, he learned a skill much more valuable in his day—that of making ox yokes—and is one of the few craftsmen of that early trade.

Because watercolor is at best extremely difficult, skimping on quality and quantity of work materials is false economy and is an unnecessary handicap for the artist. Therefore, I use only the finest hand-made papers and only those pigments known to be absolutely permanent and transparent. Many times it has been a temptation to yield to usage of opaque body color. But I have resisted this and other tricks that violate the medium. My brushes are all sizes and types—all highest quality sables.

Artists moan that they can't find subject matter close by, and viewers express utter surprise in simple discovery. Yet, subject matter is everywhere, right under our noses, and there is timeless beauty in the plainest face or object! Ruskin said, "The greatest thing a human soul ever does in this world is to see something and tell what it saw in a plain way."

BIOGRAPHY

Hubert Shuptrine, his wife, and three children live in Highlands, North Carolina, a small town in the Southern Appalachian Mountains. Hubert and his younger brother James—who lives in their native Chattanooga—have respective careers as full-time professional artist and as full-time agent for the artist, a team that has given rise to numerous public and private honors, one-man exhibitions, and unprecedented success.

Prior to his professional status, Shuptrine was represented in such national competitions as Exhibition of The Delgado, Southeastern Exhibition of Paintings (First Prize), Butler Institute of American Arts, Columbia Painting Biennial, National Religion in Art Exhibition (Award), Painting of the Year Exhibition (Award), Festival of Arts Southeastern Exhibition (First Prize), and others.

A collection of Shuptrine's watercolors appear in a major art book, titled *Jericho Behold,* published by Oxmoor House, and several portfolios of his work have been distributed by Oxmoor.

Jerald Silva

SOMETIMES I DON'T KNOW whether the garbage around the studio is the result of the painting or if the painting is the result of the garbage. The elements I'm using in my paintings are not those that have become historically sanctioned or those that are currently hip; they are instead the things I trip over constantly in my studio—things that I run into in

BIOGRAPHY

Born in Sacramento in 1936, Jerald Silva attended Sacramento Junior College, Chouinard Art Institute, and Sacramento State College, where he received his M.A. He has exhibited at the California State Fair, the Kingsley Show, the Northern California Arts Show, the Palace of the Legion of Honor in San Francisco, the Upper Grosvenor Gallery in London, and many other places. He has had over 20 one man shows, including those at the Crocker Art Gallery, Sacramento; Santa Barbara Museum of Art; Silvan Simone Gallery and Comara Gallery, Los Angeles; Candy Store Gallery, Folsom, California; and Artists Contemporary Gallery, Sacramento. His work is included in the collections of the Crocker Art Gallery, Natalie Wood, Anthony Quinn, Alan Sieroty, Stirling Silliphant, Barbara Windom, Betsy Drake Grant, Daniel Selznick, Bernie Orenstein, and others. Silva lives in Sacramento, with his wife Susan and his three sons.

my work, things that I am constantly moving out of the way so that I can paint.

But even though the elements I use in my pictures are actually there, or have actually been there, in my studio; even though the people I use as models are real people; and even though the pictures I paint actually look like the people look; even though all this is true and real, the reality of my pictures begins in my head. The images are terribly out of sequence timewise. My paintings bring together models who, in fact, never met; flowers that died long before the flowers next to them in the same picture were even planted; figures culled from a nudist magazine standing next to a drawing of my bank teller. The reality does not exist until I bring all these separate elements together in a picture. It does not happen until I finish the picture and glaze and frame it. Then it's certified; it happened. Then it becomes real and honest in much the same way that a myth, if repeated often enough and convincingly enough, becomes historic fact. All these separate elements in my paintings are crystallized certifications of moments that never happened. And they never really needed to happen, because the fact of the painting makes them fact enough.

From the beginning I liked the idea of doing the painting of John and Ann Krisik. Their father wanted to surprise their mother with the painting; it was to be kept a dark secret. Both John and Ann were students in different parts of California, and it was necessary to spirit them into Sacramento on strange pretexts and into my studio at odd hours. There was a series of very cryptic, secret phone calls. The whole thing was very cloak and dagger.

Since I rarely plan all the elements for a painting in advance, it was natural for me to do the drawings of John and Ann several days apart. In doing the drawings I was not at all concerned with how they would combine as a painting. I was only concerned with presenting John and Ann in attitudes that typified them as individuals. When I was satisfied with drawings of each, I enlarged them with an opaque projector onto large pieces of butcher paper. The figures were rendered with pencil to the scale they would ultimately appear in the painting, almost life size. To assist me with this pencil rendering, I took a lot of black and white Polaroid photo-

John and Ann Krisik, 1972, 54 x 49. Collection Mr. and Mrs. A. J. Krisik. Courtesy Silvan Simone Gallery. Painted as individuals, each figure is placed within its own frame and painted with a broadly similar, but precisely different palette. Silva used scratch lines to eliminate unwanted depth of field.

graphs. These final pencil cartoons are generally much more tightly resolved and articulate than the resulting paintings. I think I am able to develop a painting with a bit more authority and confidence and freedom having once established in my mind a sharp description of the subject.

Though I do very tight studies of the elements within a painting, I no longer do studies of a painting as a whole.

I don't use watercolor paper. There are too many things about it I don't like. It's absorbency reduces —often eliminates completely—the ability to scrub

out mistakes. The surfaces often seem too mechanical in their evenness of texture. The textures of the papers often give me a dappled look when a flat one is desired. And the tremendous expense of good papers can be intimidating. Also, good watercolor papers are available only in smallish sizes. I like the elements of a painting to be as near life size as possible. Though the Krisik painting is only a little over four feet by four feet, many are much larger.

Once the pencil cartoons are worked out I transfer them directly to my painting surface. I work on a surface of butcher paper glued to a Masonite panel.

Susan Silva, 1973, 54 x 48. Collection Dr. Robert and Laurel Silton. On the smoothly sized surface, pigment is not absorbed, and the artist can scrub off or rework an area as he chooses.

Work Floor—October, 1970, 48 x 36. Collection Susan Silva. Silva paints everyday objects, things he "moves out of his way so that he can paint."

The paper must be sized (I use a film of thinned white glue) because it is of such poor quality; otherwise a nappy surface develops when the paper is worked with a wet brush, and it soon feels much like painting on suede. Also, the film of glue keeps the atmosphere from discoloring the paper. Because the paper is sized it does not absorb the colors. And since they rest directly on top of the surface, most of them can easily be scrubbed off, and a clean, white surface often can be resurrected. If I completely botch a painting and it will tolerate no more scrubbings, I can stretch and glue and size a new paper over the ruined one for only a few cents added investment. The Masonite panels are backed with a wooden framework of 1 x 2s to give the panel rigidity and discourage warping.

The transfer technique is based on the carbon paper principal, only, instead of using carbon, I make a smooth smearing of glycerine and tube watercolor on a semi slick paper—generally pages from magazines. I position the completed pencil cartoon on the painting surface, then put the glycerine-watercolor transfer paper under the cartoon. When I trace a pencil along the parts of the cartoon I want transferred, the pencil line is duplicated in watercolor on the painting panel.

With the Krisik painting I transferred the drawing of John first. I used several transfer papers with the colors varying in accordance to the needs of the painting. As I painted the figure, most of the transfer lines were either absorbed into the painting or washed out when they were no longer necessary. The only original transfer lines that still remain are the reddish lines of the hands. The shadowed areas of the hands are blotches of clean water that borrowed pigment from the transfer lines. The figure was painted in most of the traditional manners, a series of simple washes, and some direct brushing with both stiff and soft brushes. There was a bit of direct drawing using a snipped off brush dipped directly into tubes of paint, which feels almost like using a felt-tipped pen; the trousers are an example of this. The figure of John was completed almost to its present state before any other element entered the painting. He was on an otherwise white surface. I think I originally had plans to later return to him and bring him to a much tighter state of finish.

It was some time before I decided to put the drawing of Ann into a frame of her own. Unlike the painting of John, where only the most essential details were indicated with transfer paper, the transferring of Ann was almost as complete as the pencil cartoon. I used quite a number of different colored transfer papers and I tried to use a completely different palette when painting Ann. Both figures are essentially green and blue and brown, but where I used Hooker's green on John, I used pthalocyanine green on Ann; where I used cobalt and permanent blue on John, I used Winsor blue and indigo on Ann; where I used alizarin crimson, Naples yellow, and Hooker's green in John's flesh, I used Winsor

Reclining Diane Baxter, 1973, 48 x 62. Collection Mr. and Mrs. Roy Crummer. The artist treats each painting somewhat like a "happening." Although he does tight studies of each element before it is included, the painting as a whole is not preplanned; it grows.

red, cerulean blue, Naples yellow on Ann. And so on. Though they were to be figures in a single painting, I wanted each to have its own authority. It was in keeping with this idea that I wanted to unify the surface of the rectangle that held Ann so that it would be a force of its own, independent of other elements of the painting. All the scratchy lines would, I hoped, eliminate any unwanted depth of field; I wanted to maintain a sort of surface consciousness so that it would have the effect of a flat surface on another flat surface. There were some simple washes of clean water scattered here and there through the transfer lines to borrow bits of pigment and to give the surface a more luminous, transparent look.

Other elements from the studio began creeping into the painting. I took one of the original sketches of Ann and laid it directly on the painting. I transferred it to the painting, making a special effort to maintain the crudeness that typified the drawing. Before removing the sketch from the painting, I sprayed the entire area with an atomizer filled with

pigmented water. The original sketch acted as a mask that kept the painting surface white, leaving an image representing the drawing paper.

By the time I added the fabric and table to the foreground, I decided not to develop the painting of John as far as I had originally planned. I noticed that focus on the elements of the painting seemed to diminish as the elements projected forward. Ann's face was very clear; John's hands and legs and the table and the fabric were rather mushy. To further resolve these forward elements, as I had originally planned, might have destroyed a spatial thing that had begun to happen and that I had grown to like.

I don't ever really know when a picture is finished. I just work a picture until I can take it no farther, or until the picture can take me no farther, which is always accompanied by a kind of disappointment. Generally, when I see a painting I've done in the past I feel a desire to smuggle the thing back into my studio and work on it some to bring it to a newer state of finish. Not a final state, just a newer one.

Lowell Ellsworth Smith

ON THOSE JOYFUL OCCASIONS when an outdoor study or an indoor studio painting really "comes off," I thank the Powers that Be for allowing me to practice my art primarily as a watercolorist. I also enjoy other media, but my real satisfaction comes in the exciting action and challenge of painting a·good watercolor.

Coby, 1971, 14 x 10. The freshness of watercolor is well suited for a portrait study.

Dew Web was one of those few paintings that happen now and then to come off just right as a study and then even better as a full sheet. Others will agree, I'm sure, that this is not always the case. The painting was conceived on a clear and bright late summer morning along the coast between Rockport and Gloucester, Massachusetts. I was climbing around on the rocks looking for a subject with my good friend and fellow artist, Don Stone. On this particular morning Don had settled down to study some colorful crab shells in a shallow pool while I was stopped short by a dew web surrounding a dandelion-like flower thrusting up through a crack in the rock.

First came several rather abstract value studies in my sketchbook, followed by a very minimal drawing on my quarter sheet paper. I prefer to work on a smaller size outdoors, saving the larger sheets for the comfortable confines of my studio.

After 40 minutes of painting, the light changed. With the certain feeling that I had something going, I decided to stop and return the next morning. What remained to be solved was the focal point. The flowered weed and the web required some more thought. I felt no need to rush things.

The finishing touches were added the next morning, and I placed the little watercolor in a mat, I can still recall my elation and the feeling that this study had the makings for a good exhibition painting.

Although I was anxious to see my subject projected to a full sheet, almost a year passed before I got to it. Finally, armed with my quarter sheet study, several black and white Polaroid shots of the subject, and some well-chosen words of encouragement aimed at myself, the stage was set.

First, I carefully projected the drawing directly onto a full sheet of 300 lb. cold pressed paper, being careful not to overdraw. The flowered weed was masked out with liquid rubber cement in order to make the painting of the background rock less difficult. I decided, however, to paint around the web so as to achieve softer edges.

Next, I dunked my full sheet in the bathtub for

Dew Web, 1971, 19½ x 27. From a small study and photographs made the year before, the artist developed the painting in his studio.

BIOGRAPHY

Born in Canton, Ohio, in 1924, Lowell Ellsworth Smith earned his B.F.A from Miami University, Ohio, and was a graduate of the Famous Artists Schools, Westport, Connecticut. He worked for a number of years as a feature illustrator and in 1960 began to devote full time to painting and teaching. Awards include the Charles H. Cleaves Memorial Award, Rockport Art Association (1971), and the First Painting Prize and a Purchase Prize from Mainstreams '72 International Show, Marietta College, Ohio; Purchase Prize from Mainstreams '73; H. Lester Cooke Memorial Award, Mainstreams '74. Mr. Smith has had over 30 one-man shows and is represented in over 500 collections. He is a member of the American Watercolor Society, the Rockport Art Association, and a Past President of the Hudson Society of Artists. He lives in Hudson, Ohio.

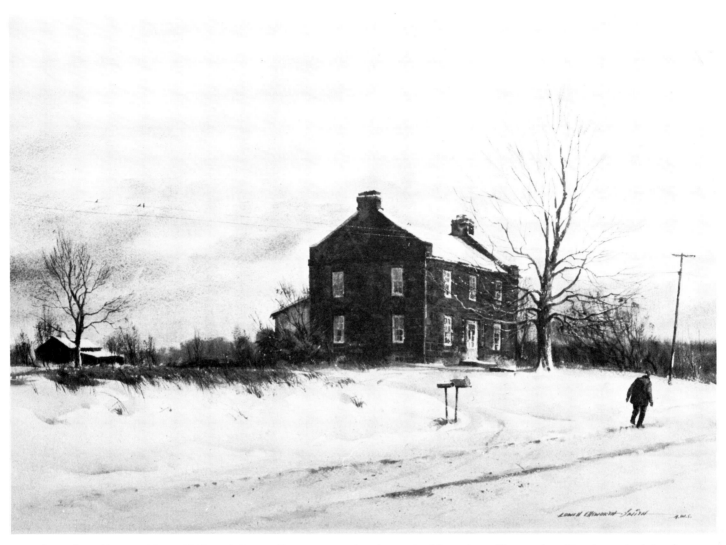

Quarry Stone House, 1972, 19 x 27. The artist began with generous washes, then worked his way toward the use of small brushes and a drybrush technique.

Lower Level, Doud's Barn, 1972, 19 x 27. A dramatic contrast of values establishes the focal point.

Torrey Pine, 1972, 10 x 14. Collection C. W. Newman. A strong feeling of movement is created by an energetic use of line. Notice the swift suggestion of trees in the background.

about 10 minutes and placed it on one of my one-inch-thick plywood painting boards. I begin most of my larger paintings in the "wet-in-wet" manner. I allow the paper to dry slightly to a receptively damp stage by the time I'm ready to lay in the first wash.

Although *Dew Web* required only a few colors for painting, my regular palette contains a full range of tube colors: vermilion, alizarin crimson, burnt sienna, Van Dyke brown, raw umber, yellow ochre, lemon yellow, cerulean blue, Winsor blue, Winsor violet, olive green, ivory black, and Chinese white. The white is used to add body to a wash when the situation seems to call for it. Acrylic white is also useful in helping to achieve final accents and to regain a small lost white shape.

My brushes range from a two inch varnish brush to medium and small pointed rounds of both sable and imitation sable. Perhaps my two favorites are a one inch flat and a No. 2 half-round.

The early stages of painting *Dew Web* went rapidly. First I brushed in the small piece of sky and then the warm, sunlit tones on the rocks. Next I established the architecture of the rocks, using both warm and cool colors in the shadow areas. The stringy, grass-like weeds were painted slightly out of focus so as not to compete with the focal point.

After these big shapes had dried and the values were judged to be correct, I began the painting of textures, cracks, and subtle variations in the rocks. Drybrush and spatter techniques were used in addition to a bit of scratching and ploughing with an old, long-used mat knife blade. "Ploughing" simply means pushing aside the pigment on a dampened surface.

I used extreme care in establishing the detail of the web and the weed. Chinese white was used in my wash to help achieve the milky off-white character of the web and to produce some of the delicate single strands. I fussed with this section for quite a while before deciding that I had done all I could.

Off and on for the next few days I added touches here and there. Then, with the addition of a new linen mat, I became hopeful that this was one of my best paintings. An enthusiastic response from my family, my father, and other gallery visitors cemented my feelings that *I had* pulled it off!

Jean Stull

AS A FRIEND WAS ABOUT to buy his ninth of my watercolors, he mumbled, "You paint the darndest things." It's true. Although my subjects are ordinary —a frog, a shell, an insect, a weed . . . things looked at often, but not really seen — I feel there is more than just the physical side of a subject. I need to get into things, to convey the emotional as well as the sensual as, for example, the smell and feel of the shaded dampness where leaves have fallen, the

BIOGRAPHY

Jean Stull was born near Waterford, Pennsylvania, where she now resides with her husband and two sons. She teaches art at Fort LeBoeuf High School in Waterford. Holding a B.S. degree in art education, which she earned at Edinboro (Pa.) State College, she has also studied at Penn State University and at Palomar College and Miracosta College, both in southern California.

Stull has had several solo shows and has exhibited widely throughout the United States. She received an Award of Excellence at Mainstreams '74, Marietta, Ohio.

She is represented in numerous public and private collections throughout the United States and is a member of the American Watercolor Society.

sounds of the wind or the quiet, the isolation and aloneness sometimes felt.

Since I paint intuitively, I'm not consciously aware of applying academic principles or special techniques. The excitement of an idea and the act of painting become a balance of responses between my physical response to the medium and my mental response to the preconceived image.

There are inevitable failures in this approach. Sometimes enthusiasm for the subject can't be sustained long enough to complete a painting. Sometimes the vivid mental concept fades, or an interruption destroys the initial intensity. After one such disappointment, there may be a series of them. I may pace around for days — thinking, agonizing, staring at a blank panel, trying to catch that elusive urgency that for me must prelude a successful painting. Then a reversal takes place. One idea is rendered successfully, and it unleashes others. Memories flood my mind—a glimpsed landscape, a color, an odd shape, a bit of light or darkness—and the painting comes out in a magical way, quite apart from me.

The sundeck of my home usually serves as a studio, because I like to work under natural light. I sit on a mat placed in front of a panel on the floor. There I may work with freedom, spreading equipment around me. The minor inconveniences of an outdoor studio are often a joy. For example, one morning I stepped out onto the deck and threw off the large sheet of plastic that was covering my equipment: a field mouse emerged from the paint box with a baby in its mouth; rescuing each young in turn, it darted back and forth across the wet palette and painting five times, leaving paths of tiny blue footprints on the unfinished work.

Often I choose a subject that, like the mouse, is small or obscure. Then I paint environmental forms, essentially shapes and colors, to camouflage the subject as in nature, so that it surfaces only after inspection. Only rarely does the subject dominate the picture plane.

My watercolors are gentle and low key, the palette consisting of cobalt blue, cerulean blue,

Ravine, 1968, 36 x 45, watercolor on tissue mounted on mat board. Courtesy 1st National Bank of Pennsylvania. The artist used a high horizon and large dark masses to portray the ravine's vastness.

Davy's gray, Payne's gray, raw sienna, burnt sienna, raw umber, yellow ochre, lemon yellow, cadmium red light, gamboge, sap green, and a number of others used as needed. They are arranged on two seldom-washed metal palettes: one for cool colors, one for warm. I select only a few colors, sometimes only one or two, for any given painting, but I must, nevertheless, have them all available and visible.

My support, white wrapping tissue or rice paper glued to tinted mat board or illustration board, is sympathetic to the fluid watercolor medium. (It seems right that I should paint on a textured surface; the natural world is textural in every aspect.) Prior to the use of this support, I preferred 300 lb. cold pressed watercolor paper. At that time my work was more traditional. I still like the sensitive feel of a smooth surface and occasionally revert to a fine grade illustration board if the concept directs it. With the change to a textured surface, however, I felt released from limitations of size and from the restrictions of true transparent watercolor as well. The wrinkled tissue invites flowing accidents that

can be controlled and manipulated at will. There are times when these accidents redirect the original intent by stimulating a more spontaneous result. To prevent the panel from warping, I place it under a rug (both before and after use) until my husband gives his final critical word and completes the mat and frame.

I prepare my painting surface by gluing old white gift-wrapping tissue paper (or rice paper) to illustration board with a mixture of Elmer's Glue-All and water: first I pour glue on the board, then water, and rub the combination over the surface with my hands. Next I lay the tissue paper—which has already been torn to fit the board, crumpled, and then opened flat—on top of the glue, sprinkle it with water, and roll a wet brayer over the surface to keep the moisture even and get air bubbles out. I let the paper wrinkle naturally. Once the surface is dry I'm ready to begin painting.

I usually begin a watercolor by applying dark washes, which frequently break the edges, to establish the abstract value pattern and tentative com-

Above: *Fringed Gentians*, 1966, 11 x 16. Courtesy Mr. and Mrs. Bert J. Rosamond. Stull develops an illusion of depth through successive layers of color and tissue.

Right: *White Bird*, 1969, 31 x 33. Courtesy Dr. and Mrs. David Doupe. A rare instance in which Stull's subject dominates the picture plane.

Opposite page: *Hawk's Nest*, 1973, 20½ x 30. Camouflaged by the shapes and colors of nature, the subject emerges only after a closer look.

position. The following stages may only involve a gradual building up of color or they may involve layers of both color and tissue, one glowing through another, creating a luminous depth. The number of layers of tissue depends upon the intended mood of the painting as well as the subject. For special effects I may build up a particular area with layers of tissue and color. Or, if I become dissatisfied with the work in progress, I re-tissue the entire surface. This provides me with a new surface and a hazy "underpainting," which I use to begin a new painting. Color too depends on the mood intended. If it is to be a warm painting, washes of ochre or umber are applied; if cool, layers of sap green or Davy's gray. I prefer each layer to dry before applying another, and I vary the degree of transparency to keep strong, opaque, shadowed areas.

The most difficult problems come early; the first hour's work requires the deepest concentration. I work rapidly, taking time only to step back 25 or 30 feet to evaluate the impact.

As successive layers of color are added, broad shapes take form. When I was working on Ravine, the large masses were developed in only a few layers. I wanted to express the ravine's vastness, its depth and width. Using a large brush and washes of india ink, I laid in the largest and darkest areas. Layers of warm earth colors followed.

As in much of my work, there is no detailed drawing in Ravine. At the top of the ravine, shades of green were washed into the texture of the tissue to suggest foliage blending into a pale yellow sky.

I paint primarily with a one inch aquarelle brush but also use an ox-hair brush to paint foliage and a worn bristle to soften edges. An elephant-ear sponge lifts out unwanted areas of color. When the overall pattern is established, I use a variety of small sables to add any necessary detail. I use a reference book, sketch, specimen, or slide taken with a dental close-up camera to authenticate colors or identifying characteristics. Sometimes, in the final stages of a work, I use touches of Chinese white softened with pale color washes to delineate an area or highlight it.

I rarely work on location and never search for something to paint. Rather, I spend every spare hour walking along the beach or in the woods and fields. That sort of mysterious not knowing what is ahead — a kind of bird I've never seen before, or a rare fern or wildflower — moves me. Using a sketchbook, I record my thoughts and experiences in the form of notes and sketches. The notes are sometimes merely jotted words or combinations of words that may later ignite an idea or bring back a memory. The drawings that fill the pages are mostly small, unrecognizable value studies, frequently with color notations. At intervals there are drawings of a flower, a leaf, or other details that interest me or are needed for later identification. At home away from the spot, freed of irrelevancies, I paint only features that characterize what I have remembered.

Zoltan Szabo

Szabo's homemade easel: top photo shows easel closed. Legs unfold. Middle photo shows interior of easel box, including storage compartment. Bottom photo shows easel open, ready to use.

AFTER 20 SOME YEARS of painting with watercolor, I am still as excited about it as a child about a Christmas tree. Long after the technique of applying the paint has become unconscious and the creative demands have taken over my conscious mind, watercolor still offers technical challenges: it demands inventions. Watercolor never becomes a routine; its temperament remains a constant challenge to even the most skilled artist.

Although I have a large palette of colors, I only use four or five in any one painting. My favorite colors are cadmium lemon pale, cadmium orange, cadmium scarlet, vermilion red, alizarin crimson, brown madder, manganese blue, cerulean blue, cobalt blue, French ultramarine blue, Antwerp blue, phthalocyanine blue, Hooker's green deep, yellow ochre, burnt sienna, sepia, warm sepia, Van Dyke brown, Davy's gray, charcoal gray, and Payne's gray. I use only high quality transparent watercolors and never include white or black on my palette and sap green or Hooker's green only occasionally. I prefer instead to mix my greens with blues and yellows.

I use several sizes of round sable brushes as well as a couple of wide flat sable brushes for large washes. A soft sponge and 2 inch brush serve as wetting equipment. Besides these conventional materials, I also rely on not-so-conventional tools. First, my homemade standing easel is ideal for outdoor painting, allowing for ample room to store paints, brushes, a good supply of pre-cut paper, and lots of wet-strength type facial tissues. Two painting knives and three flat bristle brushes with a slanted tip account for my painting tools. I use a plastic milk jug, cut in half, for a water container and a small plastic dish for clean water only.

I work a good deal both outdoors and in my studio. My favorite working size is 15 x 11 paper. I always tape the sheet on the smooth side of a slightly larger, heavy Masonite panel, using ¾ inch masking tape to adhere the edges. I do this even with the heavy paper, because I usually work on a dripping wet surface and I want maximum control of the flowing paint; the tape mounting reduces the buckling of the paper to a minimum. I keep my work surface horizontal for the same reason.

I feel excited about paint oozing on the wet paper, a process that is always unpredictable yet offers happy accidents that mean creative opportunities. A good example of this method is the *Marsh in Winter*, reproduced here in color. This

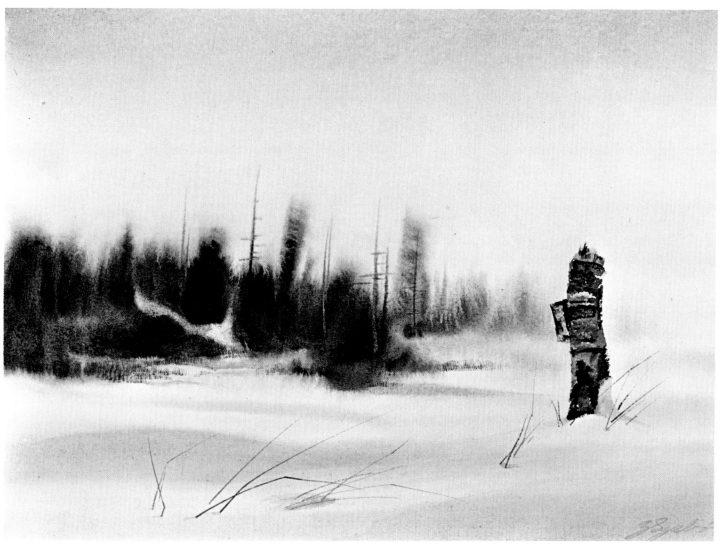

Marsh in Winter, 11 x 15. By working wet-in-wet the artist achieved a diffuse atmosphere. The stump and weeds in the foreground were painted in drybrush.

BIOGRAPHY

Zoltan Szabo is one of Canada's foremost landscape painters. Born in 1928 in Hungary, he is now a Canadian citizen and makes his home in Ontario. Szabo studied art in Hungary but is largely a self-taught artist, making frequent forays into the Canadian wilderness to paint and gather material for his unique watercolors. In addition to painting, he gives private lessons and has taught art classes and conducted art seminars both in Canada and the United States. He is the author of *Landscape Painting in Watercolor* and *Creative Watercolor Techniques* (Watson-Guptill).

Szabo's work has been exhibited in one-man shows in the Tygesen and the Penell galleries in Toronto, the Beckett Gallery in Hamilton, Ontario, and in many group shows in Canada and abroad. His paintings have also been seen in numerous shows with the Society of Canadian Artists—of which he is a member — and with the Society of Canadian Painters in Watercolor.

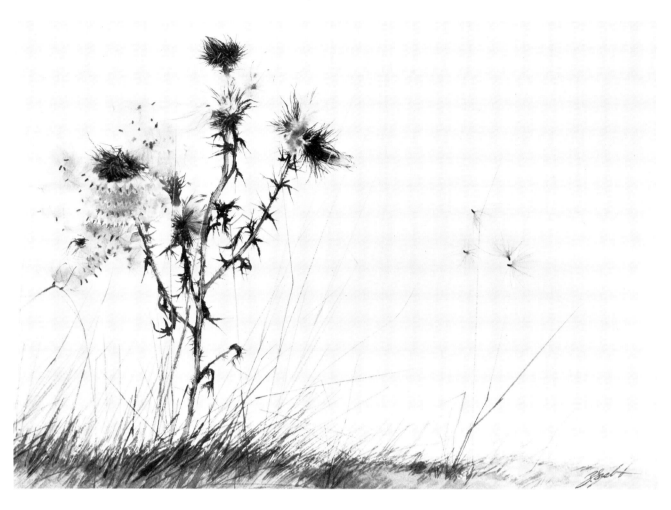

140

Snow Stars, 11 x 15. The stars were obtained by dropping salt into the wet pigment.

painting is typical of my work and demonstrates how well the soft, wet shapes complement the clear dry brush on the stump. I painted all the distant shrubs and the gentle drifts in the foreground onto dripping wet paper. After the paper dried completely, I painted the birch stump in dry-brush technique and with my small painting knife. I felt the weeds in the foreground would help lead the eyes toward the center of interest.

I love winter landscapes. In northern Ontario, where I live, the Canadian winter is always at its best. The country is magnificent, and the clear white snow just turns the landscape into an endless fairyland, giving me glorious opportunities to play with white (negative) space. *Snow Stars* depicts a view over a frozen bay of Lake Superior. First I painted sky and background hills. To create falling

snow effect, I sprinkled coarse salt into the drying paint just as it was losing its wet shine.

A Little Rest was a rare chance for me to show off watercolor. The rough, old thistle and the soft, fluffy seeds really demonstrate the technical charm of the medium without looking awkward. The background is the pure, white paper. I first painted the stems, paying a lot of attention to details. After dampening only the area of the seeds, I painted in the fluff until I created the impression of a thick flock of seeds. I followed with the grassy foreground. Here I used a painting knife and a thin, long-haired sable brush as well. My finishing touch was to paint in the four little seedlings caught on the tall weeds.

Arizona Monuments is a studio painting I worked up from a small pencil drawing. The unbelievable red and mauve rock formations and the vast space were a real treat to paint. First I painted the windswept sky on wet paper. After it dried I brushed on the layered rocks using long, horizontal brushstrokes. Then I did the grass and the odd cactus to finish off the painting.

Opposite above: *A Little Rest*, 15 x 22. The delicate details of the thistle were created with a small sable heavily charged with pigment.

Opposite below: *Arizona Monuments*, 15 x 22. The artist finds it challenging to shift from the cold climate of Canada to the arid, clear light of the Southwest.

Valfred Thelin

TO SAY THE LEAST, I was uneducated in the medium of watercolor; but, through a twist of nature, I developed an allergy to turpentine, and I started to experiment with watercolor. Instead of enrolling in a class to learn about watercolor, I applied knowledge I had about oil painting: applying color directly to the surfaces using a palette knife and finding a mounted board that, like canvas, could take such punishment. At times the watercolor seemed to have a mind of its own, getting out of hand and demanding total concentration to gain control. Being aware of what's happening, guiding the paint, and allowing the watercolor to work for itself has now made watercolor my favorite medium. I like its fresh, direct, clean look; it dries fast, and each painting is a new adventure. It never fails to cause excitement by insisting that you be prepared to improvise while expecting the unexpected.

The painting *Collonade Falls* (Yellowstone National Park) is not the conception of a particular spot or location, but an interpretation of what my mind remembers was there. Rather than paint a particular scene in its reality, I prefer to let the watercolor medium suggest the forms that strike an accord with something I remember seeing. So all of my paintings are done in my studio on a flat surface. This reverses the procedure of the abstractionist who, in my opinion, takes reality and distorts it to abstraction; instead, I take abstraction and seek its reality. I would thus call myself an abstract realist.

Using a mounted watercolor board—in this particular case 40 x 60—where the edges are taped to provide a border. I begin a painting by wetting particular areas of the surface; this enables me to contain the liquid color, because within these areas I apply color directly from the tube. In *Collonade Falls* the initial colors were raw sienna, burnt umber, Hooker's green, and alizarin crimson. Then, intently watching the shapes of the abstraction, seeking the one form of reality, moving the color in and out from the dampened areas to the dry surfaces, watching one color blend into the other, and,

when the first recognizable form emerges, linking the thought of a place with the shapes and colors before me, I gradually begin to elaborate on the semi-realistic forms. Working now into the darker tones, I begin overpainting and glazing with transparent washes of Thalo blue and mauves, scratching back in with the palette knife and a razor blade, forming the trees and rocks and again glazing. (My interpretation of glazing is throwing a light transparent wash over an area, causing a veil of color, one color over another; that is to say, if you were to paint an alizarin crimson square, then, after it completely dries, throw a transparent wash of Thalo blue over only half of the alizarin and overlap it outside the square; this gives you three shades of color.)

I do a lot of sketching and black and white drawings on location; along with photographs. This is very important, for the drawings and photos give me an understanding of things I see around me and a direct reference as to how they appear in their real state. For these sketches and drawings I have set up a small watercolor kit in which I carry the basic items used by most watercolorists (shown here), and in my studio I add palette knife, razor blade, india ink, sponge, kneaded eraser, masking tape, a white palette. (On the palette the only essential thing is to keep the cool colors, blues and greens, away from the warm colors, reds and browns.)

I never clean my palette, so I retain the multitude of subtle tones that lay in the unconscious mixtures of color and often stimulate delicate accents in my paintings. The initial palette colors are alizarin crimson; cadmium red light, medium, and deep; rose carthame; cadmium orange; cadmium yellow deep; Winsor yellow; Indian red; sepia umber; Winsor green; Hooker's green light; Thalo blue; cerulean blue; and Payne's gray. In addition, I buy colors I would never consider using, but when my favorites run out, I paint only with these colors that I have never used before, frequently finding new and rewarding experiences.

My basic brushes are all red sable: 1 inch,

Collonade Falls, 40 x 60. Collection Mr. and Mrs. Daniel Le Donne. Photo James Bull. Once the free flowing pigment suggests a particular form to Thelin, he begins to develop a painting based on a "pattern of reality" that he remembers of a particular place.

BIOGRAPHY

Born in Waterbury, Connecticut, Valfred Thelin has been painting most of his life and is the recipient of more than 65 major national awards, including the American Watercolor Society award, Watercolor U.S.A. Show; the Jurors Award of Excellence, Mainstreams '74 show; and the Barse Miller Memorial Award at the American Watercolor Society Annual in New York City.

In recent years Thelin has become involved in sculpture and acrylics, and he is in the process of composing a book entitled *Artists about Ogunquit*. His greatest interest lies in watercolor and in demonstrating his methods at museums, colleges, universities, and art organizations, as well as acting as a juror for many of these groups.

He is a member of the American Watercolor Society, Ogunquit Art Association, Philadelphia Water Color Club; charter member of the Florida Watercolor Society; and life member of Rockport Art Association. His work is in numerous museum collections, corporate and bank collections, as well as private collections.

Thelin resides in Ogunquit, Maine, where his studio-gallery is open to the public June through September and the rest of the year by appointment. He teaches a series of watercolor workshops in Florida during the winter and in Montana and Ogunquit during the summer.

Above: Thelin's watercolor setup. Photo James Bull. Rather than · paint on location, Thelin uses sketches and black and white drawings to give him an understanding of what he saw and as a direct reference from nature. Below: *Forgotten Not*, watercolor and acrylic, 24 x 30. Utilizing both overpainting and underpainting, the artist creates a dream-like quality.

1½ inch, and 3 inch flat; ½ inch square; and Nos. 5, 9, and 12 rounds. Inside the back cover of my portable painting kit are about 14 quarter sheets of 300 lb. rough watercolor paper. In addition to the watercolor paper, I carry a charcoal sketch pad (on which I draw with india ink), a razor blade, and five or six pieces of 16 x 20 illustration board. On all of these boards I have covered the edges with masking tape. This facilitates working in the field, and a painting comes to a semi-finished state simply by removing the tape: you have a relationship to what the painting would look like in a matted state. I use this masking tape technique on all of my paintings.

I am constantly adding finished details as a painting dries. If I choose to redampen an area as it comes to a complete drying point, I use an atomizer and then wash over, always being careful not to mix any of the warms with the cools, for fear of mud. At the time of complete drying I remove the tape and can study the painting, living within its boundaries. If it's necessary to make additions, I can put the tape back on and do so. Once it is completed, if I decide to frame the painting, I can achieve a double matted look by cutting just one mat ¼ inch larger than the masked area (the taped border gives the illusion of another mat). With no mat at all it looks framed as is.

Lost River Creek Falls, 39 x 25. Photo James Bull. Besides the paint and paper itself, Thelin uses a variety of tools to develop texture and detail, including sponge, razor blade, hands and fingernails.

Margy Trauerman

Margy Trauerman was born in South Dakota but lived in Fort Dodge, Iowa, throughout her school years. She attended Los Angeles City College and received her B.F.A. from State University of Iowa. She studied advertising art at the American Academy of Art in Chicago and subsequently moved to New York City for further study of fine arts at the Art Students League and with Jacob Getlar Smith.

Trauerman worked in the advertising field in Chicago and Corpus Christi, Texas. Currently she teaches advertising design at Art and Design High School in New York City.

She has exhibited and won awards in numerous national shows. Her solo exhibitions include Chatham College, Pittsburgh (1961); McAllen, Texas (1971); First Street Gallery, New York City (1972). Her work is in private collections throughout the U.S.

Trauerman is a member of the American Watercolor Society. She is represented by the First Street Gallery, New York.

IT WAS AS A STUDENT of Jacob Getlar Smith that I first became aware of the potentials of watercolors. As a master of watercolor, Smith countered the pitfalls of technique-as-goal by speaking constantly of "concomitants of art" and the appreciation of watercolor. Poussin, Constable, Cotman, Corot, and Cézanne are but a few of the artists whose paintings have helped me to understand the relationship between symbolic image and esthetic meaning, as described by Suzanne Langer in her book *Feeling and Form* (published in 1953 by Charles Scribner's Sons): "A symbol is any device whereby we are enabled to make an abstraction."

I use abstractions to show the essences of all the disparate parts of a painting and to give it a vital force. For example, in the painting *Span* (reproduced here) the abstractions I sensed were the *thrust* of the bridge, the *volume* of the boulders, the *flow* of the water, the *silhouette* of trees, and the *luminosity* from the sky. At the site I was moved by the quietness of nature, and my interest was aroused by the intruding bridge and the multifarious parts of nature (rocks, water, trees, inclines, declining planes, and delicate and vigorous growth). Each had its own life. The impetus to make a painting was in the challenge: to see if I could bring these different units together to express a solitary feeling—a total image.

The image is defined or actualized by bringing together a set of elements that I consider basic and constitute my major esthetic principles: organic form, vital force sensed, clarity and structure, concreteness, and coherence. Since all are present in nature, this may, in part, account for my not feeling the need to include the human figure.

When out looking for subject matter, I always carry my equipment with me. This includes a wooden folding easel, a child's folding canvas chair, a small sketch pad, a plastic bag for small items such as soft pencils and vine charcoal, and a canvas carryall into which everything fits except my 18 x 24 inch block of d'Arches 140 lb. cold

Span, 18 x 24. Trauerman selects commonplace subject matter rather than glowing sunsets or other highly charged phenomena because the latter are overwhelming and mask the elements she feels are more important.

Windy Slope, 18 x 24. Here disassociated objects, accidents of nature such as fallen trees, and transients, like birds or butterflies, are excluded. They might be interesting or give information, but the artist feels they would add nothing to the total symbolic expressive image.

Still Life with Tulip Plant, 24 x 18. Courtesy First Street Gallery. All esthetic elements, including planes, pigment, color, value, line, and form, are used to describe and support the rhythmic curves of the plant.

Still Life with Cinnamon Sticks, 18 x 24. Courtesy First Street Gallery. Rather than painting the "portraits" of several objects, Trauerman prefers to combine their basic shapes to create an illusion of restless harmony.

pressed watercolor paper. Round sable brushes, Nos. 14, 12, 9, and 7, and a ¾ inch flat are rolled up in a bamboo place mat. My 4½ x 9 inch metal palette opens up to four mixing areas and 18 color slots. So that I am always prepared, I keep the color slots filled with paint: cadmium lemon yellow, cadmium yellow light, cadmium yellow deep, raw sienna, cadmium orange, cadmium red, cadmium red deep, Indian red, raw umber, burnt sienna, viridian green, cerulean blue, cobalt blue, French ultramarine blue, and ivory black.

Once I've selected the subject matter and made some rudimentary studies of structure, I lay out the underlying structure of the painting with charcoal. The entire scale of values and colors for *Span* was determined by the unit of boulders, which I painted first. Although each picture dictates its own technical procedure, I generally work from light to dark, building a series of washes on dry paper. There are areas of direct color as well as soft or wet passages within a painting, but the overall appearance does not have a wet-in-wet look; it is controlled with clear-edged contours.

I paint with the subject before me and return to it until the painting is near completion. At that point I stop. Some time later, when I'm in a less intense state and able to better evaluate my efforts I return to the painting. Then I either adjust it or finish what is there, hoping that the essential character of the image is clear. The interplay of foresight, judgment, and action is, for me, the value of the creative effort.

I use watercolor in a traditional manner and adhere strictly to the transparent characteristic of the medium. Except for the occasional use of a blotter to pick up unwanted color, I have never utilized such tools as rubber cement to screen off an area, implements for scratching out color, sponges, erasers, or white paint added to pigment to give it body, hide a mistake, lighten a color, or emphasize form. I leave the paper bare for white passsages and work around an area to retain light values — even if the area is the size of a twig. To appreciate the medium and not destroy it through the use of unsympathetic tools and devices requires care. I am rather cautious by temperament and like to know where I'm headed, not only in painting but in other experiences in life where spontaneity is not the generating force. So the attitude of deliberation seems to me especially suited to a medium that is virtually irrevocable.

Richard Treaster

Detail from *Sanibel*, watercolor, pencil and tempera, 28 x 30¾. Notice varying degrees of finish in this painting.

AS A PAINTING INSTRUCTOR and practicing artist, I am constantly faced with the question of how, what, and why to paint. Fifty years ago there might have been direct answers to such questions. Today the answers are many and complex, for life itself is complex and changing rapidly. This is stimulating; I find this an exciting time to be alive. Never before has an artist had the opportunity to work in as many diverse directions. My directions are personal to me and seem to change each year.

My first love has always been watercolor. Even my painting in other media has affected my outlook on watercolor by broadening my approach and thinking, giving me a much larger range of expression. My work in egg tempera has had the largest influence on my watercolor technique. This is probably because egg tempera is practically opposite to watercolor. By its nature, watercolor affords spontaneous and rapid executing while tempera demands a methodical and precise application.

I own some sheets of practically all the good watercolor papers on the market. However, I have done the majority of my recent work on all-rag 140 lb. hot pressed sheets. My palette is wide open, containing just about any color I consider permanent, and chosen to suit the requirements of the individual pictures. At times I also paint with two palettes, since I often combine tempera and transparent watercolor. My brushes are the usual variety, with the exception of those I use for tempera, which are extremely long and pointed, designed for detail and cross hatching.

So much of my approach to a watercolor depends on the subject and how I feel about it. Generally, I begin by stretching my watercolor paper on a drawing board. I wet the paper and then staple it down with a staple gun, an instrument I find ideal for creating a perfectly flat surface. After the paper is stretched and dry I often give the entire surface a complete wash or tint, much in the manner of the early British watercolorists. I keep a number of these stretched and tinted papers on hand.

When I start a watercolor I have no predetermined method of attack. I like to let each painting

Memorial Day Flag, watercolor and pencil, 20⅜ x 27⅛. Collection Mr. Alger William Doll. With the exception of the 48-star American flag, this painting is almost totally monochromatic.

BIOGRAPHY

Born in Lorain, Ohio, in 1932, Richard Treaster earned his B.F.A. from the Cleveland Institute of Art. He has been a member of the painting faculty of the Cleveland school since 1966. His paintings have been exhibited in virtually all of the major national watercolor shows of the last decade, and he was one of 50 living artists represented in The Metropolitan Museum of Art's "200 Years of American Watercolor" in 1966. His paintings are in approximately 200 private collections in 16 states, including Butler Institute of American Art, Ford Motor Company, and National Academy of Design. He has received numerous awards, including the Syndicate Magazine Medal of Merit (1966) and the Emily Goldsmith Award (1969) of the American Watercolor Society, and the Award of Excellence (1969) at Mainstreams International Show, Marietta College. Treaster makes his home in Lakewood, Ohio.

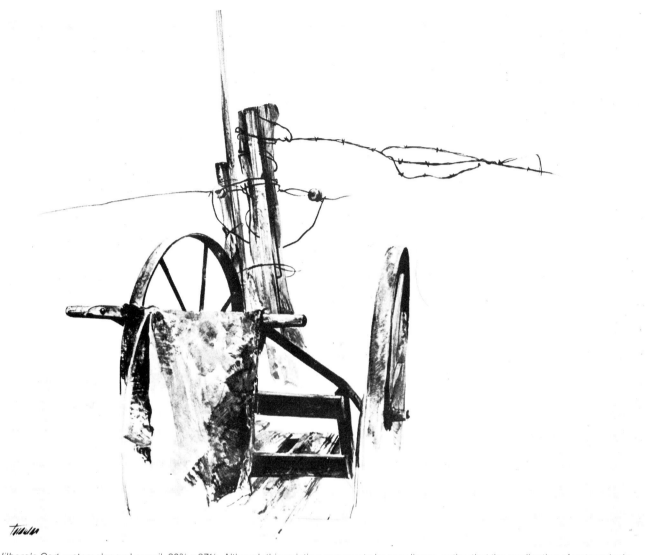

Hilberg's Cart, watercolor and pencil, 20⅜ x 27¼. Although this painting appears to be very linear, notice that the application of watercolor is actually rather broad.

develop to its own natural conclusion. Sometimes I find that after drawing for a limited period that this statement satisfies me—without color—and I stop there. At other times I paint out to all four edges to produce a complete transparent watercolor. Or again I may stop halfway with pure transparent watercolor, because I enjoy the unfinished look.

The most complex method I use is working over the transparent watercolor with pencil to add form in line and mass. Then I paint in pure egg tempera over the watercolor and pencil. The transition from watercolor to tempera is made easier by similarity of cross hatching in both pencil and tempera. This system has an advantage of being able to move from very broad areas in watercolor to more detailed sections in tempera, producing a diverse surface.

In describing all of the above approaches I must admit that I make no preliminary sketches or thumbnail compositions. At one time I did, but now I like to be completely free to search for the unexpected as I paint. As one might expect, this practice leads to a number of watercolors being dropped into the waste basket, but this is natural and part of

the search, part of the creative process. A mature artist must expect to discard many efforts. As a matter of fact, I am very suspicious of any artist who does not reject some of his own work. An artist who pretends to be always successful may be merely repeating past successes and not growing.

I have given some thought to how much time it takes to complete a painting. It seems to me that it matters little whether the painting is completed in 30 minutes or in five months. What does matter is that the artist has endowed his picture with real value.

For this reason I believe that the subject and how the artist feels about it are of extreme importance. I am fortunate to have an abundance of good subject material in our family farm in Henrietta, Ohio. The painting *Memorial Day Flag* is such an example. It was painted in the bedroom of my brother's farm house. The dresser was my grandmother's and the 48-star flag has been in the family since my childhood. But nothing about the objects is as important as my feeling about the combination of flag, furniture, and atmosphere. This is what I have tried to express.

Above: *The Cellist*, watercolor, pencil, and tempera, 20½ x 22½. Collection Mrs. Richard Treaster. Pigment—watercolor and tempera—is applied to specific areas for emphasis.

Left: *The Graduate*, watercolor and pencil, 17⅛ x 9⅝. Treaster has actually washed on the watercolor, unlike the other paintings shown here.

Below: *Virginia Avenue*, watercolor, pencil, and tempera. The artist has depicted his wife with tenderness. Pencil strokes create an atmosphere of concentration, enveloping her with intimacy.

Larry Webster

EXECUTING A WATERCOLOR painting on location in late fall, winter, or early spring is an exciting, exhilarating experience. The season reveals the basic structure of the landscape, the stark simplicity of forms against snow, the wide value range from extreme lights to dark darks, and (most important to me) the invigorating weather itself. When it's warm and pleasant I tend to become too comfortable, painting rather lackadaisically. When the temperature is stimulating, chilly, and I'm stomping around in the snow, there's time only to put down the essentials before my hands become too numb to paint. A little snow or rain in the air enhances some of the textural effects, as does a wash that freezes on the sheet before it dries. (I use rubbing alcohol in the water to keep ice from forming.)

Speed of execution is a requisite during this season, and the best way I find to achieve this speed is by planning *before* setting foot outside the studio. By that time I have become well acquainted with my subject, having looked at it from many angles, familiarizing myself with its details; I have become fascinated with the subject. I now can plan the composition, lighting, and how to work the painting up (dark to light, light to dark, wet or dry, loose or tight, for example). The more problems I've solved mentally before attacking the painting, the smoother things move, and the more I enjoy painting. To go out and look for a subject to paint on the spur of the moment usually results in disaster.

All my pre-planning will have taken place only in my mind; I do no preliminary studies or sketches, for I have found this takes away a great deal of the spontaneity so desirable in watercolor. If a small study or sketch turns out well, I have a tendency to try to copy on to the larger painting the effects and feeling in the sketches, making it studied, labored, and tight.

My palette contains raw sienna, raw umber, burnt sienna, burnt umber, alizarin crimson, French ultramarine, Payne's gray, new gamboge, black, and sometimes cadmium yellow medium, Winsor blue, and yellow ochre. I use standard transparent watercolors and acrylics, both applied in a loose, transparent manner. I use acrylics mainly for large free-flowing washes and underpainting. When dry they are almost insoluble and immovable with water so that overpainting is easily achieved without destroying the intriguing accidents or spontaneity of the underpainting.

Until a few years ago, I painted for the most part on d'Arches medium 300 lb. watercolor paper, but I have gradually changed to Strathmore double-thick illustration board almost exclusively. Both the smooth, hot pressed board and the regular surface with a little tooth serve me well. Occasionally I will give the regular surface board a coat of gesso, providing me another surface variation to work on. The smooth, hot pressed surface seems to work best for me, offering no built-in surface textures to interfere with painted textural effects; also the paint can be more easily moved around and manipulated with sponge, knife, or fist. Because the double-thick board is two-sided, I get two chances on one board to make a successful painting.

My watercolors are usually made on full 30 x 40 sheets, which I attach to a slightly larger sheet of plywood with a staple gun. I have nailed strips of wood to the underside of the plywood so that it will fit the clamp of my outside, lightweight easel. Because of the large, flat area of the painting surface and the lightweight easel, both painting and easel tend to become airborne in a breeze. I have countered this somewhat by hanging a large container of water from the easel for ballast, also doubling as my medium.

The majority of my work is done with 2 inch and 1½ inch flat bristle brushes. I also carry along a 1

Corrugated Facade, 1971, 22 x 40. Using an architectural facade as his subject, Webster creates geometric patterns of design, almost abstract in conception.

BIOGRAPHY

Larry Webster was born in Arlington, Massachusetts, in 1930. He received a Bachelor of Fine Arts degree from Massachusetts College of Art in 1952 and a Master of Science in Communication Arts in 1953. Presently he is the graphic designer, vice president, and director of the Thomas Todd Company, Boston. His watercolors are represented in museum, business, and private collections throughout the country. His awards include the American Watercolor Society Silver Medal of Honor; the Obrig Prize for Watercolor of the National Academy of Design; and the Allied Artists of America Gold Medal of Honor. He is a member of the American Watercolor Society, Allied Artists of America, Boston Watercolor Society, Rockport Art Association, and the Guild of Boston Artists.

inch flat sable as well as Nos. 12, 8, 5, and 3 round sables for detail work. Other tools my painting kit contains are razor blades, jack knife, sponges, cleansing tissues, brayer, palette knives, and most important of all, fingernails, fingers, thumbs, palms, and fists.

To begin a painting such as *Corrugated Facade* I make a careful, simple pencil drawing directly on the painting surface (in this case a gesso coated surface), paying particular attention to design. The placement or juxtaposition of shapes, particularly geometric shapes, intrigues me. The drawing is not detailed, but the shapes are worked out meticulously as far as proportion and placement are concerned.

Next I establish the overall light value of the painting by covering the surface with clear water, except those areas I want to remain lighter. I do not delineate these lighter areas carefully because I want to stay away from too many hard edges. Before applying the clear water to the surface, I will have mixed up one or two tints for these light tones in a muffin tin so that as soon as the water is on the painting surface I can start sloshing on the washes. While the surface is still wet, I will add some of the medium values and spatter texture, letting them flow freely and not worrying about drips or blemishes. From there I lay in the larger deep tones and shadow areas so that I now can see my value extremes. I find it much easier to establish the majority of the middle tones now that I know what values are on either side. While I'm laying in these large tonal washes, my hands are also busy dabbing, smudging, scratching into these wet and semi-wet areas, working up textural effects.

For me the final detail work is the hardest and most precarious step in the whole painting procedure. I have probably ruined more paintings by becoming overly engrossed in minutiae than for any other reason. The watercolor then turns into a mish-mash of meaningless detail and texture. To try to avoid this I usually pack up and leave the scene when the painting is about three-quarters done just so I won't be tempted to put in every little twig and brick. It takes a great deal of self-control to stop painting at that point, but I find if I do and place the painting behind a mat in the studio and don't touch it for a week, much of the detail I otherwise would have added is unnecessary. Also during that time I may find things that bother me, which I attempt to correct by wiping here and there with a sponge, breaking up edges, lightening up large dark areas, or throwing a wash over an area to push it back or bring it out.

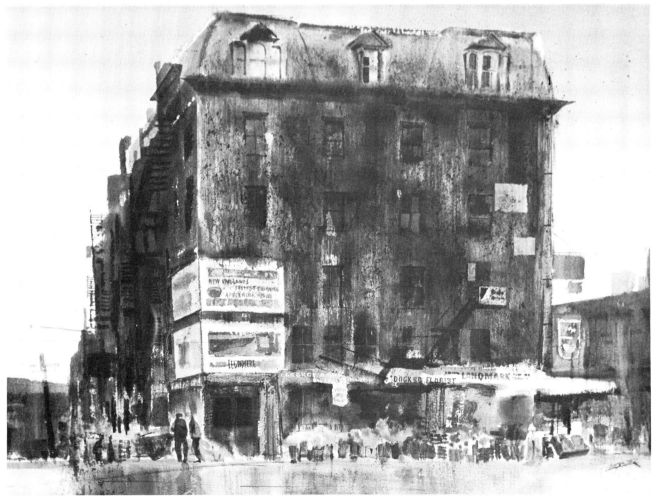

Dock Square Florist, 1968, 28½ x 30½. Webster has sharpened the focus in some areas, subdued it in others.

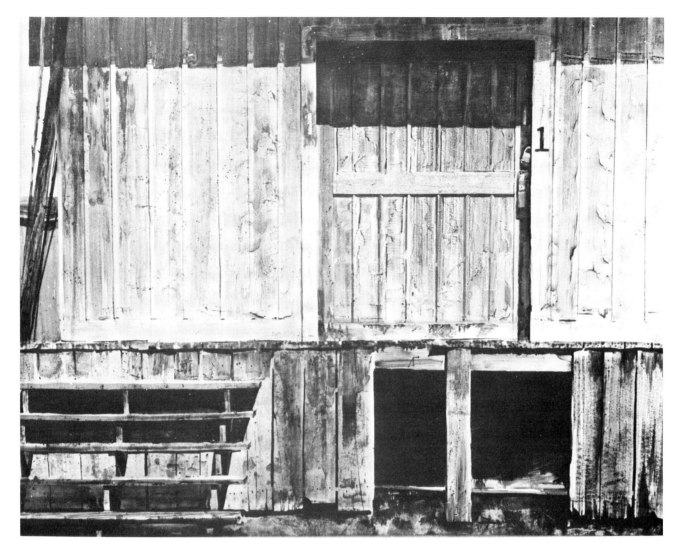

Above: *Shed Number One*, 1967, 20 x 40. The artist first laid in an underpainting in acrylic, a common practice for him, then completed the painting in watercolor.

Left: *Rock Study*, 1970, 17 inches in diameter. Using the surface of a natural form for reference, Webster creates abstract shapes that are closely related in value.

Lee Weiss

INITIALLY MY WATERCOLOR work was rather orthodox, with traditional techniques and subject matter, but it was difficult to go out on location when my children were small, and I soon tired of still lifes and work translated from hastily done sketches. I found that I was increasingly able to recall the important image from walks taken with my husband: the quality of light that turned an ordinary hillside orchard into a marvel, the way the grasses bent before the

Stream with Snow, 1968, 40 x 26. Collection Judge Edward H. Beard. Working on a fairly large scale, the artist is intrigued with landscape details.

sundown-wind. Attempts to capture these rarer occurrences led to experimentation with effects that watercolor, in particular, could produce. By 1961 I abandoned other media entirely in order to concentrate on what had become a fascinating pursuit: finding means by which to enrich the surface qualities of watercolor while retaining its marvelous transparency and inner light at the same time.

In the mid-60s I found larger papers that allowed me greater freedom but demanded an enrichment of pigment; as washes were expanded, so was their shallowness. With new papers I discovered new problems and, in solving them, new techniques. I've become a purist about using only transparent watercolor and watercolor brushes, but I do not hesitate to manipulate these in a circus of ways. "Found" textures often suggest new yet untried subjects.

One method developed initially from an accidental discovery. Unhappy with a first attempt on a new, hard-surface paper, I turned the sheet over onto my Formica painting table to begin anew on the back. This attempt proved no better than the first, so I peeled the paper off the slick table to throw it away and discovered that the still-wet pigmented surface on the first side had acquired some very interesting areas. I was intrigued with the possibilities and started a series of trials with this transfer process (basically a monoprint technique), enlarging upon the method by repeatedly flipping the paper. First I wet the paper thoroughly, brushing in areas of color and compositional elements. Then I flipped that surface over onto the flat Formica table and did the same on the back side, trying to retain a mental mirror-image of the initially worked side so that what I do on the back will complement what I do on the front. Then I pulled up the paper and flipped it once again, picking up the pigment deposited on the table by the first with the second, etc.

I find this process can be repeated up to four or five times, each time laying on a new pigment or washing out, delineating a suggestive area, or defining a mass, but building continually. Color can be laid on color, and dryer areas acquire distinctive textures, elements that can stimulate the inventive mind. It's an exciting, plastic process and can be utilized for very different effects, as I have done in the rather dryly worked *Stones*.

Like any technique, this one can be abused, but

Stones, 1969, 26 x 40. Collection Mrs. Oscar S. Brewer. The artist works on both sides of her paper, flipping it to pick up pigment from the surface of a Formica table, and working directly on the sheet as well.

BIOGRAPHY

Born in California in 1928, Lee Weiss (nee Elyse Crouse) attended the California College of Arts and Crafts in Oakland and became a designer in San Francisco. Resuming her interest in painting after her marriage, Weiss studied with N. Eric Oback and Alexander Nepote. Now living in Madison, Wisconsin, Lee Weiss has had many solo shows and has participated in numerous group and invitational shows as well. She has received a variety of awards, including the Emily Lowe Memorial Award and the Henry Ward Ranger Fund Purchase Award at the American Watercolor Society, Medal of Honor for Watercolor at the Knickerbocker Artists, the First Award at the Illinois Seven-State Regional Exhibition in Springfield, and five consecutive awards at Watercolor U.S.A., among many others. Three of her paintings were selected by the Smithsonian Institution for display in the White House in 1969 and 1972. She is a member of the American Watercolor Society.

Swamp Grass, 1970, 25 x 40. National Collection of Fine Arts, Smithsonian Institution. Weiss first indicated the blades of grass on a wet surface, and continued to paint in other areas as the paper began to dry.

Woods in Snowfall, 1968, 26 x 40. Collection Mr. and Mrs. Carroll R. Wetzel. On a uniformly wet surface the artist flicked spots of clean water to give the illusion of snowflakes obscuring the trees.

Snow on Branches, 1971, 28 x 40. Collection Dr. and Mrs. Charles D. Matthews. Here the artist resolved a difficult problem: how to use the white of the paper in such a way that the forms seem to advance.

with practice it becomes a valid tool with predictable and predetermined results. The critical moment of decision arrives: which side has the most going for it, and at what point should I abandon the other and begin to paint directly? This last stage is the real work. The colors and textures form the base from which the artist must build his painting; it won't just happen.

This process requires a harder-surfaced paper. I use a roll of watercolor paper that is 42 inches wide by 10 yards. I cut this an extra inch larger in all directions than the finished painting so that in trimming it afterward I eliminate the worst of the buckling and edge-wrinkling. (After trimming, it is possible to stretch and smooth the painting by turning it face down, taping the corners and, with a sponge, wetting the back, taking care not to get water under the edges. The surface should be wiped dry immediately. As the paper stretches, move out the taped corners to pull the sheet flat. After the paper contracts and dries, remove the tapes.)

I use many different papers and techniques to avoid falling into the trap of repeating past successes and to keep learning what else is possible. One of my favorite sheets is a double elephant size imported French paper. You don't fool around with it! Direct painting is imperative, but it doesn't have to be dull: its softer surface allows beautiful brushing and lifting.

Snow on Branches presented a ticklish problem: I wanted to retain strong patterns of near-white while building rich areas of visible branch surface at the same time. I had to work from negative to positive; although I retained the white of the paper, I wanted the white areas to appear to advance and the painted areas to recede. I did "flip" this sheet, but only once or twice, turning then to direct painting and articulating some edges while fuzzing others with flooding and flicking.

I rarely use colors straight from the tube, preferring to combine the pigments instead. For example, a mix of Winsor green and alizarin crimson golden will produce a velvety black with fascinating color-separated edges, the heavier and lighter pigments pulling apart from each other to produce an effect not unlike the glowing edges Mark Rothko painted to illumine his more solid masses. Grays that are created by mixing color-wheel opposites or several scattered colors can produce marvelous separations as later brushstrokes intercept them and new colors mingle.

My palette is simple and involves a heavy use of the earth colors: cadmium yellow, yellow ochre, raw sienna, and raw umber are favorites; burnt sienna, cadmium orange, cadmium red light, alizarin crimson golden, French ultramarine, Winsor blue, Winsor green, and occasionally Hooker's green dark are also included.

Ruth Wynn

SINCE MY SOURCES of inspiration are often found in un-expected places, I try always to be prepared to paint. I carry a small 2 x 2½ inch paint box containing tiny pans of paint, my six basic colors, and a 1 inch varnish brush in my handbag. With these I can record a small sketch of an unexpected scene. (An artist must constantly improvise, and on one occasion I managed to soak up enough rain water,

holding my brush out my car window, to make the necessary color notes.) I always paint on smooth four- or five-ply watercolor paper, which I cut into small sizes for use with my tiny paint box.

I store a collapsible bicycle in my station wagon, since the subjects so challenging to me are usually off the beaten path and inaccessible to an automobile. Needing still more equipment for painting than that generally available to a watercolorist, I have invented a device (patent applied for) that I have named the Wheezle: an easel on wheels.

This invention consists of a metal watercolor box that is attachable to the rear fender of the bicycle. The watercolor box has legs that extend to support it when stationary, while its cover opens to form a unique easel. And with the front wheel of the bicycle properly angled, the Wheezle is practically wind resistant. Seated on a campstool, in front of my Wheezle, I am as comfortably situated for painting as in my own studio. (See photograph.)

When using the Wheezle, I usually limit myself to 8 x 10 sketches. (Larger outdoor paintings are done on an easel.) I use my varnish brush to block in the design. I make many of these sketches on the spot. Although I may have an idea for a watercolor in mind, the sketches help me determine its final design. Occasionally I even take some black and white photographs as additional reference material.

My palette, indoors or out, consists of burnt umber, raw umber, cobalt blue, cerulean blue, raw sienna, cadmium red light, and alizarin crimson.

But painting materials used in my studio are somewhat different from those used on location. In my studio my smooth paper is usually 30 x 40. (I work exclusively on smooth Strathmore four- or five-ply paper. Because this paper is non-absorbent, the intensity of colors painted on it appears greater than on more absorbent paper.) My painting tools consist of a large, flat 2½ inch watercolor brush, a 1 inch varnish brush, a No. 15 sable brush, and a small rigger for fine details. In addition to a water container, I use a bottle of water with an adjustable spray attachment.

By the time I've made several outdoor sketches and am in the studio, I've determined exactly how I want to portray my subject and whether the painting is to be horizontal or vertical. I make a pencil sketch of the object that is to be the focal point and block the surrounding areas into geometrical forms. Then I apply the paint heavily and allow it to dry.

Next, using the spray attachment, I direct a spray of water onto the painting and use a brush to ma-

BIOGRAPHY

Ruth Wynn was born in Sudbury, Massachusetts. She studied at The Oak Grove School in Vassalboro, Maine, and at the Museum School and The Modern School, both in Boston.

Wynn has won numerous awards, and her works hang in public and private collections around the country. Among her awards are the 1974 Winsor & Newton Award and the 1975 Martha McKinnon Award from the American Watercolor Society, the National Academy's 1974 Award of Merit, and the 1975 Associates Award from Allied Artists of America. She is a member of the American Watercolor Society, Boston Watercolor Society (its first woman officer in history), the Rockport Art Association, The Salmagundi Club, and The Guild of Boston Artists, where she is secretary and serves on its Board of Managers.

She served as "artist in residence" for the Cambridge school system and presently makes her home in Waltham, Massachusetts, with her husband and three children.

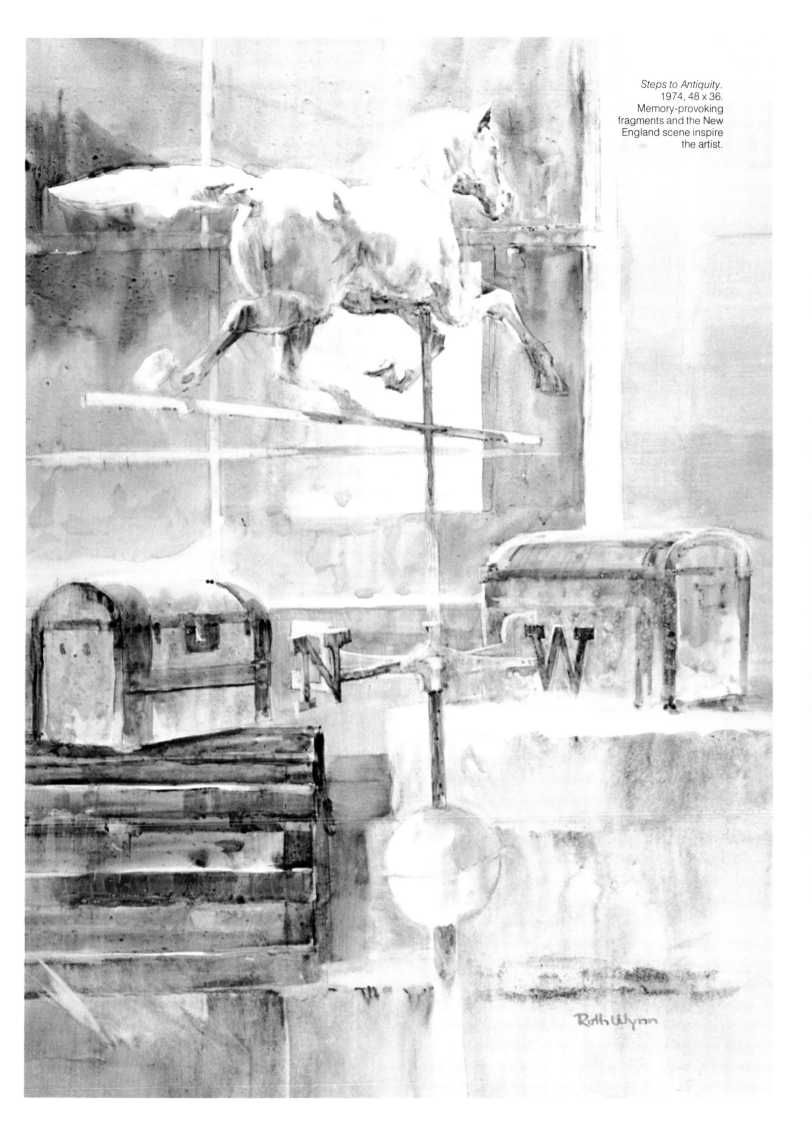

Steps to Antiquity.
1974, 48 x 36.
Memory-provoking
fragments and the New
England scene inspire
the artist.

Ruth Wynn

Whispers of Her Presence, 1975, 48 x 36. Collection Mrs. Helen Ginty. In some areas colors were merely floated over the dried first wash, but when disturbed underlying colors flow together to form a new wash.

Leaves from Former Falls, 1974, 48 x 36. Collection the artist. Wynn feels that her choice of paper permits every stroke of the brush to be visible or for the surface to appear as fluid as running water.

Opposite page: *Vinal Haven*, 1975, 48 x 36. Collection the artist.

Above, left: The Wheezle. Wynn's working utensils atop her Wheezle, a watercolor box attached to the rear fender of her bicycle. Above, right: Drawing of Wynn's palette box. Notice the detail of the U-shaped metal screw handle, upper right. This fits under the rack on the bicycle. Its top protrudes through the palette box and is secured by an L-shaped rod.

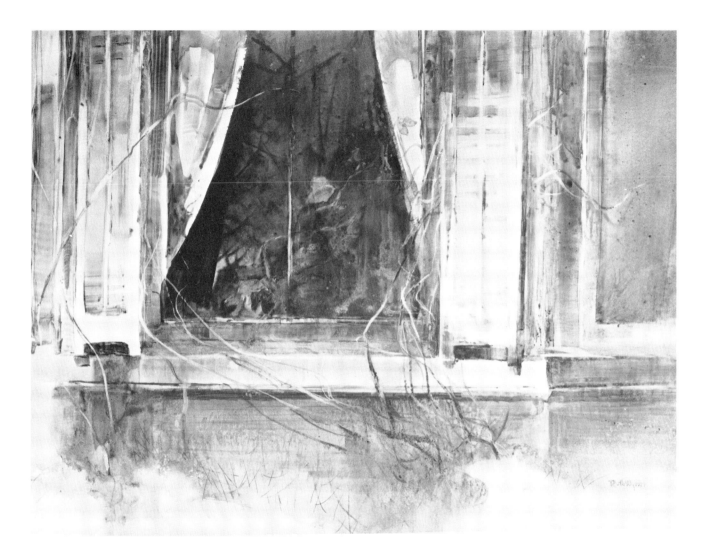

nipulate the colors already applied to the paper. The results of the spraying may be varied by how far away from the work I stand and how fine or heavy a mist I use. Through this technique I can create a glaze-like effect. Once the effect is created, tones may be adjusted: darkened by additional color or lightened by wiping.

I use my 2½ inch watercolor brush to soak up excess water from the paper, then wipe it on a cloth. This has proved the most effective and rapid way to eliminate water once I have achieved the misty blurred effect I want. For the most part, this procedure lends itself best to large areas.

When I want the effect of something growing in a painting, I use another technique. First I take a rigger dripping with clear water and skip it along over the dry painting, leaving a clear, wet line on a dried area. Then I lightly spray the whole painting. The water runs more freely where I have deposited the clear stroke, and this running begins to disturb the underlying washes, leaving a hard-edged track. By tipping and turning the paper, I can effect a climbing vine, or by standing it straight up I get a fast run, as on the stem of a weed. If blotted, these areas will come back to almost white paper.

The effect of a well-worn, weathered fence board can be achieved on this Strathmore paper by first laying the usual washes of the desired color and value. I then spray with a fine mist, and with my trusty, dirty (by this time), well-worn finger, I rub the too-hard edges of color. Blending the too-sharp edges leaves the textures sharp with suggested edges.

Steps to Antiquity was inspired by a horse weathervane displayed in an antique shop yard in Cape Ann, Massachusetts. I was returning from Rockport after delivering a painting to the Art Association Gallery for their summer exhibition. The sun glinting on this weathervane so intrigued me that, despite the "no parking" sign, I stopped to make some sketches and took photographs for additional reference material. Since horses are not one of my favorite subjects, I needed photographs. And it took many preliminary sketches to get what I needed.

Later, working in my studio under my sign "Be Bold, Be Bold, Be Bold," I designed the areas around the weathervane, building up total surfaces — feeling the presence of the former owners — keeping the first impression in mind throughout the painting period. I pictured the trunks piling up through the years, filled with memories, and the weathervane that turns at the whim of the wind: all just a moment of time in the steps to antiquity.

Marvin Yates

INTERPRETING FROM WITHIN, as well as what my eyes see; conveying an idea, as well as a sense of belonging; creating a mood: these are the things I try to achieve in my paintings. To create a sense of belonging in a work means simply bringing the viewer into the painting: interpreting a particular subject so that the viewer feels comfortable and possibly reminiscent.

Watercolor fits my personality because of the immediacy and spontaneity it offers as a medium. It can be temperamental in its sensitivity and unpredictability, yet very profound and exact, depending on what the artist is trying to communicate. The subtle delicacy and fusion of colors offered by the medium are very exciting when interpreting an idea on paper.

My being somewhat impatient is another reason why watercolor fits my personality. Because of the direct and almost instantaneous results, I can usually complete a painting in two to five hours. However, in light of the exacting nature of watercolor, I often find myself destroying many more paintings than I keep and feeling frustrated in the process. This frustration is entirely overcome by the occasional painting that achieves, to some extent, what I set out to accomplish. *Hills Shopping Center* is one of those occasional paintings whereby I felt as if I came close to achieving what I set out to accomplish.

The majority of my paintings are done in my studio. Since I don't have enough time to do as much on-the-spot painting as I would like, I rely

BIOGRAPHY

Marvin Yates was born in Jackson, Tennessee in 1943. He received a B.A. degree from The Memphis Academy of Arts.

He has exhibited in numerous regional and national exhibitions, such as Watercolor U.S.A., Mainstreams '74, the American Watercolor Society 1973 and 1974. He received the top purchase award in the Tennessee Watercolor Society exhibition in 1972 and the Washington School of Art Award in the 1974 American Watercolor Society exhibition.

Yates is a member of the Tennessee Watercolor Society and a member and co-founder of the Memphis Watercolor Group, and the Southern Watercolor Society. He is also an associate member of the American Watercolor Society. His paintings are in several hundred public and private collections. His work is exhibited in 18 states and over 37 galleries and he is represented in over 250 public, private, and corporate collections. He is married and lives in Germantown, Tennessee, a suburb of Memphis.

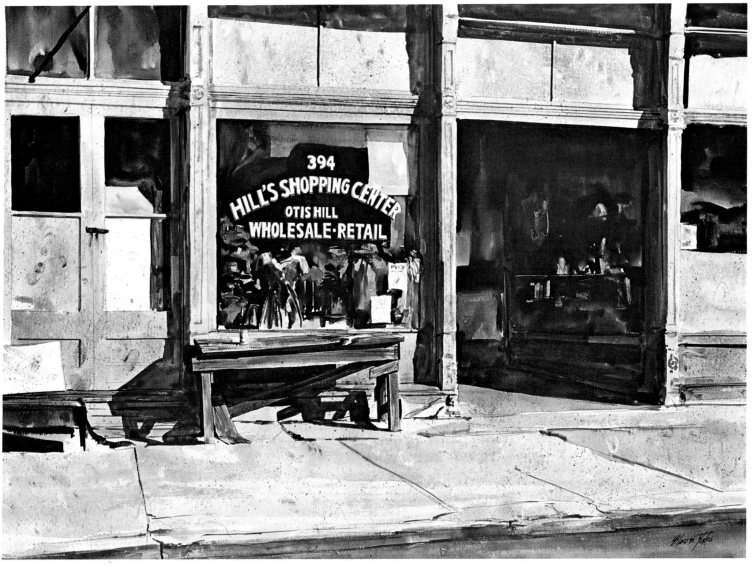

Hills Shopping Center, 1973, 19 x 28. Collection Mr. and Mrs. Kenneth D. Guthrie. The artist develops his value patterns first, working from light to dark. Patterns and color shapes are used to create a focal point.

heavily on my 35mm camera for gathering material. This camera permits me to gather more material in a shorter period of time and also to capture a particular subject without worrying about changing light and other conditions.

After deciding on a subject, I try to preplan technical aspects of the painting as much as possible. This way I can approach a painting with confidence and determination and can become more involved with my emotional interpretation. I try to work out composition and value in numerous thumbnail sketches.

Hills Shopping Center was done on Crescent acrylic board, which has a texture similar to a linen mat board. I also use a smooth, hot press, Crescent watercolor board and a very smooth surfaced (high), double thick Strathmore illustration board, which offers the artist more freedom of interpretation in textural effects.

My palette consists of yellow ochre, raw and burnt umber, the siennas, sepia, Davy's gray, charcoal gray, ultramarine, cerulean and cobalt blues, olive green, new gamboge, and an occasional use of vermilion, brown madder and Naples yellow. But seldom do I use more than four or five colors in any one painting.

My brushes range from Nos. 3 and 5 red sables for detailed work to 1 and 1½ inch flat bristle brushes, which are similar to a housepainter's brush but of finer quality. These brushes hold a tremendous amount of pigment for background and large wash areas. I also use 2 and 3 inch goat's hair brushes for larger paintings. I probably use my 1 inch flat aquarelle red sable brush more than any other, because of the flexibility it affords, not only in applying pigment to the surface, but also by using the opposite end for scratching out shapes and light areas in structural subjects and grass and limbs in landscapes. I use sandpaper to soften edges and tissue paper to pick up pigment to lighten an area and often to create texture. I use other tools such as sponges, razor blades, most anything I can get my hands on to achieve a textural effect.

In the painting *Hills Shopping Center* I started

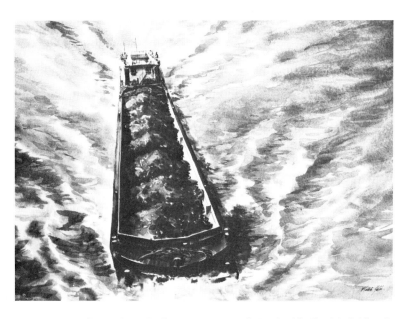

Above: *River Traffic*, 1973, 20 x 28. Collection Ms. Patricia A. Kissell. The artist contrasts the freely painted diagonals of the waves with a precisely defined barge.

Below: *The Divine Miss "D,"* 1973, 23 x 30. Collection Dr. and Mrs. Robert C. Reeder. Yates creates a mood of quiet expectancy. Empty of people, the riverboat is anchored. Yet it waits for business with its door open to the viewer.

with a detailed drawing on the acrylic board, taking my artistic license to work out a pleasing composition. Working rapidly, I applied the underpainting in a transparent manner, and loosely worked in other colors to create the overall tonal value. (I almost always work from light to dark, establishing value patterns as I go and creating textural effects by various means to give the painting depth.)

After establishing my overall value patterns, I started to pin down various shapes by putting in my darkest shadows and creating details and contrast in design and value. There are few real details as such in this particular painting; mainly the large patterns and color shapes, particularly in the window, create a focal point, which hopefully is pleasing to the eye. I try to keep my approach to painting very simple, relying principally on the design and value patterns to create an exciting composition that relates to the focal point.

I like to view the finished painting day after day to see if my much-expended mental and physical energy achieved what I originally set out to achieve. If it turns out to be that occasional painting I spoke of earlier, I'm elated. For me, this is what it's all about.

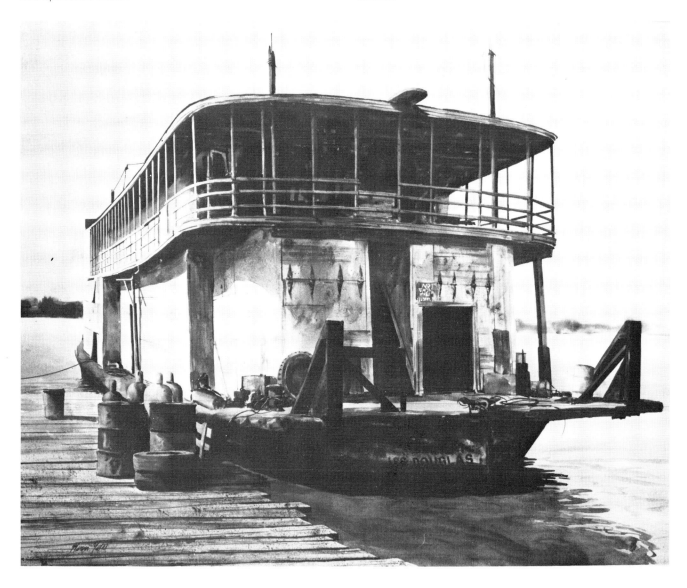

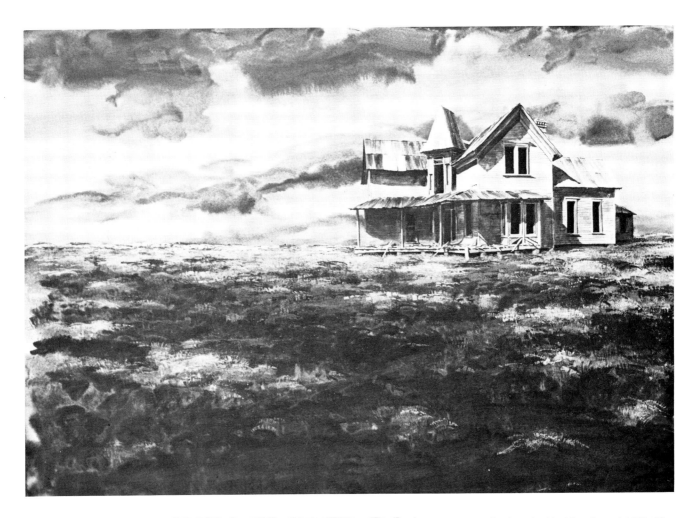

Above: *Far from the Madding Crowd*, 1972, 22 x 32. Collection Dr. and Mrs. John C. Mankin. Yates uses whatever material necessary to achieve the textural effect he wants. Here he contrasts geometric quality of the house with a bristly foreground and a loosely painted sky.

Left: *Price's Barber Shop*, 1973, 20 x 16. Collection the artist. The artist creates a sense of familiarity in the viewer by his setting and choice of objects.

169

Index

(Note: Where information is contained in figure captions, page number appears in *italics*.)

Edited by Susan E. Meyer
Designed by Bob Fillie
Composed in 10 point Melior by Gerard Associates/Graphic Arts Inc.
Manufactured in Japan by Dai Nippon Printing Co.